STAR TREK™
DESIGNING STARSHIPS
THE KELVIN TIMELINE

FROM THE MOVIES *STAR TREK*, *STAR TREK INTO DARKNESS*, AND *STAR TREK BEYOND*

Published by Hero Collector Books, a division of Eaglemoss Ltd. 2019
1st Floor, Kensington Village, Avonmore Road, W14 8TS, London, UK.

General Editor **Ben Robinson**
Project Manager **Jo Bourne**
Written by **Ben Robinson**
Designed by **Stephen Scanlan**
Proofread by **Joe Hawkes**

Most of the contents of this book were originally published as part of
STAR TREK – The Official Starships Collection 2013-2017
For back issues: order online at
www.shop.eaglemoss.com

ISBN 978-1-85875-538-0

Printed in China

CONTENTS

08: **DESIGNING THE** *U.S.S. ENTERPRISE*

28: **DESIGNING THE** *U.S.S. KELVIN*

42: **DESIGNING THE** *JELLYFISH*

56: **DESIGNING THE** *NARADA*

72: **DESIGNING THE ARMADA**

80: **DESIGNING THE** *U.S.S. VENGEANCE*

98: **DESIGNING THE** *D4* **BIRD-OF-PREY**

114: **DESIGNING THE** *U.S.S. FRANKLIN*

128: **DESIGNING THE ALTAMID SWARM SHIP**

142: **DESIGNING THE** *U.S.S. YORKTOWN*

150: **DESIGNING THE** *U.S.S. ENTERPRISE* NCC-1701-A

156: **DESIGNING THE FORGOTTEN SHIPS**

ACKNOWLEDGMENTS

We would like to thank all of the artists, production designers,
visual effects artists, directors, producers and writers who contributed
to the ships that fill the pages of this book.

The greatest thanks of all are due to Gene Roddenberry and
Matt Jefferies, who started it all and gave us a genuinely new kind of
starship that has provided an amazingly adaptable template for what has
followed. They are both much missed, but their legacy lives on.

We'd like to thank in no particular order Scott Chambliss, Ryan Church,
James Clyne, Sean Hargreaves, Romek Delimata, Tim Flattery,
John Eaves, Bryan Hitch, Niel Bushnell, Nathan Schroeder, Harald Belker,
Steven Messing, Pierre Drolet, Alex Jaeger, Bruce Holcomb, John Goodson,
and Ben Grossman, all of whom contributed to this book when they gave
the original interviews for STAR TREK – The Official Starships Collection.
They could not have been more helpful or generous with their time.
We'd also like to thank all the artists whose work is featured and the teams
at ILM, Pixomondo and Double Negative.

Our special thanks to the team at CBS consumer products:
Risa Kessler, John Van Citters and Marian Cordry.

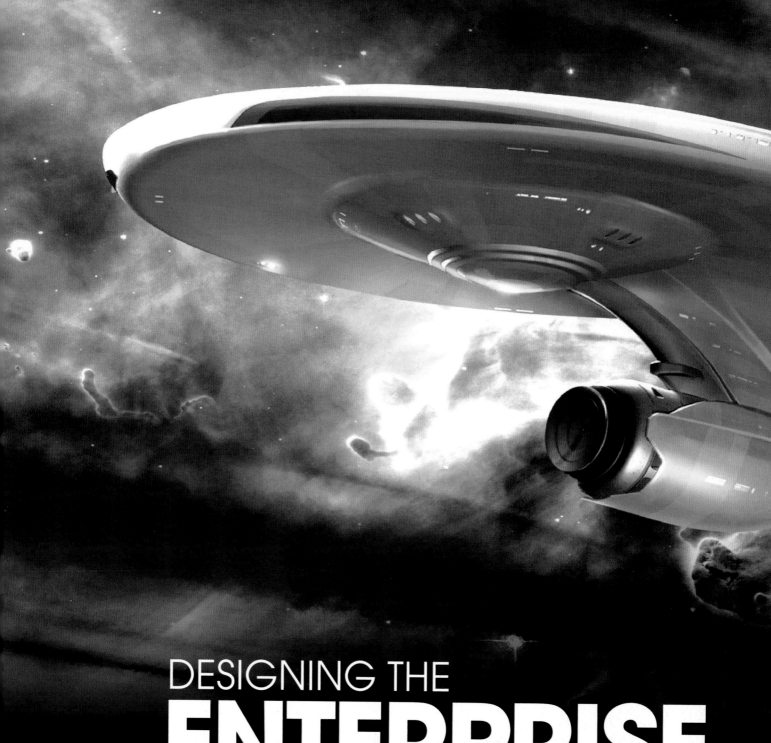

DESIGNING THE
ENTERPRISE

When *STAR TREK* returned in 2009, everything was updated including the famous starship, which was cooler than ever.

F or many people the *Enterprise* is *STAR TREK*, so getting the design of the new version right was every bit as important as casting a new Captain Kirk or a new Mr. Spock. In many ways, redesigning it for the 21st century summed up the challenge the whole movie presented to director

JJ Abrams – somehow he had to make it instantly recognizable, but at the same time it had to be modern and sexy. In essence this was the brief that he gave his production designer Scott Chambliss: design a new *Enterprise* that would be both similar and noticeably different to Matt Jefferies' original

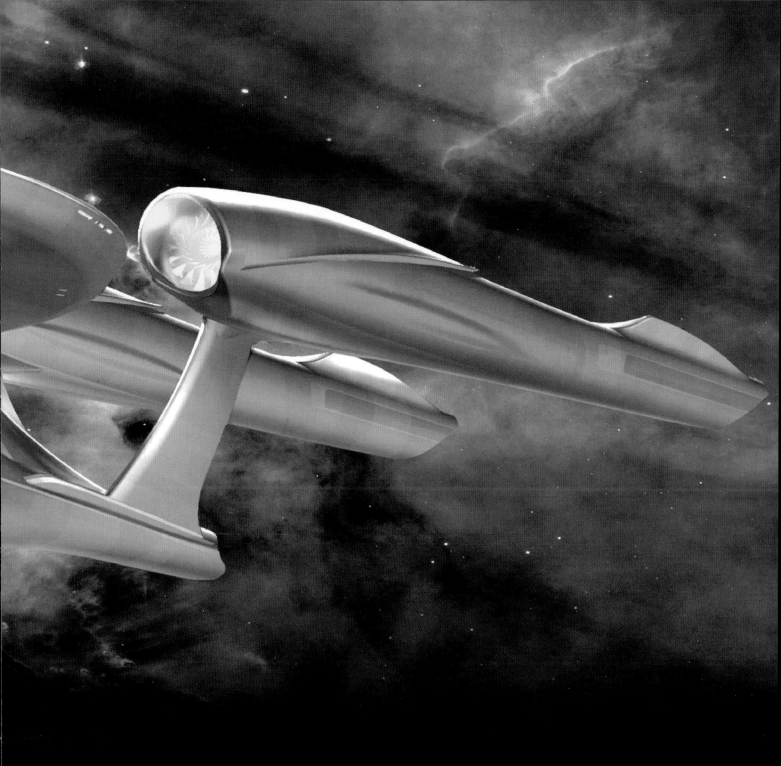

As Chambliss explains, Abrams stressed that while he wanted to make a tribute to Roddenberry's original series, he wanted to do so without following slavishly in its footsteps. "At the same time, he wanted to embrace the inherent optimism of Roddenberry's point of view. That was a great relief to me as I was concerned that JJ might take a more contemporary, cynical approach. It dovetailed nicely with my intention, which was to explore the strongest and most lasting futuristic thought and design from the era of the original series."

With that idea in mind Chambliss and Abrams gravitated towards 1960s futurism as exemplified by the Finnish-American architect Eero Saarinen, who designed the TWA terminal at JFK airport. They decided that this 1960s vision for the future was exactly the look and feel they wanted to bring to their new *STAR TREK* universe, believing that this approach to the design would give the film a particular visual signature that would make it stand out against other movies.

They also had the chance to revisit some of the ideas that had been behind the design of the

▲ Ryan Church's concept painting for the new *Starship Enterprise*, which was sent to ILM, where Alex Jaeger and his team completed the design.

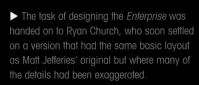

▶ The task of designing the *Enterprise* was handed on to Ryan Church, who soon settled on a version that had the same basic layout as Matt Jefferies' original but where many of the details had been exaggerated.

▲ The new *Enterprise* was designed under the direction of production designer Scott Chambliss, who was responsible for realizing JJ Abrams' vision for the new movie.

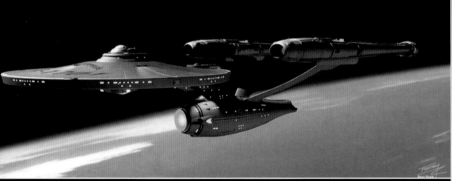

▲▼ The first person to work on concepts for the new version of the *Enterprise* was Tim Flattery. The designs he produced show an *Enterprise* that is similar to the version that made its debut in *STAR TREK: THE MOTION PICTURE,* and Chambliss and Abrams wanted more of a departure.

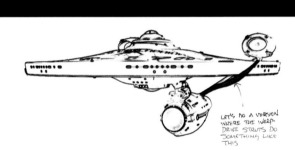

LET'S DO A VERSION WHERE THE WARP DRIVE STRUTS DO SOMETHING LIKE THIS

▲ As this early drawing shows, the team worked from the motion picture version of the *Enterprise,* looking for interesting ways to refine the shapes and enhance the design for a 21st-century audience.

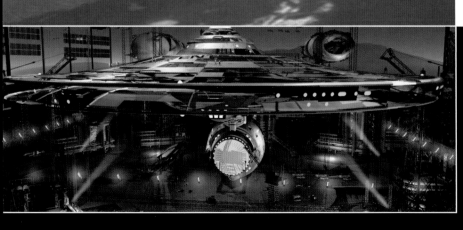

original series, only this time with a much bigger budget. "Our task was to reinterpret what was essentially an original, lowish budget television-show design that was much too undeveloped to stand up to big screen requirements. Even before

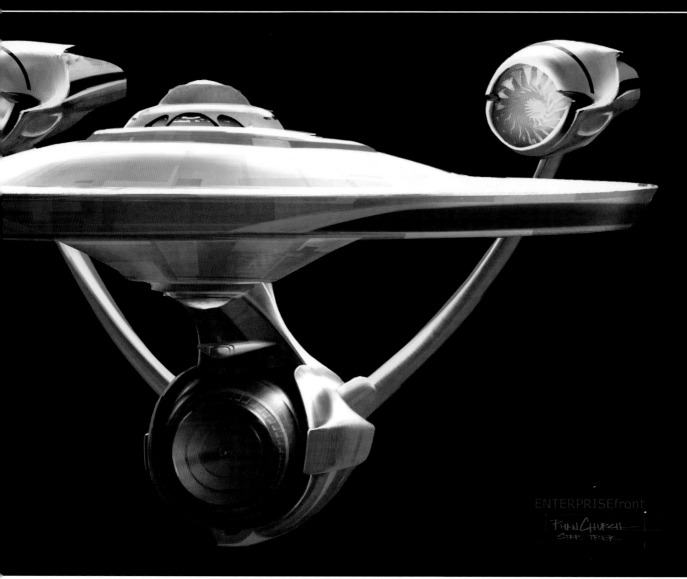

ENTERPRISEfront

RYAN CHURCH
STAR TREK

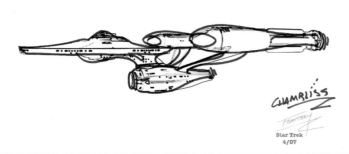

CHAMBLISS

Star Trek
4/07

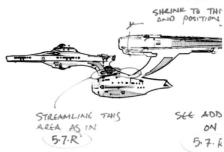

SHRINK TO THI'
AND POSITION

STREAMLINE THIS
AREA AS IN
5.7.R'

SEE ADD
ON
5.7.R

▲ Scott Chambliss' hand-drawn notes show that he was already thinking about turning the *Enterprise* into a "hot rod" by exaggerating the shape of the engines.

▲ Chambliss was also looking at ways of altering the proportions of the different elements without interfering with the fundamentals of Matt Jefferies' original design.

beginning the design process we knew that we had the opportunity to enhance the purpose, the functionality and the very industrial design of the ship inside out and from top to bottom." But, Chambliss adds, they didn't want to redesign

things just to make them look cool and modern. "I felt it was important that – just as in the series – everything that could be seen on the ship needed to be readily accessible to an audience. Whether we understood the technology or not, visually the

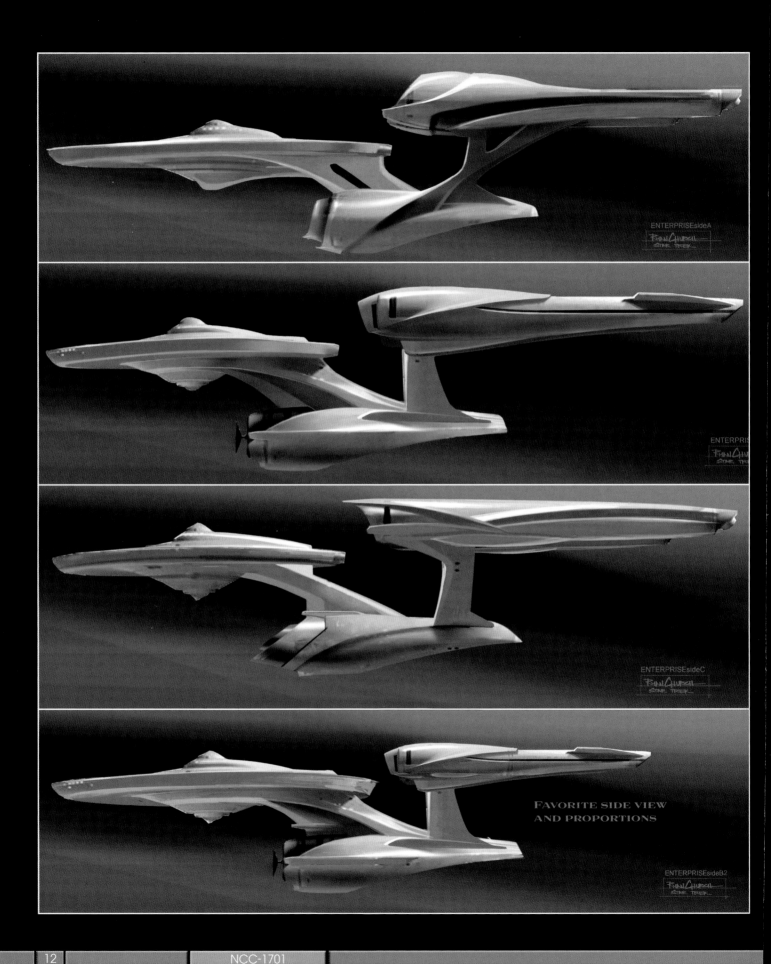

ENTERPRISEsideA

ENTERPRIS

ENTERPRISEsideC

FAVORITE SIDE VIEW
AND PROPORTIONS

ENTERPRISEsideB2

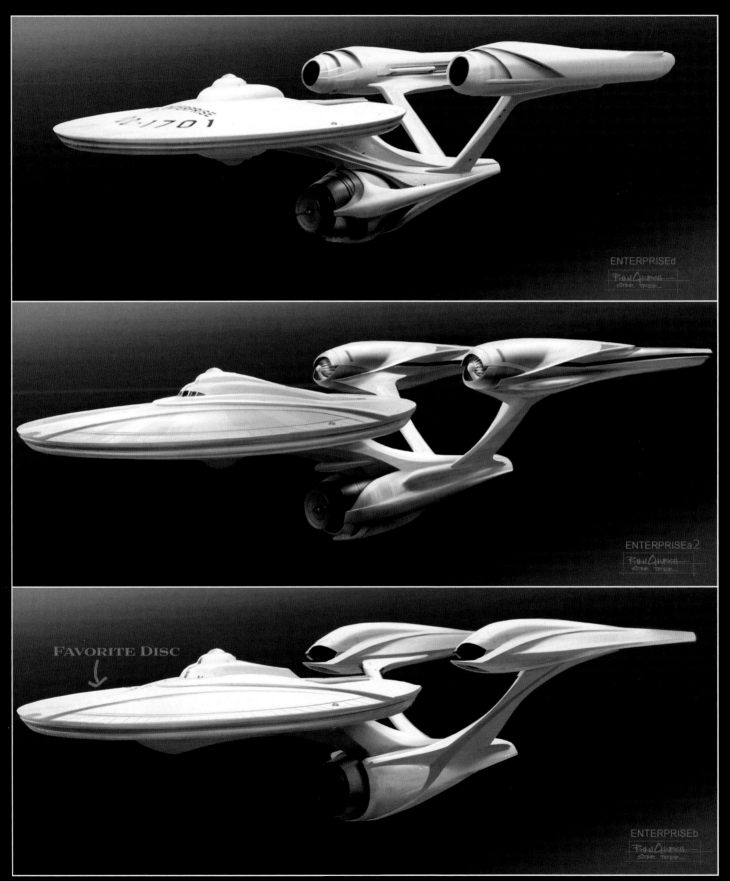

ENTERPRISEd

ENTERPRISEa2

FAVORITE DISC

ENTERPRISEb

▲ Church experimented with a variety of subtly different profiles for the redesigned ship, where different elements were exaggerated.

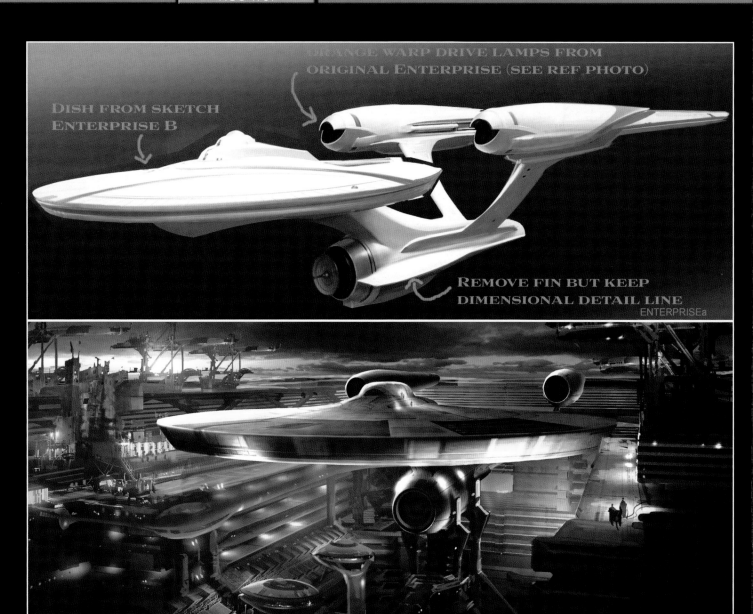

DISH FROM SKETCH
ENTERPRISE B

ORANGE WARP DRIVE LAMPS FROM
ORIGINAL ENTERPRISE (SEE REF PHOTO)

REMOVE FIN BUT KEEP
DIMENSIONAL DETAIL LINE

ENTERPRISEa

▲ Ryan Church
continued to produce
concept drawings even
after ILM started work
on the ship. He also
created several paintings
that showed important
VFX scenes such as
the moment when Kirk
looks up and sees
the *Enterprise* under
construction.

audience had to be able to grasp what the crew
were doing and how it all added up to running
a big space ship."

Chambliss also developed an important
principle that would inform the look of everything
his team created. The movie featured three major
cultures – Starfleet, Vulcans, and Romulans – each
of which Chambliss reasoned would have their
own approach to design.

LOGIC AND EMOTION

"I saw our *STAR TREK* as a fantastic opportunity for
me to visually define three very different cultures:
human, Vulcan and Romulan. By defining them in
archetypal terms – Vulcan equals logic-driven,
Romulans equals violently emotional, and human
equals logic and emotion – I had the means to

develop their physical worlds as utterly individual,
using those ideas as the conceptual motivator of
each design choice for their distinct cultures." So
for the *Enterprise* the idea was to develop a design
that sat between the aggressive design of the
villain Nero's ship and the extremely rational
designs favoured by his Vulcan cousins.

The earliest designs for the new *Enterprise* were
done by Tim Flattery. The visuals that he produced
were a little too close to the familiar movie version
of the *Enterprise* and Abrams and Chambliss
wanted to find a design that was less familiar.
Another designer, Ryan Church, also started work
on the design. As a veteran of the *Star Wars*
prequels and *Avatar*, he had plenty of experience
designing starships. "Ryan brought a very refined
sensibility to the table alongside enormous

ENTERPRISE Interiors

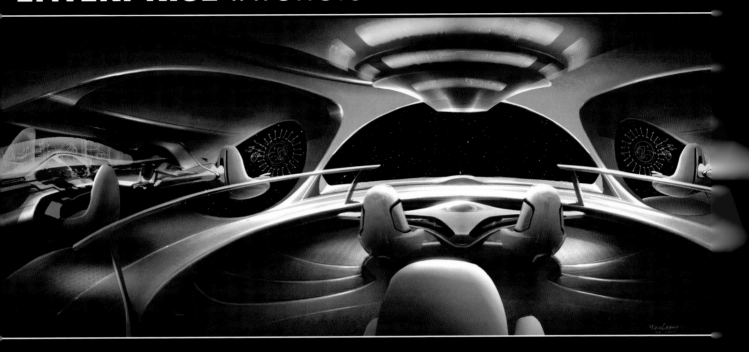

The *Enterprise*'s interiors were designed at the same time as the ship's exterior, with Ryan Church once again producing concept artwork, though in this case he was joined by Andrew Reeder, who worked on the design of the bridge and the corridors and would contribute the warp core when the team returned to make *STAR TREK INTO DARKNESS*. Chambliss was delighted with the results and describes the interiors as looking good and feeling good to work in. "The detail of the design was so thorough that each character could only feel pride being a member of the team on that ship."

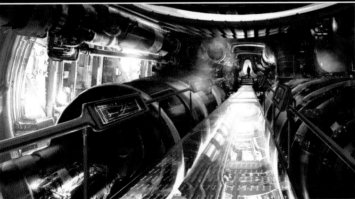

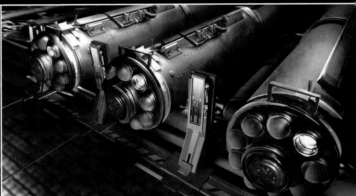

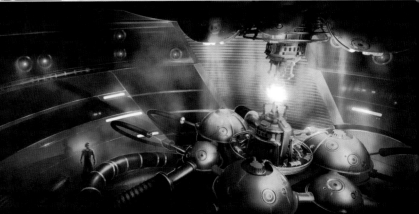

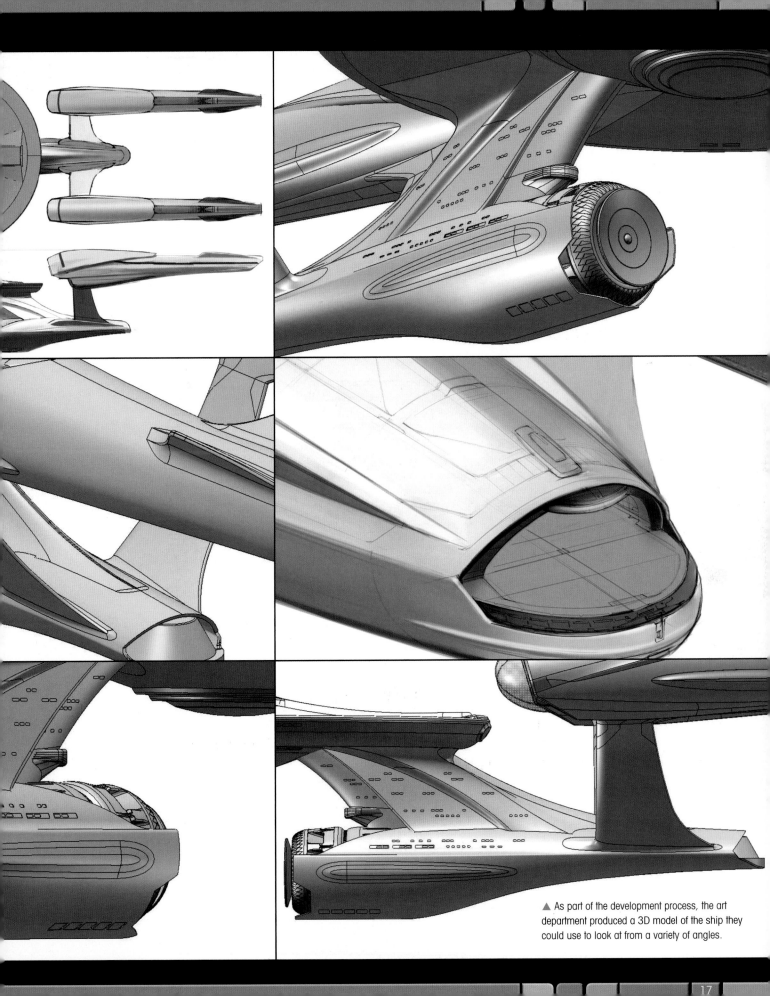

▲ As part of the development process, the art department produced a 3D model of the ship they could use to look at from a variety of angles.

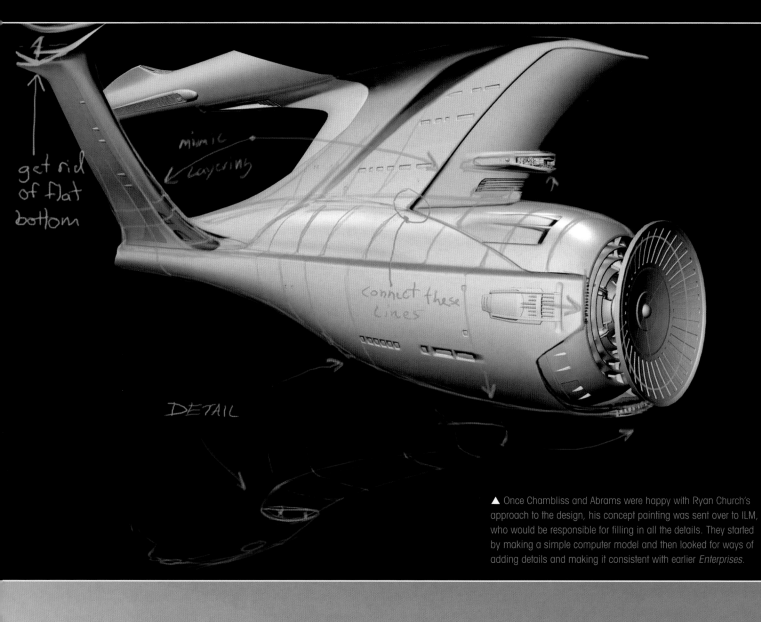

get rid
of flat
bottom

mimic
layering

connect these
lines

DETAIL

▲ Once Chambliss and Abrams were happy with Ryan Church's approach to the design, his concept painting was sent over to ILM, who would be responsible for filling in all the details. They started by making a simple computer model and then looked for ways of adding details and making it consistent with earlier *Enterprises*.

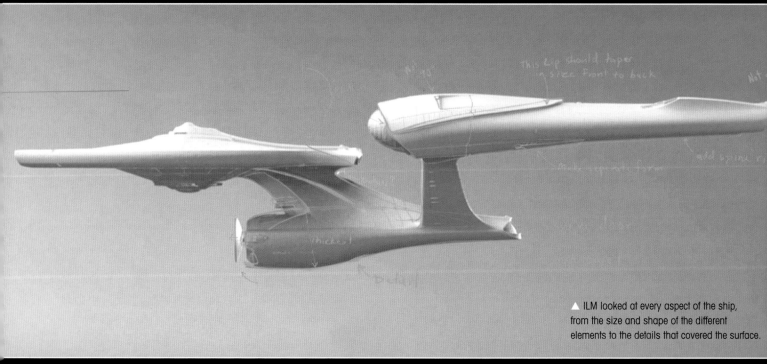

This lip should taper in size front to back

▲ ILM looked at every aspect of the ship, from the size and shape of the different elements to the details that covered the surface.

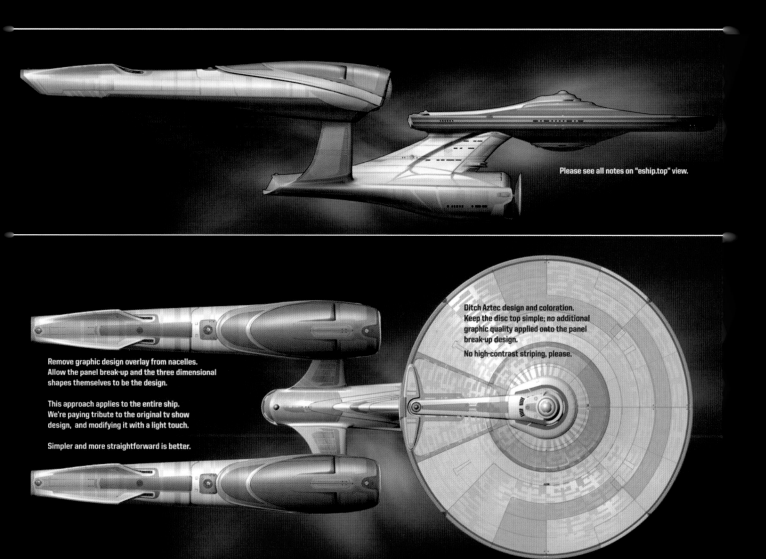

Please see all notes on "eship.top" view.

Ditch Aztec design and coloration. Keep the disc top simple; no additional graphic quality applied onto the panel break-up design.

No high-contrast striping, please.

Remove graphic design overlay from nacelles. Allow the panel break-up and the three dimensional shapes themselves to be the design.

This approach applies to the entire ship. We're paying tribute to the original tv show design, and modifying it with a light touch.

Simpler and more straightforward is better.

'CHQ' Overall Panel and details work-in-progress concept 9/6/07 A. Jaeger ILM

technical skills," says Chambliss. "His tastes and styles were in strong accord with the design sensibility I wished to develop for the exterior of the ship and later for the interior environments."

Church remembers being told that Abrams was open to anything, and that Chambliss was keen for him to try out an entire gamut of design possibilities from very subtle re-skins of the original *Enterprise* all the way to a look that would be barely recognizable. However, as Chambliss is quick to point out, while it was worth considering, such a radical departure from the original design was unlikely to work. "There would have been no point in making a new *STAR TREK* if the *Enterprise* were unrecognizable," says Chambliss. "If that had ended up being the case we might as well have called the film *The Incredible Voyages Of Five Young Space Cadets* and given them an entirely

different space ship and world to exist in. It was important that whatever designs we came up with, audiences instantly see it as the *Enterprise*."

Luckily, Church was already very familiar with the older *Enterprise* designs. "They're all really great and iconic designs and that made the challenge even harder," he recalls. "To create something that lived up to the high standards of all the versions that had gone before, and especially the very first Jefferies design, which was just so bold." With this in mind, Church concentrated on coming up with designs that kept the basic shape of Matt Jefferies' original design but exaggerated certain elements of it, such as the curve on the underside of the engineering hull.

"The thing is there is only so much you can do with the shape of the original ship until it breaks down. For that reason I ended up going down

▲ At one point, Alex Jaeger suggested that they should consider giving the *Enterprise* much heavier panel lines that would have made it look chunkier and given more of a sense of scale. ILM produced these drawings, but the team decided to adopt a different approach.

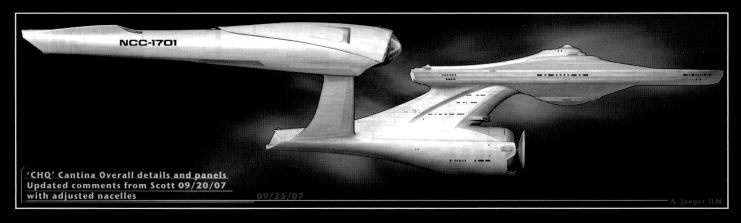

NCC-1701

'CHQ' Cantina Overall details and panels
Updated comments from Scott 09/20/07
with adjusted nacelles 09/25/07
— A. Jaeger ILM

▲ It was decided that the *Enterprise* should be smooth and gleaming white. A subtle Aztec pattern was added to the surface to create a sense of scale.

▼ No detail was too small for ILM who took care to add familiar elements such as RCS thrusters that had featured on earlier ships.

many dead ends. I was working very sketchily and impressionistically compared to how I would usually work. But Scott and JJ like to work this way – they can see through the eye candy and detail passes and don't need that much information in a sketch to tell if it's going to work or not and how it will look on film."

"I played around with sleeker silhouettes and also more functional ones. I noticed that Scott and JJ tended to respond more favorably to designs that looked the most cohesive and sleek – more 'all of a piece' than the slightly tinkertoy feel you get from the original."

EXPLORING SHAPES

One of the most obvious differences in Church's design is the larger, more bulbous nacelles. On the original *Enterprise* the nacelles had been a relatively simple shape. That had been restyled

and given something of an art deco style for the movies. So Church started to look at different shapes that he could use for the nacelles and how they might attach to the main body. "I was also keen to come up with a design that implied an interaction between the saucer and the nacelles so that it looked like the saucer was almost part of the propulsion system. I decided I wanted the scanner array to articulate and I had the idea that when the ship was in warp, or just out of it, that the nacelles would glow from inside from being superheated."

By the end of the concept design stage, Church had developed a ship that was recognizably a version of Jefferies' *Enterprise*, but that had more sweeping organic lines and pronounced shapes. Whilst still smooth and sleek, it had various raised sections such as cowling on the nacelles, exaggerated separation lines on the engineering hull, and a more swept back rear end, together with a more pronounced sweep towards the back of the engineering hull and the shuttlebay. At this point, the design still had a very traditional deflector dish that could have come straight off the 1960s ship. He also produced a number of passes resolving details and playing with different markings, surface treatments, hangar and dish configurations before sending the package over to ILM, marking the beginning of the detail design process.

The team at ILM was led by Alex Jaeger, who, as a young man had worked on *STAR TREK: FIRST CONTACT*, for which he had famously designed the *Akira* class. As he explains, ILM's job was to take a concept and turn it into a finished ship. "We were given Ryan's painting as a basis but JJ also gave us the mandate to do what ILM does best – make it look fitting to the film and give it all the history

'CHQ' Cantina saucer edge details and windows.
9/25/07 A. Jaeger ILM

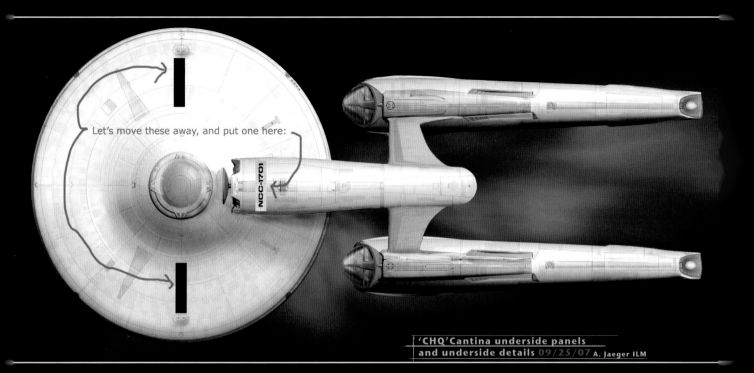

Let's move these away, and put one here:

NCC-1701

'CHQ' Cantina underside panels
and underside details 09/25/07 A. Jaeger ILM

and the detail that a ship called the *Enterprise* deserves. Given that ILM had worked on most of the previous *STAR TREK* films and helped out with some of the TV shows we already knew what it takes to 'make it so'."

A BADASS ENTERPRISE

As the VFX Art Director, Jaeger was charged with finessing every element of the ship – from the nacelles to the lighting and from the way the shapes blended to the details of the shuttlecraft doors – all of which needed to be fleshed out.

"I did a lot of back and forth with Scott Chambliss during the beginning stages to make

sure we were capturing many of the ideas he had as production designer, but ultimately it was JJ giving us as much freedom to do what we thought the most badass 1960s *Enterprise* might look like with a bigger budget. Between myself, John Goodson, Bruce Holcomb, and Ron Woodall, we pooled decades of experience."

The first and biggest part of Church's design that changed from the concept was the size of the nacelles. "Although JJ had given the mandate to make this a 'hot rod', the nacelles on the first model based on the concept were dramatically too large. It gave the ship a cartoonish feel and, in the 2:35 aspect ratio of the film, the Bussards

▲ Some details were moved to new positions – for example, the registry was added to the underside of the engineering hull. The design continued to evolve and this wasn't present in *STAR TREK INTO DARKNESS*.

◀ One of the ideas that could be seen in Ryan Church's concept artwork was that the nacelles would light up in some way. Exactly how would be left to ILM.

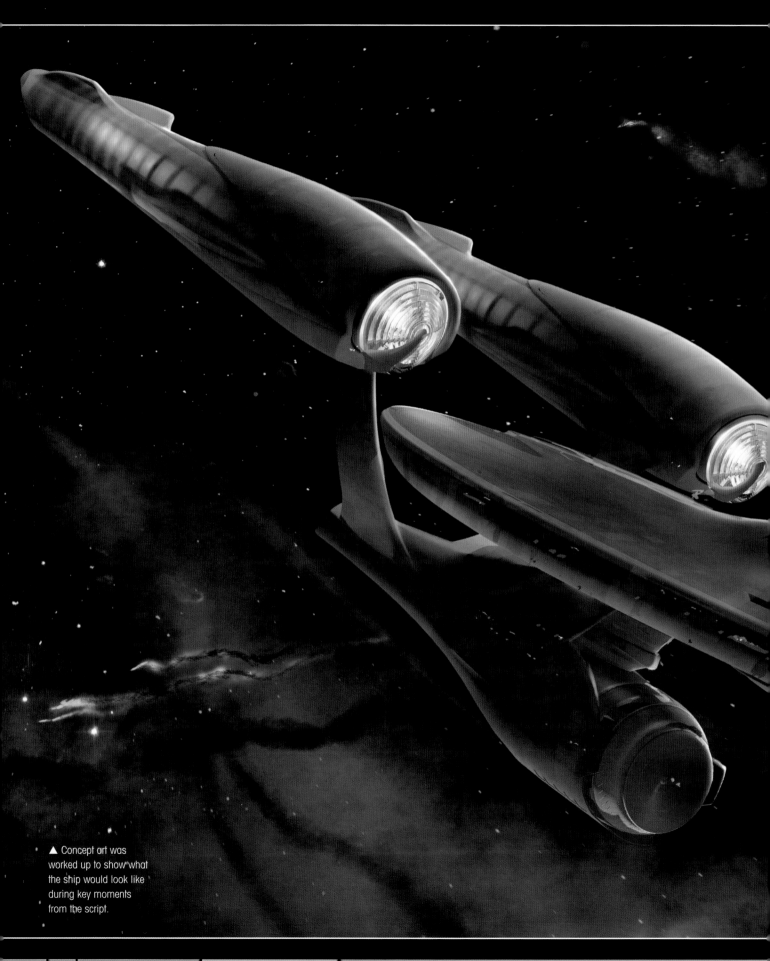

▲ Concept art was worked up to show what the ship would look like during key moments from the script.

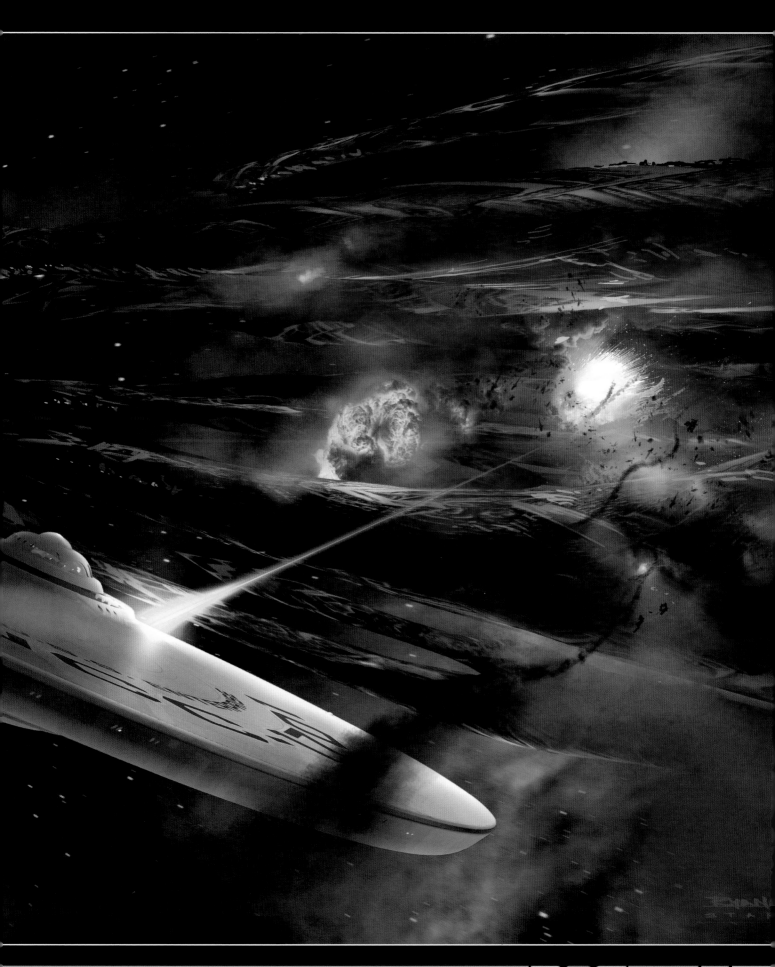

▶ One of the things that ILM put a lot of work into was the design of the warp nacelles and they refined the design of both the front and the back. As this concept drawing shows, they always referred back to Matt Jefferies' original design, which provided them with inspiration.

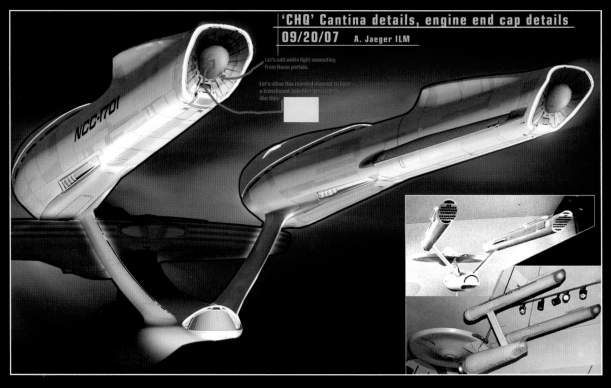

'CHQ' Cantina details, engine end cap details
09/20/07 A. Jaeger ILM

Let's add white light emanating from these portals.

Let's allow this rounded element to have a translucent pale blue spine to have like this.

looked overpowering from every angle. So we scaled them down in diameter and length. The Bussards also changed in form and color. We did pursue the more orange color with hints of movements within to mimic the original *Enterprise* pattern, but it was still in development when we were playing with the black hole effects. In some of the lightning frames were a few flash frames where the color of the ship was inverted. This showed the Bussards as dark with a bluish-white tornado in the middle. We all knew it was a complete fluke, but we also all knew that it looked pretty cool and JJ agreed.

"When the Bussards changed to the blue, it helped the whole design to gel better. Then there was the tail end of the nacelles, which in the model were just flat cutoffs. I researched the various *Enterprises* and designed a hybrid end cone that we could also light up."

The shape of the ship was also refined with a vast number of subtle form changes and proportion adjustments taking place during the modeling process. "As well as changing the size of the nacelles the support struts had to be adjusted, with various sweep angles being considered until the right one was finally selected. Subtle

▶ At this point the design of the Bussard collectors at the front of the nacelles was a direct tribute to the original 1960s TV series and orange energy could be seen swirling at the front of the nacelles. ILM took the opportunity to add more sophisticated animation effects, but something about the orange color didn't seem quite right.

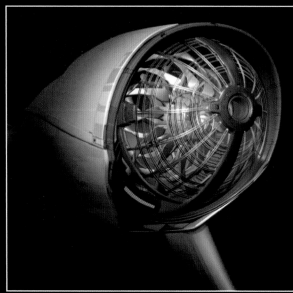

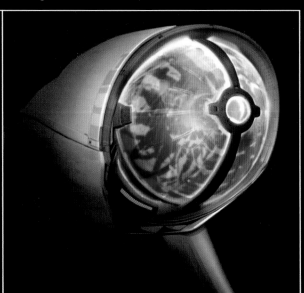

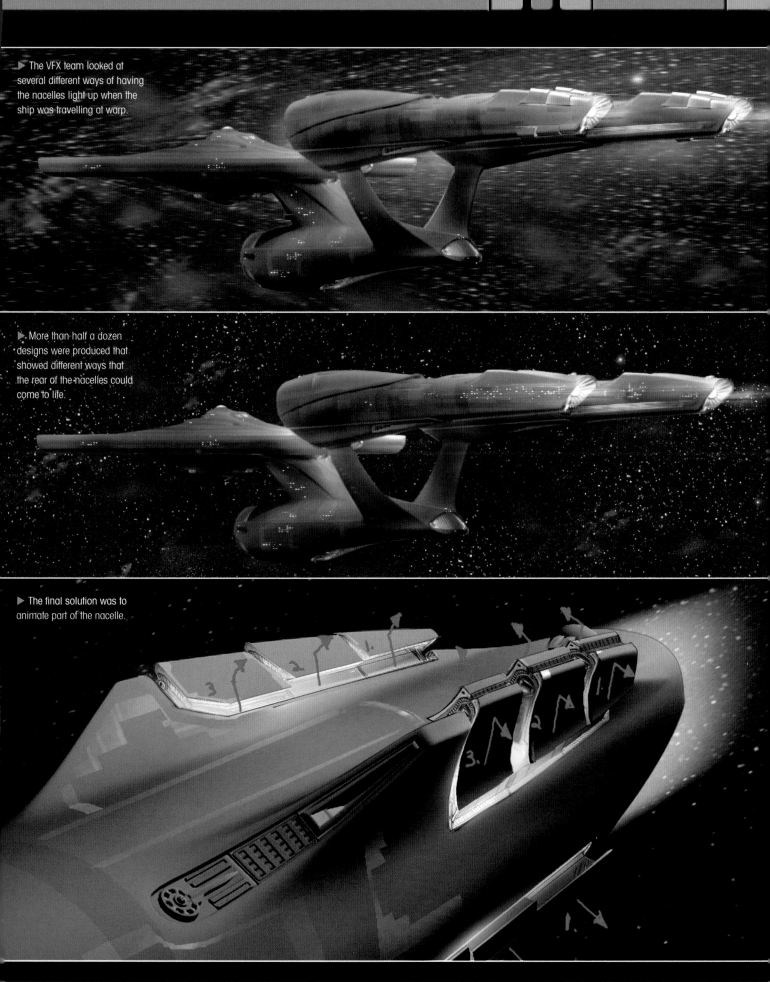

▶ The VFX team looked at several different ways of having the nacelles light up when the ship was travelling at warp.

▶ More than half a dozen designs were produced that showed different ways that the rear of the nacelles could come to life.

▶ The final solution was to animate part of the nacelle.

◀ The shuttlebay ended up having a profound influence on the size of the ship as a whole. The *Enterprise* was originally intended to be much the same length as the original TV version but this made the shuttles seem disconcertingly large so the size of the ship was doubled.

adjustments were also made to the curves of the ship in order to give the body more tension and flow, with the final shape becoming a more taut, lean and sexy form that evoked the original while at the same time giving it a new matured edge."

In creating a sense of scale, Jaeger was also keen to ensure that some of the traditional details gained a new sophistication. For example, they upgraded the sensor dome on the bottom of the saucer. "We were true to some very iconic details, but I wanted to make sure the dome had some structure and internal detail that we would see in the few fly-by shots. So I imagined it was a slightly tinted and beveled glass dome, much like an old lighthouse spot lens. And then inside would be an array of sensors that we would see backlit and refracted through the surface. Another scale cue I added was the way the ship illuminates itself. Thinking of the *Enterprise* as a modern building, and taking account of its size, I added a bank of stadium lights to the docking station as well as the floodlights on the ship."

At the same time as they were working on the shape of the ship, Jaeger and his team were experimenting with different approaches to the surface texture. "The original brief was that the ship

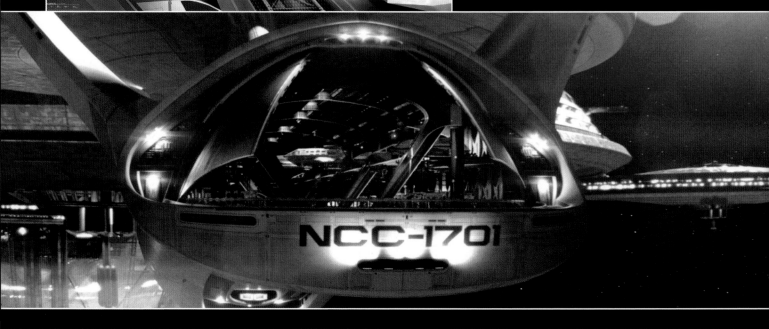

Back of struts
and shuttlebay
details
10/01/07

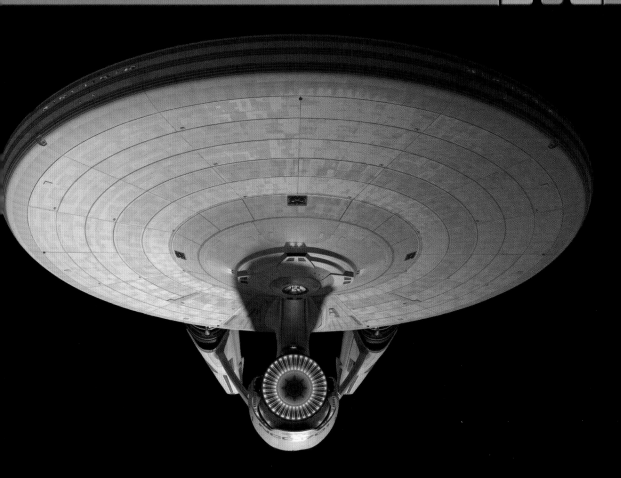

◄ ILM's final agreed version of the new *Enterprise*, complete with sophisticated, multi-toned deflector dish and the familiar Aztec pattern that is a feature of almost every Federation ship.

be almost shiny white with very little panel break-up. That version was quickly passed on for the more traditional subtle panel lines and flecks of iridescent pearl panels." Jaeger's team even considered a more high contrast version, much like the *Enterprise-E*, but this was quickly turned down in favour of the more subtle scheme.

The team also looked at ways to give the ship moving parts. Abrams had made it known that there were a number of animation effects that he wanted to see happen before the ship would go to warp. At the same time Scott Chambliss had requested that the portholes at the back of the nacelles glow like floors in an office building.

MOVEMENT AND COLOR

"JJ wanted a more physical transformation of the ship, something that made it obvious that the ship was about to enter warp speed. So the idea of vents or panels popping out on the trailing edge of the nacelles was explored in conjunction with a change to the deflector dish. The deflector dish would extend its central spire and, at the back of the nacelles, larger sections of the exhaust port would slide open in sections."

As the ILM team worked, various elements changed color. On Church's original concept, the deflector dish was called out as being copper, but as the design process progressed, that seemed to look dated so it was given a more neutral color and the blue lighting was added. ILM also added a hidden light source effect – putting lights behind the panels, with the resulting spill onto the dish surface giving it a more modern feel.

After having nailed the details, the actual size of the ship still continued to alter. The design was originally much the same size as the *Enterprises* that had gone before, but when it came to filming a shuttle approaching it or seeing it parked in a field in Iowa the results were far from impressive.

"We had shots involving the shuttlebay which was portrayed as being a massive, multi-level space, which didn't fit into the ship at standard size. So the decision was made to almost double the scale, which seemed to make everything click with what everyone had imagined."

The finished model of the *Enterprise* couldn't be mistaken for anything else. Matt Jefferies' clear, bold lines show through and countless tiny details ILM added call out to the past, but it is also what JJ Abrams asked for – a badass, hot rod *Enterprise* that is ready for a new audience.

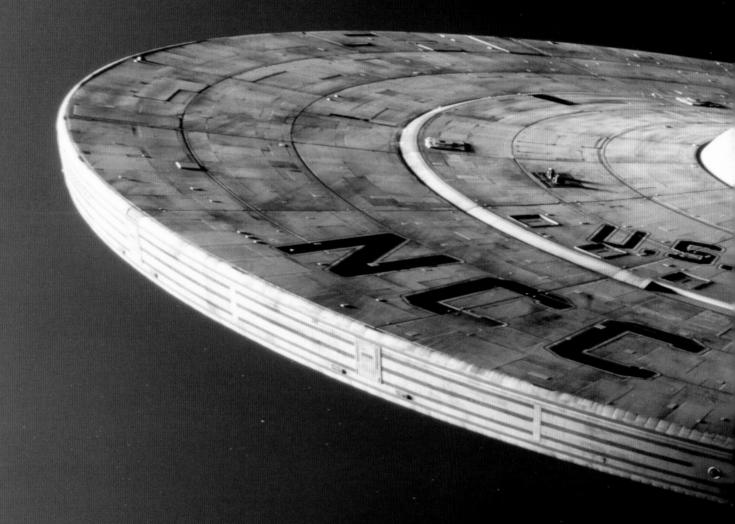

DESIGNING THE
KELVIN

The first ship to appear in the re-imagined *STAR TREK* had to
be instantly familiar but also had to have a unique design.

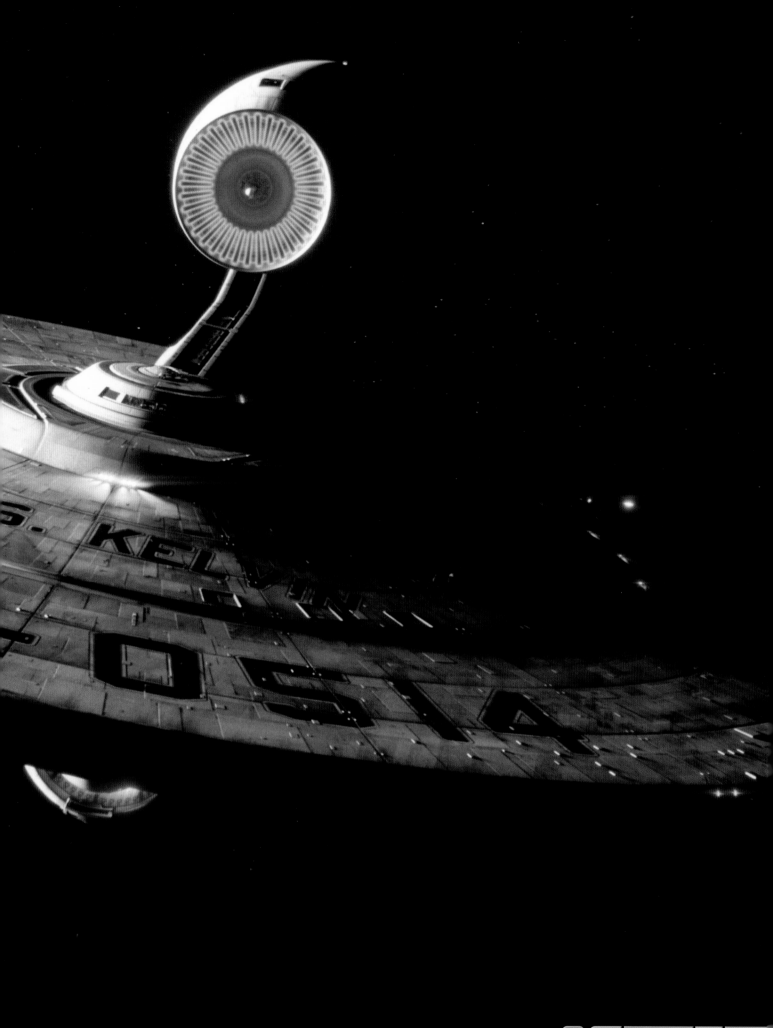

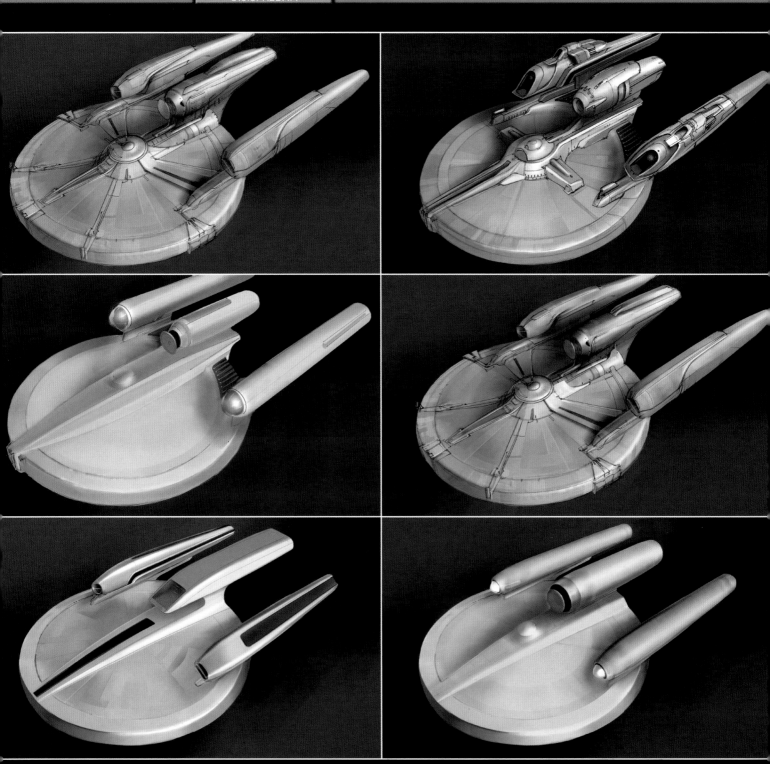

JJ Abrams' 2009 *STAR TREK* movie opens with a close-up of a starship. The camera moves quickly across the surface as we hear the familiar pinging sound of a Starfleet bridge. For a second we think this must be the new *Enterprise*, but then the camera pulls back and we discover that it is actually the *U.S.S. Kelvin*, a ship that will literally play a role in changing history.

Designing the Kelvin posed the *STAR TREK* art department, and in particular Ryan Church, who designed the exterior, with several challenges. "It was imperative," he explains, "that nobody confuse this ship with the *Enterprise* but everyone know that it was a 'good guy' *STAR TREK* ship. It also had to look kind of 'inferior' to the *Enterprise*, so that when we do see the *Enterprise*, we know it's the flagship."

When Church first heard about the Kelvin it was actually called the *Iowa*. This was a nod to Kirk's line in *STAR TREK IV* when he tells Gillian Taylor that

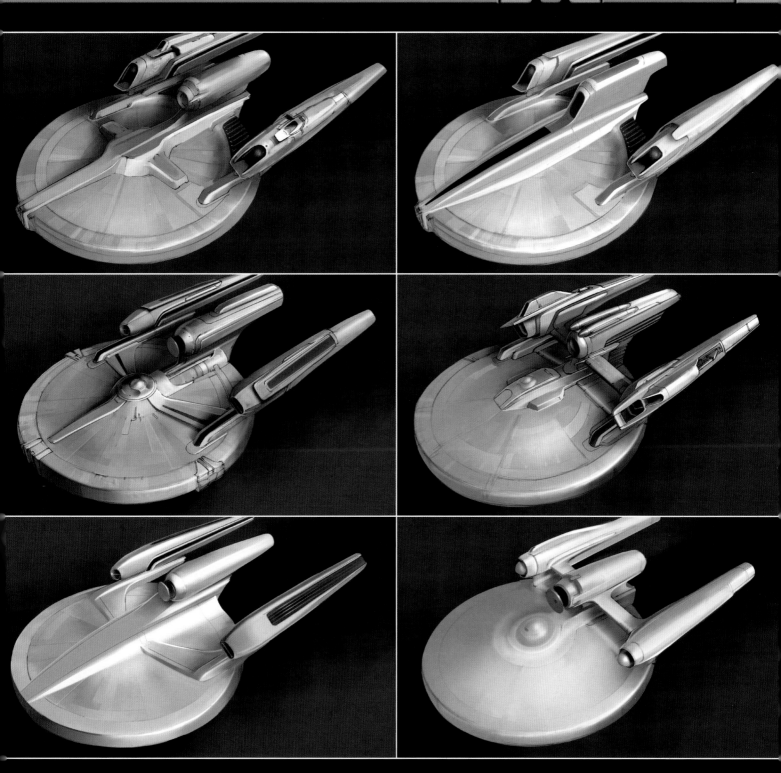

he is from Iowa and only works in outer space. Church was busy working on the *Enterprise* when director JJ Abrams and production designer Scott Chambliss called him in to talk about this second Starfleet ship. As he remembers it, they had a fairly clear idea about what they wanted from the *Iowa.*

"Scott and JJ had a lot of discussions about it before getting me to start sketching. We knew we wanted something like the *Reliant.* That was the target early on. In *STAR TREK II* it serves a very similar function to the *Iowa* – it's a foil to the *Enterprise,* it looks less majestic and sexy, and it's instantly distinguishable from the *Enterprise."*

The design of the *Reliant* had taken the familiar elements of the *Enterprise,* cut them down, and rearranged them to make something new and the idea with the *Iowa* was to do something similar. By this point, Church says the design of the *Enterprise* was fairly advanced so he knew what approach they were taking to Starfleet design.

▲ Ryan Church's first two passes for the design of the *U.S.S. Iowa* generated 12 drawings. The basic layout stayed the same, but the surface details and some of the shapes varied. Several of the 'sketches' including the one in the bottom right corner are labelled 'TOS'.

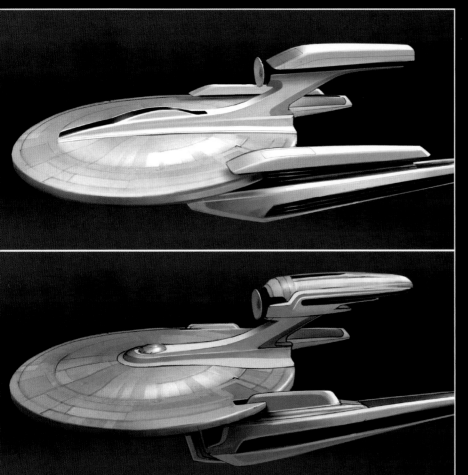

▲ Church's third round of drawings involved a new approach where the nacelles were dropped under the saucer and connected directly to it. There were only two drawings in this round, but director JJ Abrams and production designer Scott Chambliss saw a direction they liked.

Abrams and Chambliss were also able to give him something else to work with: James Clyne, who had already started work on the *Iowa*'s bridge. As Church explains, Abrams wanted it to look very different from the *Enterprise*. "JJ wanted it to be very military and almost submarine-like in contrast to the *Enterprise*. So that was one of our jumping off points for the *Kelvin* exterior."

A DIFFERENT ERA

Another consideration was that the *Iowa* was destroyed nearly 30 years before the *Enterprise* was launched. Abrams felt that even then it was an old ship that had been in service for years. "So," Church says, "it was an older model, something next to which the *Enterprise* would look that much more impressive, modern, and beautiful. It was an early JJ call that the engineering hull go on the top, probably to further differentiate it from the *Enterprise*."

Church's first round of sketches all follow the same basic layout, which has clear echoes of the *Reliant*. The nacelles have been pulled in closer to the saucer, which they are directly connected to, and a truncated engineering hull has been moved between them on the top of the saucer.

"It would be hard to find a design that distills the Federation form language any more than the *Iowa*

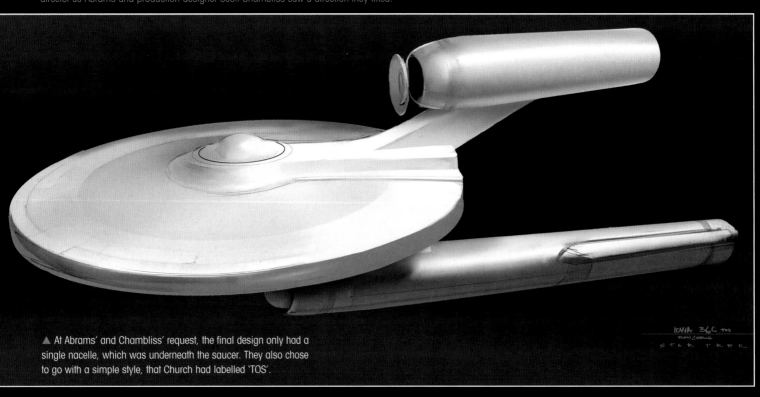

▲ At Abrams' and Chambliss' request, the final design only had a single nacelle, which was underneath the saucer. They also chose to go with a simple style, that Church had labelled 'TOS'.

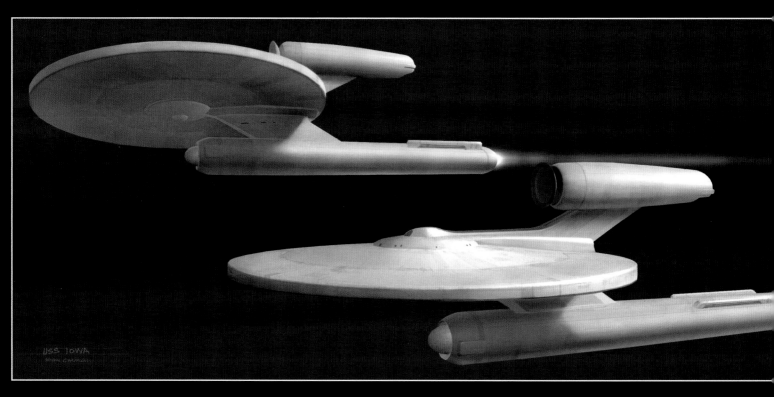

does," Church says. "If you add anything it becomes needlessly complex; if you take anything away you are no longer a totally 'STAR TREK' ship."

The sketches only show minor changes to the layout, with Church concentrating on the surface details and the exact shapes of the different elements. "It was like casting actors with me providing different looks," he says. "They are all sketches over a basic saucer CGI I threw in there because I knew that would be the constant and I didn't want to keep drawing the ellipses each time." Some of the design elements were taken from rejected Enterprise concepts, and most of the sketches show a heavier detailing than would be used elsewhere in the movie.

CHUNKY, MILITARY DESIGN

"I started out with kind of odd, non-TREK looking surface details," Church remembers. "I thought of them as kind of early – but linear – predecessors to the Enterprise aesthetic. They were chunky, functional details, what I call the 'military greeblie' look. That was something that was implied by what James Clyne was doing with his interior at the time which was very military, chunky looking."

Church also threw in an incredibly smooth version labeled 'TOS' that could have come straight out of the original 1960s series, reasoning that this was another form of 'primitive' design.

The drawings were well received, but Church remembers that when he presented them there wasn't a clear favorite. "Sometimes – and this was one of those times – JJ won't give a lot of feedback, he'll just say, 'Keep going!' This is always a little disconcerting to hear and it either means you, as a designer, are doing a really good job or a really bad job. The problem is that you don't know which one it is at the time! It's a great challenge and you have to do exactly that – keep going.

"In this case, that meant refining the ideas I'd already presented and then going off in some new directions as well. JJ and Scott did have the note that I should back off on the military greeblie look that is in some of them. There was a drive even at that early time towards smoother, more streamlined shapes."

SINGLE NACELLE

The next round of drawings consisted of eight concepts, all of which kept the same basic layout but showed more options for the surface details and the exact shape of the nacelles and engineering hull. Again Church threw in several drawings that had a very definite original series aesthetic. The design still wasn't quite there and for the next round of drawings he dropped the nacelles under the saucer, but kept them very close to it, while the engineering hull stayed on the

▲ After the basic approach to the design was approved, Church worked up a drawing that showed the Iowa in more detail and from different angles.

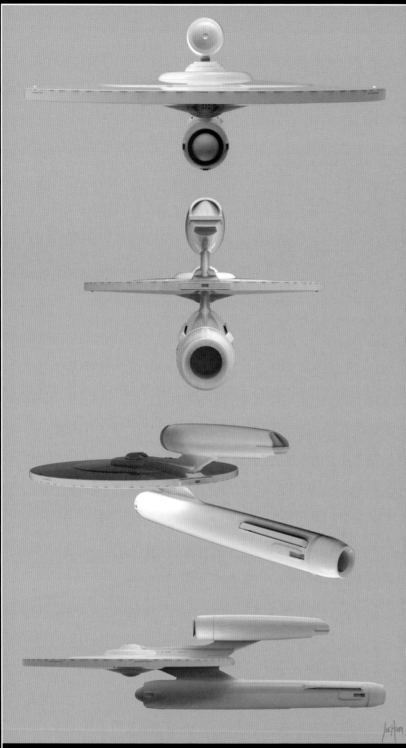

CG Design

One of the innovations on *STAR TREK* was that the art department used their own 3D modelers, who would work up simple CG versions of the ships so that the designs could be looked at from every possible angle. Joe Hiura was given Ryan Church's initial drawings of the *U.S.S. Iowa* and produced this model, which was shown to JJ Abrams and Scott Chambliss. When the design was sent over to ILM they built an entirely new version of the model that was suitable for filming.

top. When they saw these drawings, Abrams and Chambliss hit on what they wanted and asked Church to prepare another version with a single engine underneath the saucer, and told him to go with the smooth original series approach. "JJ and Scott thought I should try a version with one engine and one fuselage and that was the one that was chosen. I think it's the right call: we didn't want the shape to be anywhere near something that could be mistaken for the *Enterprise*, from any view – front, side, rear, partially obscured by smoke. And the *Iowa* fits that bill nicely."

TRADITIONAL LOOK

It wasn't the original intention when Church started sketching, but he says the design that was chosen has the most in common with the traditional look that had been established in the original *STAR TREK* movies. "JJ ended up picking the simplest design and one that looked like it came right out of the 1979 movie, which makes a lot of sense in terms of the story. It seems like a no-brainer when you look at it now, but the ship fits perfectly into the pre-changed timeline. It makes complete sense, but it also makes sense that JJ wanted to see a bunch of options before making that decision – he'll often do that with designs: make sure he's considered every possible option. That's the fun of presenting a bunch of designs to him, you can see the wheels turning as he considers how the end product will look in his movie."

Church worked with the art department's in-house CG artist Joe Hiura to produce a relatively simple, virtual study of the model so they could work out any kinks in the design and to see how it looked from a variety of angles before it was passed on to ILM, who would build the final model that was used in the film.

ENTER ILM

As VFX art director Alex Jaeger remembers, ILM got Church's drawings for the *Iowa* and the *Enterprise* at about the same time. (By now the Iowa had been renamed the *Kelvin* in honor of the physicist Lord Kelvin and JJ Abrams' grandfather Harry Kelvin.) "The look of the two ships played off of each other," Jaeger says, "We had to make sure that we made the *Kelvin* look old and the *Enterprise* look new."

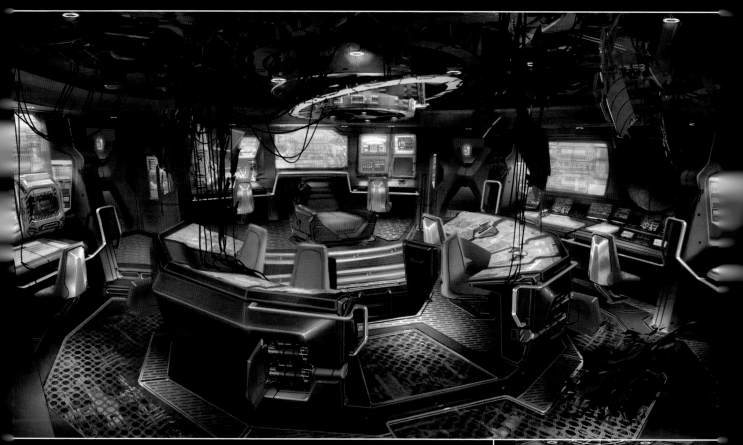

Inside the **U.S.S. KELVIN**

Concept artist James Clyne, who also designed the *Vengeance* and the Klingon fighter, started work on the interiors of the *Kelvin*, before Ryan Church was briefed about the exterior. And his designs had a very definite influence on the way that Church thought about the ship.

The brief that Clyne was given for the interiors was to make them look as if they belonged on a submarine, and he amassed a large folder of reference showing the gauges and other instrumentation on real-world, 21st-century submarines. Handrails around the set gave the impression that it wasn't entirely stable, and all the elements were deliberately distressed to give the impression that the *Kelvin* had been in service for years.

Equally importantly, the design of the bridge was much more like that of a traditional *STAR TREK* ship. This meant that audiences would start out feeling comfortable before some of the radical changes they saw later in the movie.

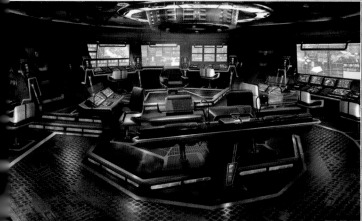

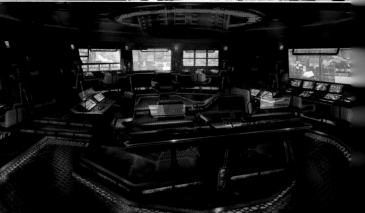

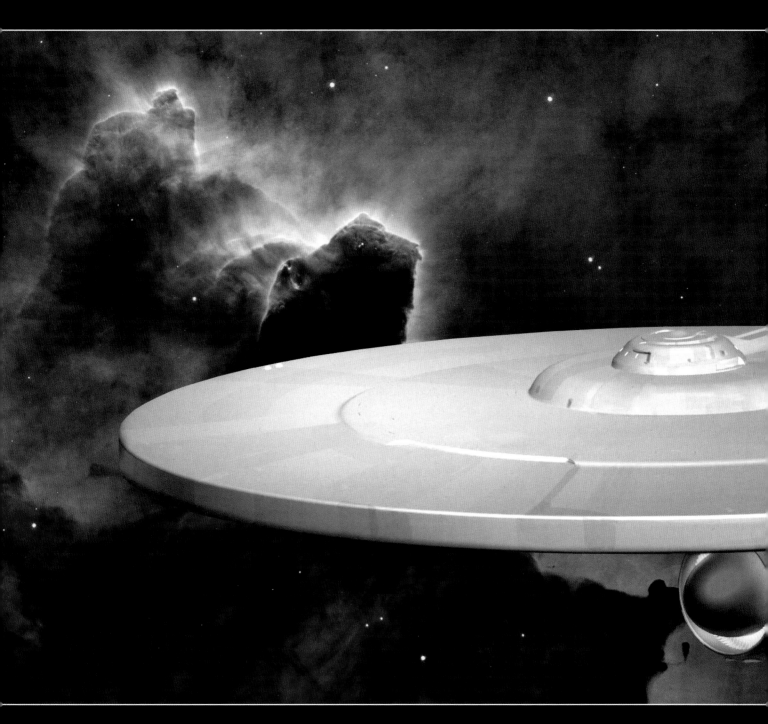

Of the two ships, ILM were clear that the *Kelvin* should be much more like the traditional *STAR TREK* ships they had worked on in the past. However, Jaeger adds that VFX technology had moved on considerably since the last time ILM had built a *STAR TREK* ship and they were determined to make their CG model of the *Kelvin* as sophisticated as possible. "We looked back at anything that had bugged us before. We'd say, 'Okay well that looks cheesy and that looks hokey. How can we fix that so that it looks a little more believable to the more modern audience?' We made sure that if there

was a big lit-up dome on the ship that it looked like it had some sort of function and it wasn't just this back-lit Plexiglas dome. You could tell that there were different light sources in there, something shadowed inside."

MOVING WEAPONS
Abrams was also clear that the *Kelvin* should be a more primitive ship than we were used to from previous *STAR TREK* films. "JJ's brief for the *Kelvin*," Jaeger says, "was to make it feel more like a submarine kind of ship. He wanted it to have kind

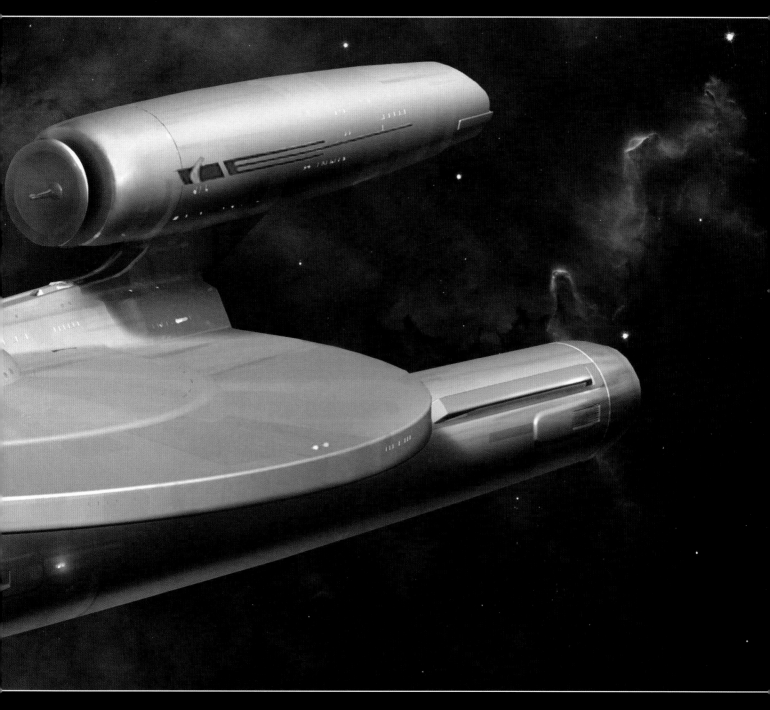

of a World War II sort of hardware feel to it."
Jaeger's colleague, ILM digital model supervisor
Bruce Holcomb goes on to explain that at Abrams'
request they gave the *Kelvin* a chunkier design of
weapons systems. "The phasers were like these little
pop-up guns inside the phaser strip. We did the
same thing on the *Enterprise,* but then we had
these really slick little design balls; these were just
these kind of square boxy type of thing that were
more like laser cannons than anything else. Then it
had like cobalt projectile items that would pop up
and those were those little blue things that kept

shooting out. So it definitely had some old
technology in it."

The Bussard collectors at the front of the
nacelles were also given a more primitive design
that harked back to the 1960s TV series rather than
STAR TREK: THE MOTION PICTURE.

OLD AND BATTERED

The biggest differences though involved the
surface texture. Church's drawing showed the ship
looking smooth, but Abrams was clear that he
wanted ILM to give the impression that the *Kelvin*

▲ Church also produced
this large digital painting
of the *Iowa* that showed
much more detail,
including the position
of the Starfleet pennant.
This was sent over to ILM
to give them an idea of
what the final ship should
look like.

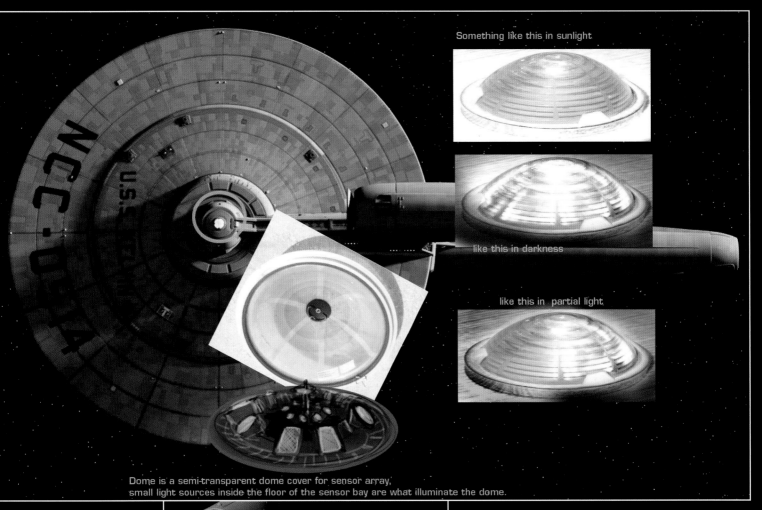

Something like this in sunlight

like this in darkness

like this in partial light

Dome is a semi-transparent dome cover for sensor array,
small light sources inside the floor of the sensor bay are what illuminate the dome.

▶ ILM looked for lots of ways of adding detail to the model of the *Kelvin*. One of the changes they made involved upgrading the louvered doors of the shuttlebay, giving it a more complex look, as if it could fold open.

current model

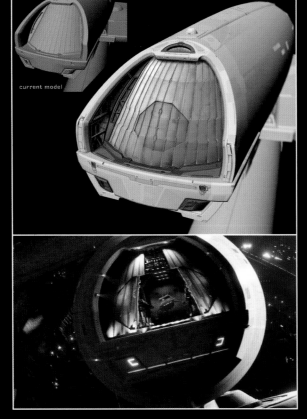

▶ The finished shot of Robau's shuttle leaving the shuttlebay at the back of the engineering hull.

▲ Although the Kelvin was an 'old-style' ship, ILM were determined to upgrade the level of detail in the model. One of the ways they did this was by adding multiple lights inside the sensor dome.

was an old and battered ship. "JJ was really keen to make this thing look like it's been around for a while," Jaeger remembers. "On the *Enterprise* all the panels sort of blended together, we wanted the *Kelvin* to look like some of the panels had been blown off in previous battles and then patched over."

"It was a lot of fun for us," Holcomb adds. "It was supposed to be really beaten up, it had been through a lot of adventures already. There was nothing flush about it. The dish itself was really thick – it wasn't streamlined. We had to do a lot of plates that didn't really fit. For us that was a pretty easy thing – not going towards a *Star Wars* level, but staying still within the *STAR TREK* Universe."

In order to achieve this effect, Jaeger explains that ILM made sure that none of the edges of the panels were absolutely perfect and then for selected panels, they added a hint of damage

that had been repaired. "You leave a little bit of scorching on the panels around it and then you put the new ones on top. It looks like that one was repaired because something happened there before and you could see just a little evidence of it on all the edges. In the paint they would have put a slight displacement map on those panels so they raised it a touch."

ILM also took great care with the Aztec pattern on the surface of the Kelvin's hull, altering the amount of reflection in parts of the pattern so that no two panels were exactly the same.

They also devoted time to working out exactly what color the *Kelvin* should be. They ran a series of different tests showing it with a traditional light blue hull that was similar to the *U.S.S. Excelsior*, and even a dark brown, almost red coloring before finally settling on a light tan color that Holcomb describes as warmer than anything they had done in previous *STAR TREK* films.

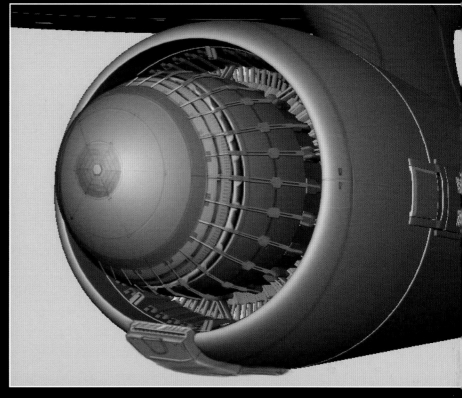

DAMAGE CONTROL

One of the biggest challenges though had to do with destroying the *Kelvin*. During the opening sequence of the movie it takes an enormous amount of damage as it is attacked by the *Narada*. Traditionally, this would have involved building many different models of the *Kelvin*, each of which showed a different amount of damage. This time, Holcomb says, ILM wanted to try something new. "It's a difficult procedure trying to

wrangle that many different levels of damage," he explains. "I think it rolled over almost sixteen different shots. Sometimes you'll have multiple models in one scene and you'll make one invisible and the other one not. But we developed a system here where you could tag different categories of damage. The neat part about it was that it would swap in pieces of the ship, not the entire model. Let's say the *Narada* was shooting the *Kelvin* and the whole front of the dish blows off, then that

▲ In particular ILM wanted to make the collector at the front of the single warp nacelle as detailed as possible. The final design has echoes of the original TV series where the nacelle caps had rotating components inside them.

CHQ SWEET JUDY | Weathering Concept (side view) | 3/6/08 | A. Jaeger: ILM

▲ A lot of effort went into the exact coloring of the Kelvin's hull and the surface textures. Jaeger says that they 'smeared' it with virtual grease to give the impression that it had been in space for a long time. The color of the hull was originally much closer to the traditional Starfleet blue.

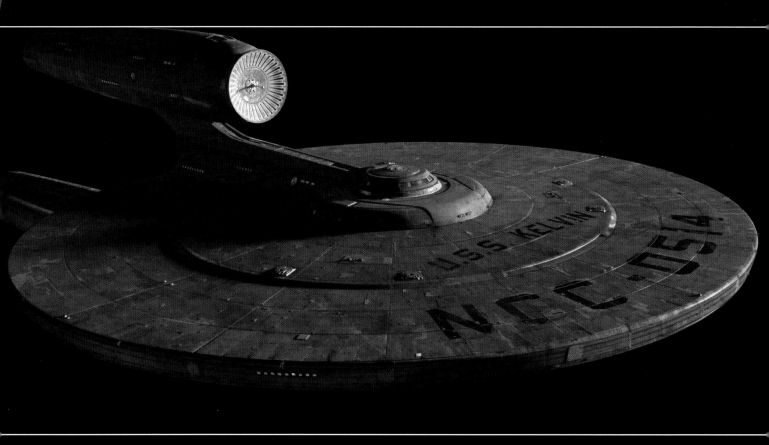

▲ ILM worked their way through several different color treatments for the hull, including this very 'red' version. The final version was a warm grey. This render also shows how the panels were carefully distressed to give the impression they were old and had been repaired.

whole front part of the dish would come in as a separate model and it would hide the geometry that's there.

"The people who were running the shots would be able to load and unload the damage depending on the tag. We had this whole graph that showed if you had this shot number you would load this asset. It turned out to be a good way to deal with that whole final battle with the *Narada*. And actually we kind of ended up using that system for a lot of the films after that."

As Abrams was working on the edit of the movie, he decided to start with a massive close-up of the *Kelvin*, with the camera completing a complicated 720 degree roll as it passes over the surface of the ship. As Jaeger says this meant that ILM had to build the *Kelvin* in much more detail than they might have expected. "The very first shot of the film sort of played right up to the window of the *Kelvin*, so we had to 'plush' that out, so we could go closer than we would even with most physical models."

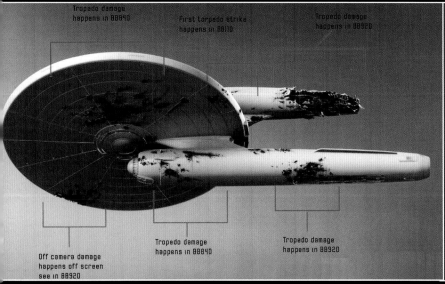

Tropedo damage happens in BB940

First torpedo strike happens in BB110

Tropedo damage happens in BB920

Off camera damage happens off screen see in BB920

Tropedo damage happens in BB940

Tropedo damage happens in BB920

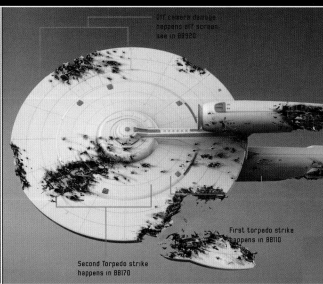

Off camera damage happens off screen see in BB920

First torpedo strike happens in BB110

Second Torpedo strike happens in BB170

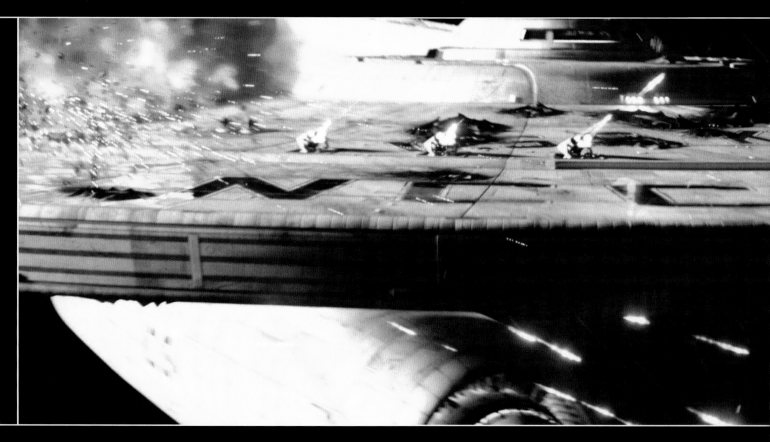

When Church saw what ILM had done with his design, he was delighted. "I was afraid the *Kelvin* configuration would look too wimpy in the film, but when it was detailed out JJ shot it in such a way that it looks great. I could tell even by the early animatics that it was looking sleek and heroic in its own way and really an underdog in that sequence at the beginning of the film."

He was also pleased with the way it harkened back to earlier *STAR TREK* incarnations while also doing something new. "I would say that the look of

the final product is 90% *STAR TREK: THE MOTION PICTURE* and 10% harder and more militaristic. It also helps that, because it appears in the opening sequence, its conservative design allowed JJ to ease the audience in to his new vision of *TREK*, to concentrate on the storytelling first off and then let the *Enterprise* reveal to be that much more impressive."

In short, the *Kelvin* had accomplished its mission: it reminded us of *STAR TREK's* past, while ushering in new era that took us all in a bold new direction.

▲ In a departure for *STAR TREK*, Abrams asked for the *Kelvin's* phaser emitters to be small turrets that popped up out of the hull. Other hatches on the hull were used to fire projectiles.

◀ One of the major innovations in the movie involved the way ILM showed and controlled the damage the *Kelvin* took in its battle with the *Narada*. After they chose where the damage would take place and what it would look like, they modelled a series of sections that could be switched out with the pristine versions as required. A series of tags allowed them to keep track of what damage was needed at each stage of the battle.

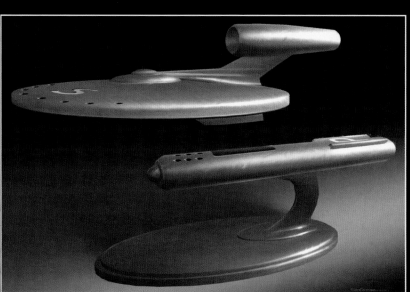

◀ Long after he had finished his work on the ship, Ryan Church revisited the *Kelvin* to design these *Kelvin*-inspired salt and pepper shakers that were used in the bar in Iowa. If you look carefully, you can see the holes for the shakers and the 'S' and the 'P' that show which parts are which.

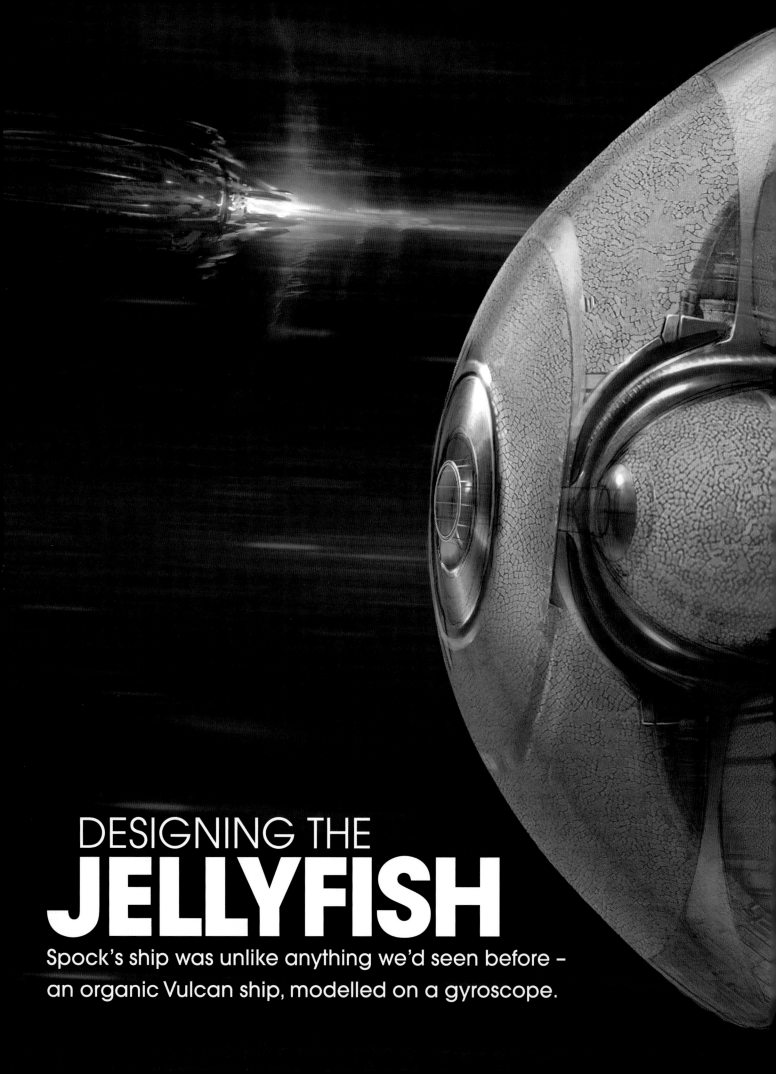

DESIGNING THE
JELLYFISH

Spock's ship was unlike anything we'd seen before –
an organic Vulcan ship, modelled on a gyroscope.

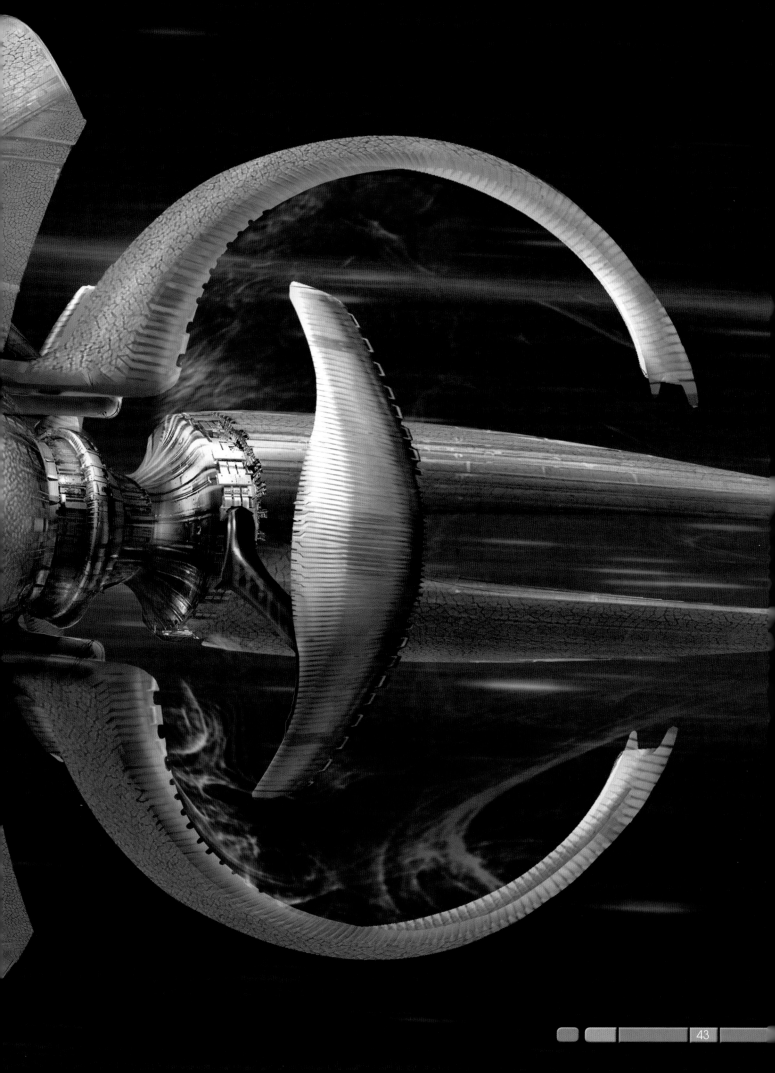

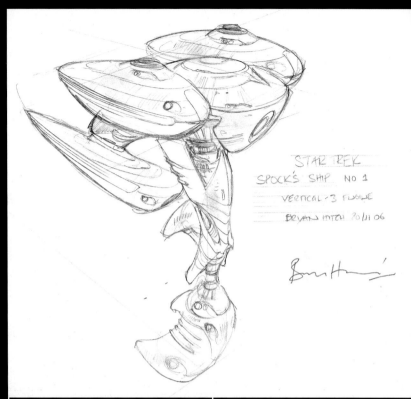

STAR TREK
SPOCK'S SHIP NO 1
VERTICAL - 3 ENGINE
BRYAN HITCH 20/11 06

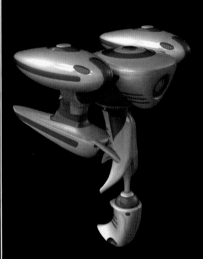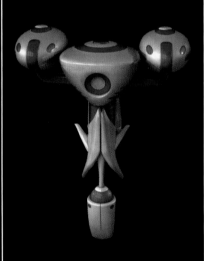

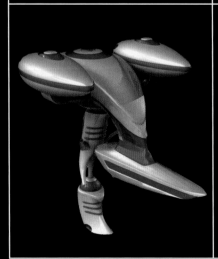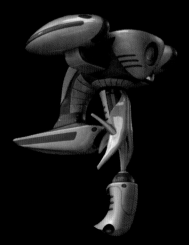

ork on Spock's ship began long before there was a script. Director JJ Abrams was working on the story with Alex Kurtzman, Roberto Orci and Damon Lindelof and while many things would change they already had the idea that Spock would travel back in time after a failed attempt to avert a disastrous supernova. This was a year or more before actual production started, but even then Abrams wanted to see what their ideas might look like. One of Lindelof's friends was a famous comic book artist who had played a major role in reinventing many of Marvel's super heroes for the 21st century, Bryan Hitch. Hitch also describes himself as a *STAR TREK* fan "to the core" so he was pleased when Lindelof asked him if he would be interested in working up some concepts.

"There was no script," Hitch remembers. "Damon sent me a very rough first draft of the story to read. All they knew was that Spock's ship had to carry the red matter and that was it. So I was designing it with pretty much nothing but that requirement. I knew that it was essentially a single-man Vulcan ship. That suggested a small, fast ship but one that was powerful enough to hold a huge quantity of black hole-making red stuff."

A NEW DIRECTION

From the beginning Hitch knew that he wanted to design something that was unconventional. He says that *DEEP SPACE NINE* is his favorite modern *STAR TREK* show precisely because it pushed the boundaries of storytelling to new levels. So although he knew his way around *STAR TREK*, he didn't feel the need to be bound by its traditional approach to starship design.

"I wanted something *not* like conventional Federation ships," he explains. "The key thing for me was that I wanted a ship that could move in an interesting way physically. I was very keen to try to establish movement in a way that was different from the usual left to right approach – the 'sailing ship' method – used in all the shows and films. Space offers such unlimited senses of what should be up or down."

◀ The earliest designs for Spock's ship were produced by comic book artist Bryan Hitch. He sent several sketches to Abrams who picked two which were then worked up as basic CG models by Hitch's long-time friend Niel Bushnell.

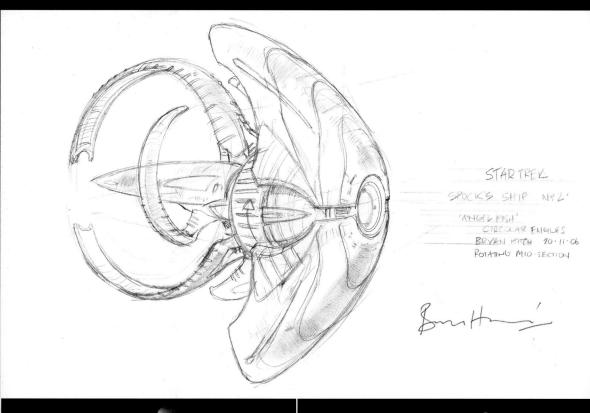

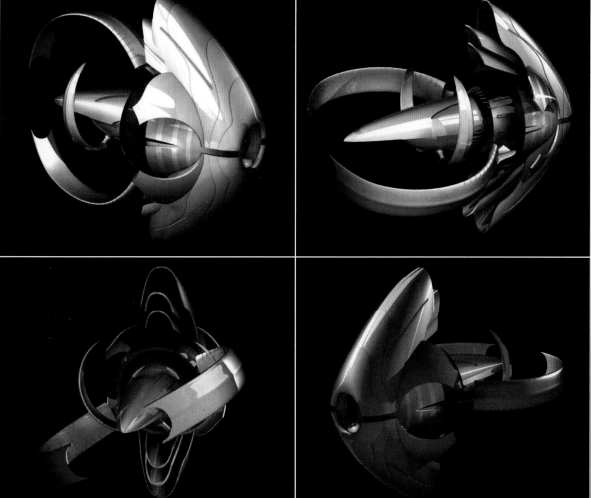

STAR TREK

SPOCK'S SHIP N°2'

'ANGEL FISH'
 CIRCULAR ENGINES
BRYAN HITCH 20·11·06
ROTATING MID-SECTION

◄ Bryan Hitch labelled his favorite design for Spock's ship 'Angel Fish'. He always intended most of the parts to rotate around a single fixed point, which would later become the cockpit; at this point, Hitch thought it would be the red matter injector.

◄ The basic CG models were designed to show the ship from a variety of angles and to show how such a complex design might move in three dimensions.

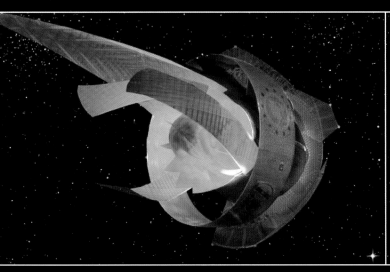
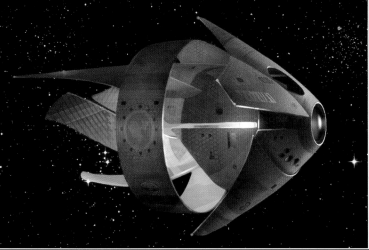

▲ Nathan Schroeder produced illustrations that showed a possible evolution of Hitch's initial design.

The other thing that Hitch wanted to do was to give the ship moving parts, something that – mostly due to budgetary constraints – *TREK* had never really achieved in the past.

"I loved *Voyager*'s nacelles moving in that design," he says. "I wanted bits that turned and swung as the ship moved around a stable cockpit area." With this in mind, Hitch produced "four or five" sketches, only two of which survive. "The very first one I did I labeled 'Angel Fish'," he says.

STRANGE MOVEMENT

This drawing is remarkably close to the finished design, but it was only the first step on a long journey. As Hitch recalls, both he and Abrams were immediately pleased with it. "A rare first thought that seemed to work. I said I'd send several though, so sketched up a few others. He liked two of them but *loved* the Angel Fish one (the coolest ship he'd ever seen, he said, and as a *Star Wars* fan I appreciated the compliment)."

Hitch describes the other design that Abrams liked as being like an outboard motor, explaining that he came up with the idea because he was interested in the way its center of balance would effect its movement.

The next step was to work up the two designs that Abrams had identified, so Hitch sent the drawings to an old friend, and fellow *STAR TREK* fan, Niel Bushnell. "Bryan got in touch and asked me to create some 3D turnaround renders of his drawings. We'd become good friends watching the latest releases of *TNG* and *DS9*, so I was delighted. At the time I was running an animation studio called Qurios, producing CGI for shows like

Spooks and *Hyperdrive*. Bryan sent through two designs suggesting very different directions for the ship. We created computer models with basic textures based on the drawings he sent. They were intended as discussion models, something to help them visualize the complex shapes, so we didn't go to town on producing finished textures."

These 'CG sketches' went back to Abrams and his team but at this point, as Hitch remembers, work started to slow down. "We spoke on the phone, and had a very long chat about design approaches to the whole *TREK* universe, how the *Enterprise* would function and move, scale, etcetera, but there was no green light and we were a long time away from pre-production," Hitch recalls. "I was supposed to be part of the full design team. JJ asked me to stay with the film when or if that green light came but it was by no means certain it would. It was a year or so before the film finally went into production and due to several things, not least the birth of my son Ted the day Paramount green-lit the movie, I couldn't go out to work on it."

THE NEXT PHASE

With Hitch unable to travel to LA, the design moved into a new phase, under the supervision of production designer Scott Chambliss. As Hitch remembers, he expected everything to change. "The production designer told me that my design would end up being drastically reworked…"

Chambliss explains that he was keen that every avenue would be left open. "I always give direction with conceptual conversation and visual reference material, but the real magic happens in

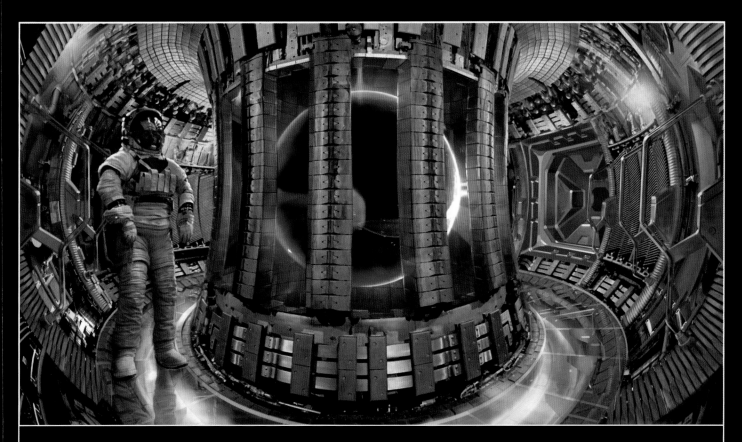

Inside the **Jellyfish**

The same team that worked on the exterior of the Jellyfish produced the interior. Originally the script called for several locations: the cockpit, a transporter station (which was later cut) and a curved corridor that connected the cockpit to the red matter containment area.

As always Chambliss gave his illustrators a concept for the interior, in particular the cockpit. "I wanted it to be a visualization of neurons firing and synapses connecting in the form of the ship's inner technical workings," he says, "literally looking at

the brain of the ship with the information visually swirling all around Spock as he piloted it."

This time the work started with Nathan Schroeder, who remembers that he also had an idea that informed the design of the cockpit. "I did a little visual joke in the cockpit. The way the script originally read you didn't know this was Spock's ship. You saw the pilot from behind and you didn't know who this guy was. I was a fan from way back when of the old show. What I tried to do was to echo the Vulcan IDIC

symbol. There's a big circular window and he sits in the middle in a triangular chair, so it recreates the shape of the pendant. I thought this would be a nice bit of foreshadowing, for anyone who got it. But in the end you always knew it was Spock."

The final work on the design was done by Ryan Church, who worked up new concepts for the red matter chamber, which originally showed a mysterious figure in a spacesuit, designed an airlock, and finalized Schroeder's concept for the cockpit.

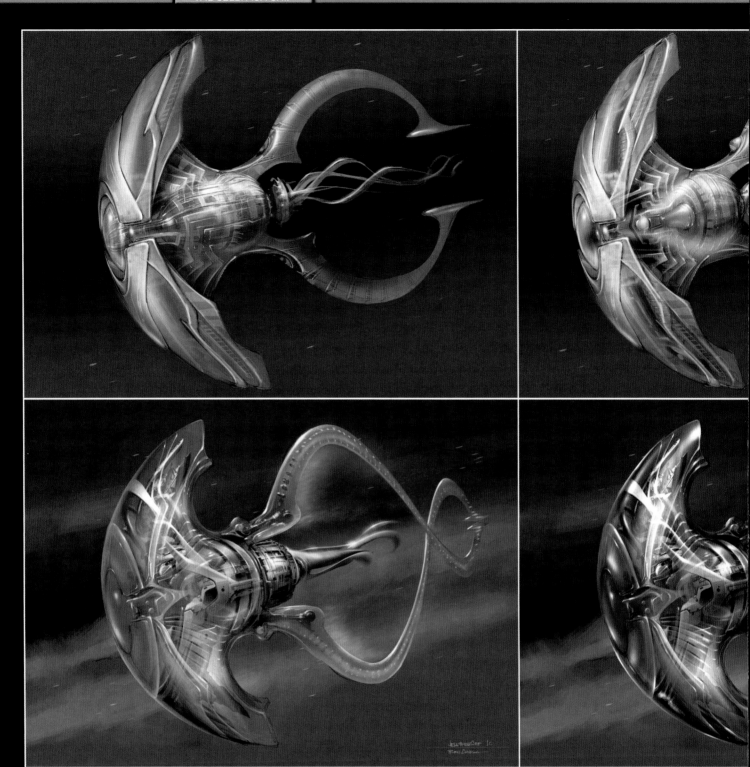

the collaboration process with my illustrators. That's the beauty and value of this job, and why I love it. When visual collaborators develop an articulate verbal language and inspire new thoughts in each other, we create something better, stronger, more beautiful together than we can manifest individually on our own. That to me is the addictive magic of movie making."

Chambliss also believes that it is important that

designs proceed from an idea and don't simply look cool, but have a reason behind why they look the way they do. He worked with Abrams to establish a Vulcan design ethic that would inform the ship's nature.

VULCAN IDEAS

"Our approach to the Vulcan culture was as straightforward as can be. Their society and

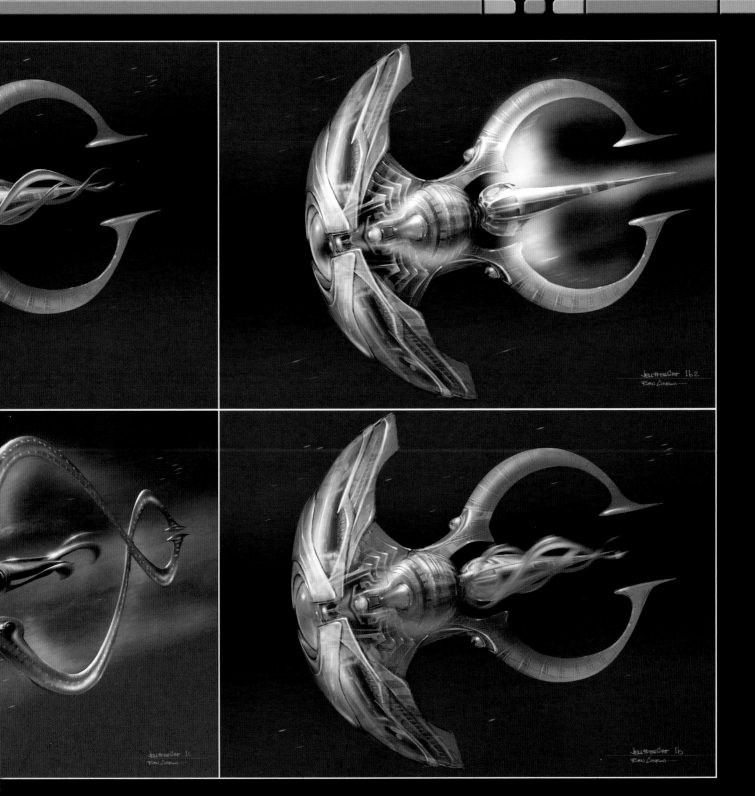

everything it produced was rooted in pure, unassailable logic. Whether or not the conclusions drawn from their logical processes produced ultimate truths as a result remains an open question. For the Jellyfish ship we wanted a craft engineered with deep understanding of both man-made technological/mechanical principles as well as nature's design and processes. We wanted to make this little one-person vehicle

utterly distinctive from the rest of our collection, and even a little bit (don't tell Spock) fun. Whether any of those notions were successfully conveyed is to be determined by others... which makes the design of the Jellyship authentically Vulcan!"

The first concept artist that Chambliss set to work on the design was Nathan Schroeder, who was given Hitch's sketch and started to work it up into a more finished design.

▲ A selection of Ryan Church's early 'sketches' for Spock's Jellyfish ship. At this point, Church was looking at ways of developing Hitch's initial idea, but many of these designs felt too much like real sea creatures.

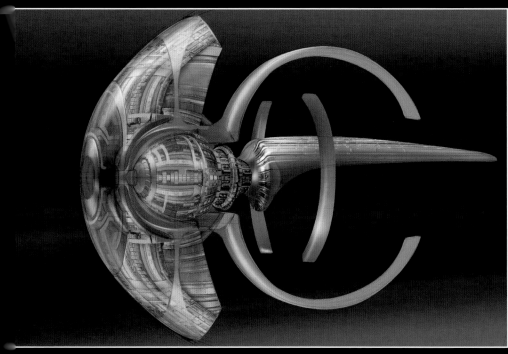

"It was pretty early in the design phase," Schroeder remembers. "The pencil sketch was a starting point. They wanted it to have some kind of locomotion device that was somewhat mysterious and not necessarily easy to comprehend. I came up with a design with some kind of turbine in the middle." Schroeder would also play a major role in designing the interior of the ship but he then moved on to work on a different movie and wasn't able to continue working on the Jellyfish.

A little later on, Ryan Church started work on another set of concepts for the ship. "His first designs were less directly an interpretation of sea life," Chambliss explains, "as Bryan had already covered that angle."

ENTER RYAN CHURCH
As Church recalls, by the time he saw the script, Hitch's scribbled name – the Angel Fish – had become attached to the ship, but somewhere

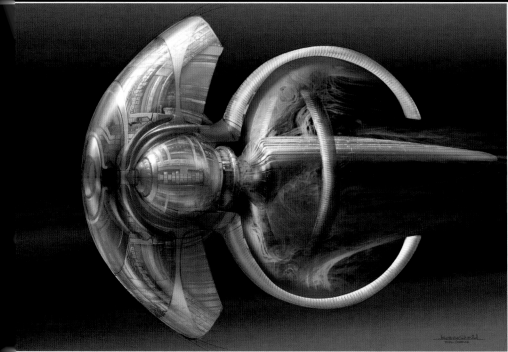

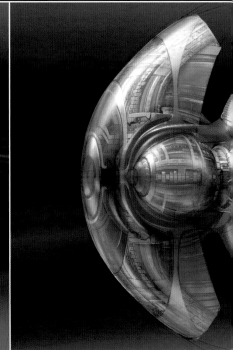

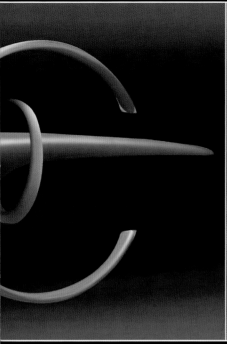

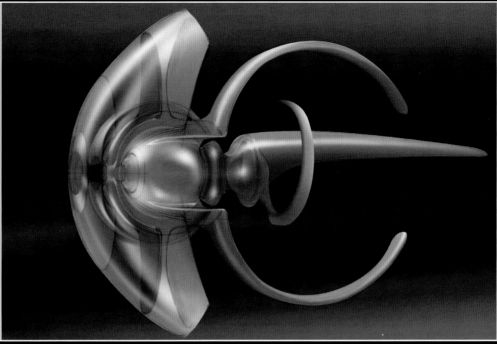

along the line had transformed into the Jellyfish. "I first read the script in JJ's office and I remember the 'Jellyfish ship' name really jumped out at me. From that first thought, I pictured something very transparent and ethereal, which made sense in that this ship's purpose was to be something very different, very advanced even for the Vulcans to be making.

"Scott gave me an early brief just to do something that looked different than any other

ship I'd seen – something completely alien. I did a few quick sketches in very early JJ meetings. My intent was always to go back and work them up, but I was busy working on the *Kelvin* and the *Enterprise* and things had changed before I ever got back to them."

According to Church, those sketches included some radical departures, including a cube of pure energy. Abrams, however, wanted the ship to have as much character as Spock did himself, and,

▲ Church's next round of sketches experimented with different surface textures, many of which were slightly transparent like a real jellyfish, and showed the Vulcan technology under the organic skin.

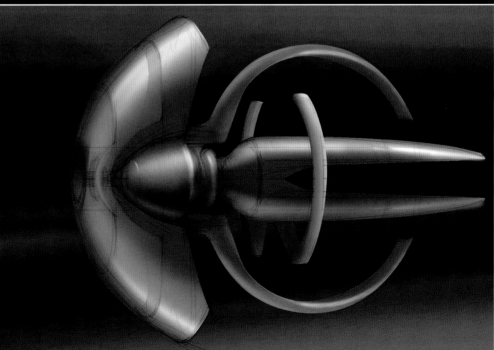

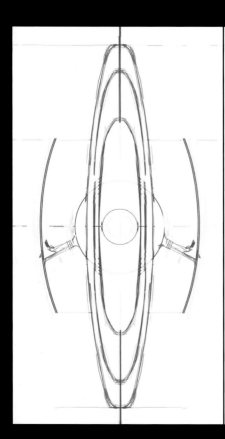
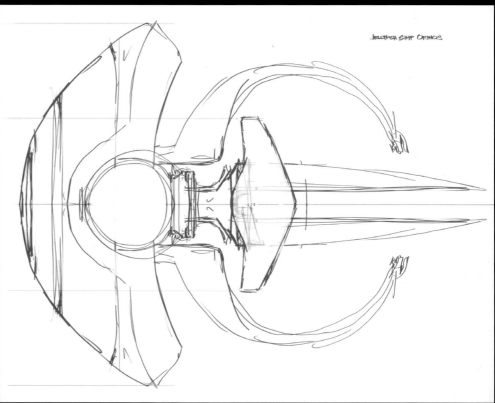

JELLYFISH SHIP ORTHOS

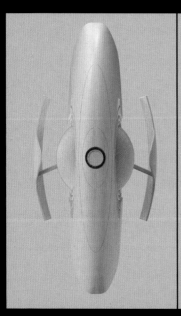
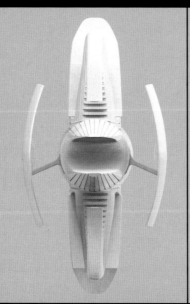
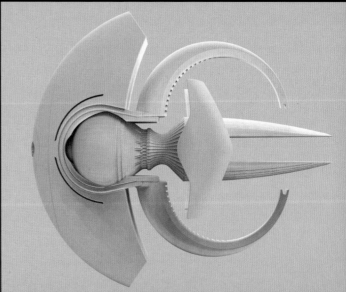

▲ After Church's second round of sketches, the final shape was locked down and Church produced this sketch showing the plan views.

▼ Joe Hiura took Church's sketches and produced a basic 3D model for the producers to study.

having explored the alternatives, he pulled the team back toward Hitch's original sketch.

BACK TO THE JELLYFISH

"Bryan was a great interpreter," Chambliss says, "and the Jellyfish was our favorite of his options. It had a sustaining influence on our final design. One of JJ's specifics was that he wanted the gyroscopic movement that you see when the ship is flying, which he thought would be a great visual

dynamic for the piece. There was a mechanical believability to the bones of his interpretation, which put us on our path to the final product."

So when Church finally returned to work on the project, he took Hitch's design as his starting point. "When we got Bryan's sketch, Scott wanted to try some variations to further flesh them out and have options to show JJ during our meetings." As usual Church started to produce digital illustrations that showed variations of the same basic design.

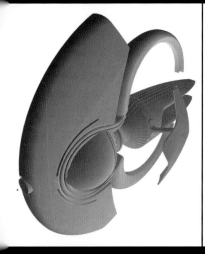
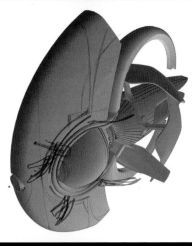
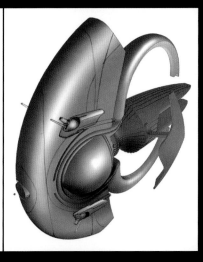

◀ Joe Hiura worked up a simple CG model based on Church's design, and the production team looked at ways it could be improved, including the introduction of weaponry.

His first round consisted of eight versions, which all maintained the same basic shape, but explored different approaches to the surface texture and in particular the shape of the tail and method of propulsion. "The goal with these variations," Church says, "was to try different material passes, different complexities, different ways of making the design look more real. There are tail variations that make the design more 'jellyfish'-like. We were also thinking of different ways to portray the engine exhaust or propulsion technique. We tried different things but we always knew we didn't want a conventional glowing exhaust."

"Some of the versions I looked at were going for a more organic look, I knew that in the movie we would have a flashback showing it being built and I wanted to do something to differentiate it from the *Enterprise* being built, so I pushed the idea that this very organic ship was in fact 'grown' in some way to make its creation completely distinct from what we were seeing with the *Enterprise*."

Chambliss and Abrams felt that some of these designs were taking the jellyfish idea a little too literally and that this was causing problems because they were going in a similar direction with Nero's ship, the *Narada*.

▼ This James Clyne painting shows the Jellyfish ship being constructed on Vulcan.

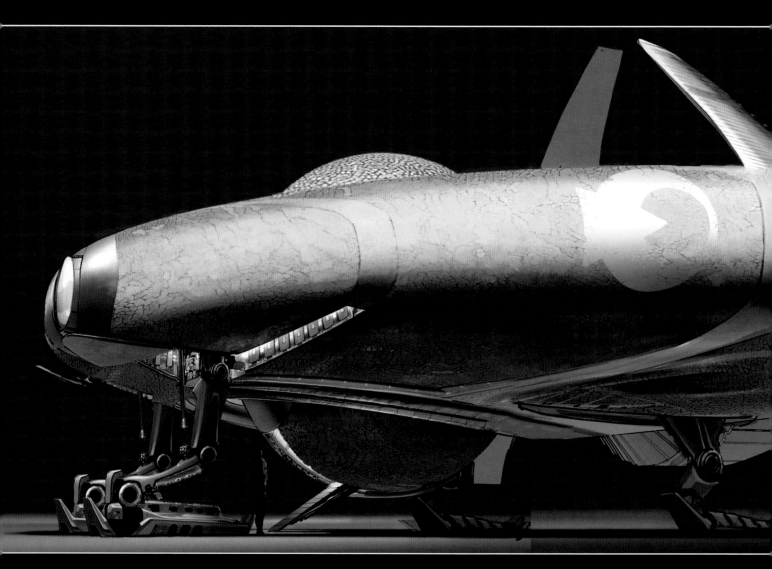

▲ Working out how the ship would land presented something of a challenge. Because it was vertical, the cockpit would have been a long way off the ground. The solution was to turn it on its side.

"We were searching for our foundations in these early ideas," Chambliss explains, "and it quickly became clear that the more sea creature-ish the ship was, the more it weakened the design approach of the *Narada*. They both seemed to become sea creatures when viewed together. It didn't take much development time to realize this, and to switch the emphasis of the Jellyfish."

FINAL EVOLUTION
Church's next round of concepts, another set of eight, moved away from the more obviously organic approach, while continuing different looks for the engines. "In a few of my versions," Church says, "I thought of the large curved pieces as holding some sort of dimensional distorter, something that looked like a soap bubble stretched over a curved shape."

Although the design was moving away from anything that looked too much like a literal sea

creature, Church was still experimenting with making large parts of the exterior translucent like a real jellyfish. Finding the right texture would be the final key to the design. As Chambliss explains, he was keen on the idea that Vulcan technology was somehow grown rather than manufactured by traditional means. "I wanted to discover how we could literally unite nature with a machine in a fundamental and necessary way with the Jellyfish."

STRANGE TEXTURES
Church continues, "I kept reintroducing and reminding myself about the transparency aspect. We did some unpainted metal versions and other things. I remember Scott arrived at the 'green pebble scale' type texture that's in the final design and in some of my illustrations. When he first suggested that, I admit I thought it was an odd direction, but it looks great and the thinking is that it serves some type of 'ablative insulation'

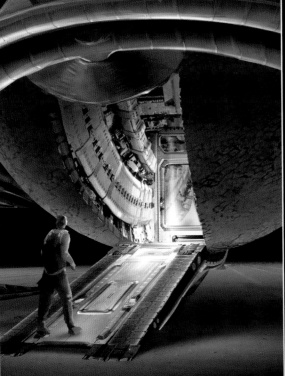

function to protect the ship from its unique stresses and loads."

For Chambliss, a significant point about the texture was that it provided a uniquely Vulcan approach to the final design, one that suggested that the ship could have been 'grown'. "The textural exploration was a journey toward making the hard shell of the Jellyfish an actual grown, living skin that has hardened to become virtually impermeable – a concept borrowed from nature and elaborated upon."

By this point, the shape and the texture had been more or less locked down. There were some experiments in which the ship gained obvious guns mounted on the outside, something Chambliss describes as "inevitable" with science fiction.

ON THE GROUND

The other major consideration was how the ship would land. "It's always a challenge to put landing gear on a vertically oriented ship," Church says. "I did a few versions that showed ways to do this and how to get in and out of the thing, knowing that in this case the set builders were going to actually construct the stairs going up and into the ship. That affected the way the tail and spinning parts moved: once we decided the landing orientation we had to be mindful of that and be sure there was a 'landed configuration' that looks like it makes sense and can actually look right."

The eventual solution was to turn the ship on its side and build a ramp into the 'bottom' – though 'side' and 'bottom' were meaningless concepts on a ship where the cockpit stayed stationary and everything else rotated.

The final design that was sent over to ILM, where it was built as a CG model, was remarkably close to Hitch's original sketch; something which he says came as a great surprise to him.

"Ryan Church did a beautiful job fleshing out the structure and giving it texture and it moved exactly as we'd envisaged. Honestly, it's very rare for a design to be carried through a long process like this and maintain its integrity. So when I saw the movie it was surprising to see just how much made it through all that to the finished film. Getting to work on *TREK*, let alone contribute something like Spock's ship to the mythology, has been a dream come true."

◄ The production team knew that although the ship would be built in CG, the ramp that led up to it would have to be constructed on the soundstage.

DESIGNING THE
NARADA

Nero's ship was like a vast knife in space
that was designed to dwarf the Enterprise.

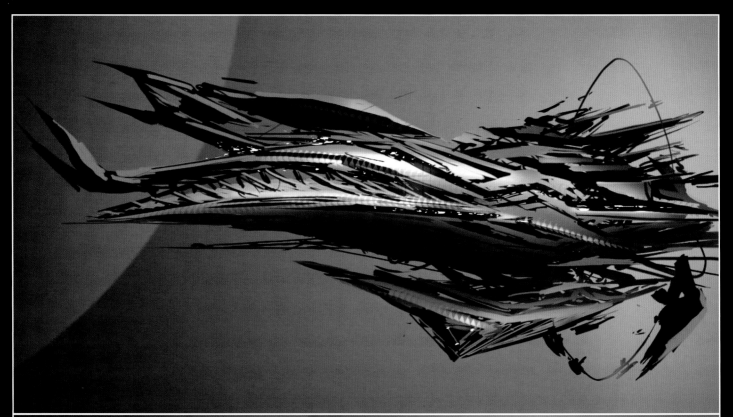

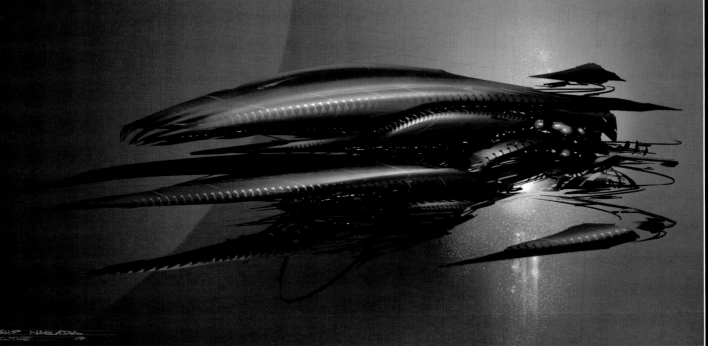

In the opening moments of 2009's *STAR TREK* an extraordinary alien ship appears through a black hole and instantly attacks a small Starfleet ship, the *U.S.S. Kelvin,* killing Kirk's father and changing the course of history forever. The *Narada,* a Romulan mining ship from the future, was at the heart of the film – a six mile long nightmare that would destroy Vulcan and come close to

destroying Earth. The task of designing it would fall to concept artist James Clyne, and as he remembers, production designer Scott Chambliss and director JJ Abrams gave him a lot of freedom. "Initially the *Narada* was nebulous," Clyne says. "The only information I really got was that it was a new ship that would be the antagonist to the *Enterprise,* that it was Romulan, and that JJ wanted

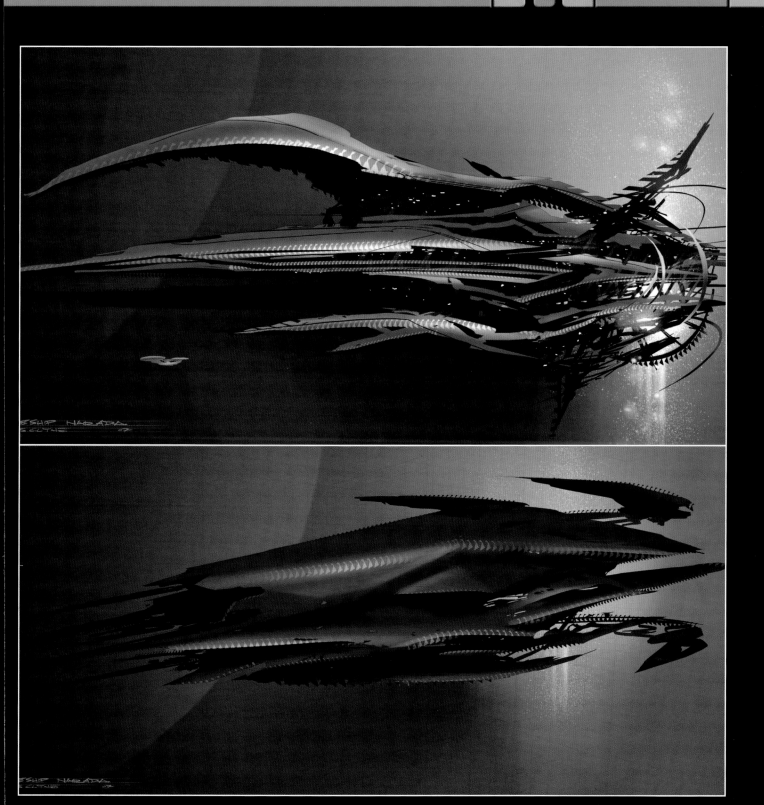

ESHIP NARADA
S CLYNE 07

ESHIP NARADA
S CLYNE 07

to see something that he'd never seen before. They didn't want it to be too conventional; they wanted it to be more sculptural or just more alien."

Clyne freely admits that he didn't have a detailed knowledge of *STAR TREK*'s different cultures so he didn't worry too much about what it meant to be Romulan, instead he concentrated on the rest of the brief.

"I started to do very rough black and white sketches," he says, "knowing that they wanted something new and strange. It's important for a design that it evokes something visceral. I was thinking about being organic and about whalebone, or vertebrae, or a repetitive shape that you see in nature from a Mojave plant to the backbone of a humpback whale."

▲ James Clyne began by creating a series of quick digital sketches showing possible directions for the *Narada*. He wanted something organic and was inspired by the skeletons of whales and plants that grow in the Mojave desert.

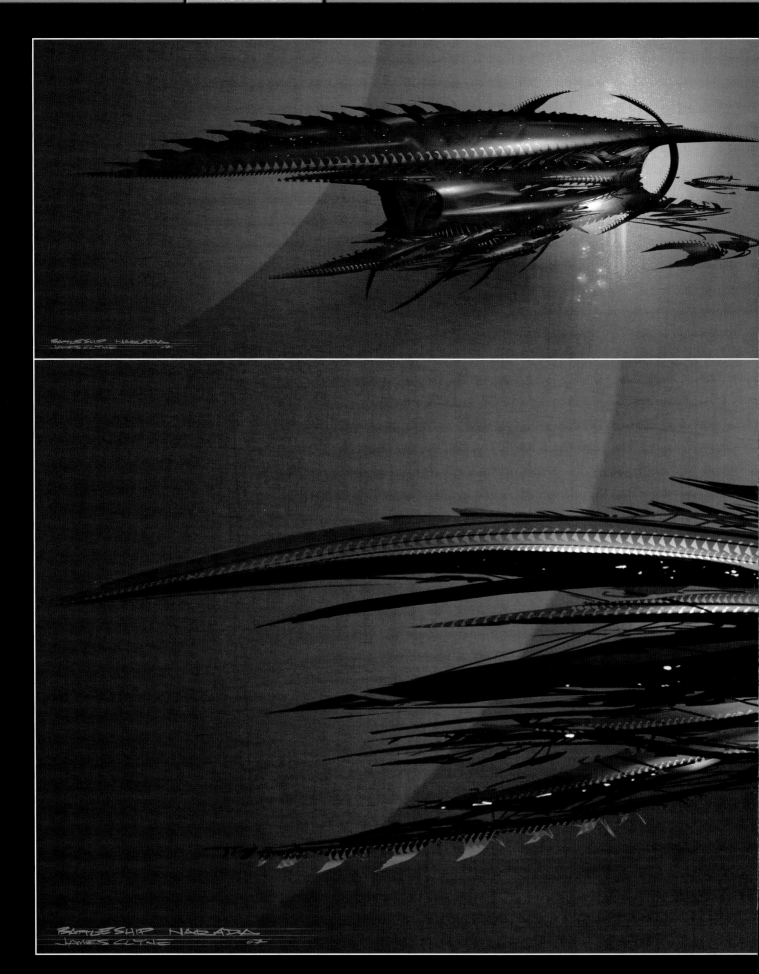

BATTLESHIP NARADA
JAMES CLYNE 07

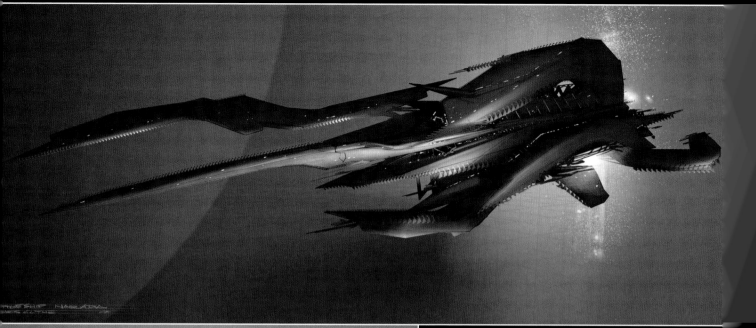

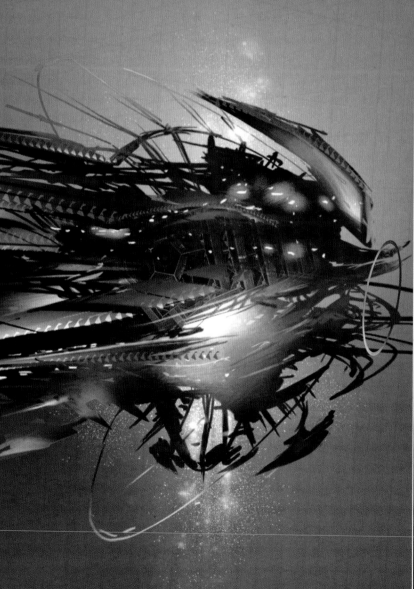

He rapidly produced 12 sketches that showed variations on this theme, each evoking the skeleton of a whale or some other vast creature. They had, as he says, a "Jules Verne feel to them." When he presented the sketches to Chambliss and JJ Abrams, one of them instantly stood out as the favorite. "JJ looked at one and said, 'That's kind of it,' which surprised everybody. He liked this very organic, animal carcass feel. He liked the way it was very aggressive and very 'alien strange'. It had these very aggressive blades, which were sticking forward, which gives it a very menacing feel."

For Chambliss, the appeal of the design was that it looked like "an organism primarily constructed of sharp knife blades pointed directly at anything or anyone that approaches it." This instantly made it threatening and ominous.

UNDER THE SKIN

The sketch gave a pretty good sense of what the *Narada* looked like from the outside but, as Clyne explains, there was a still a lot of creative work to do. "The hard process wasn't coming up with the actual skin, it was removing that skin and finding out what kind of structural elements were underneath. We had this general shape of this spiky object, but we had to work out what exactly

◄ Abrams and Chambliss chose the third of the twelve sketches Clyne produced and asked him to work it up into a more developed design. The rear of the ship, which would house the propulsion system, is on the right of the drawing.

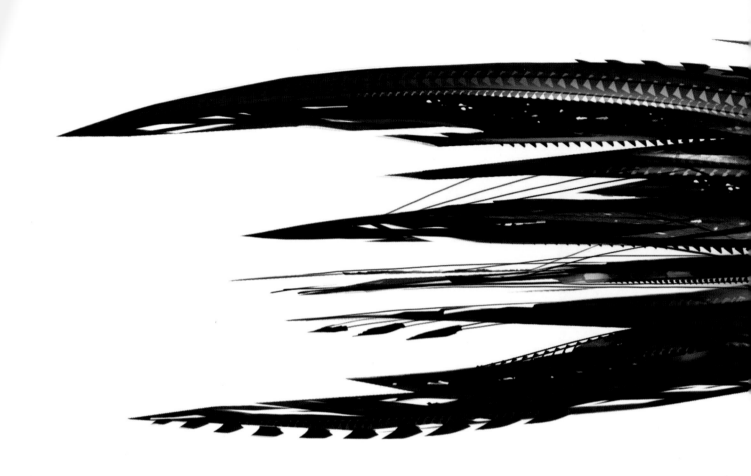

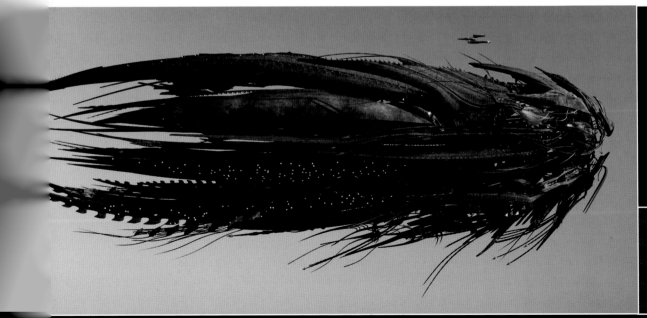

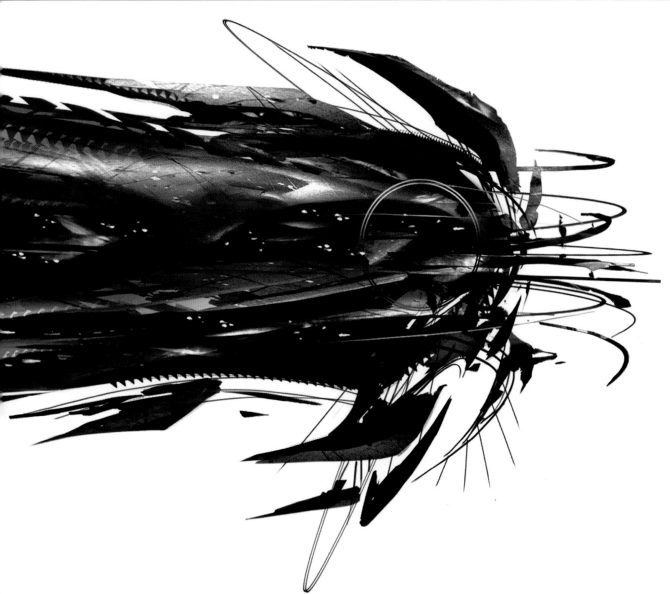

▲ Once the initial sketch had been chosen, Clyne created a more refined concept. This drawing was produced in the August of 2007. The arrow showing the direction of flight was added because some members of the staff assumed it flew from left to right.

◄ ILM followed Clyne's drawing of the glowing engines (bottom right) to show the *Narada's* propulsion system in action.

it was and if it just looked like some big artichoke flying through space."

One of the most obvious questions was what did the different elements in Clyne's early sketch actually do? "We started to dig into some logic. There was some organization to it. The top maybe had more of a shell and then the back end would have more of a specific look to it for the propulsion. What propulsion system did it use? What direction did it move in?

"Initially, I went with a vertical wash of afterburner rather than a horizontal one, but In the end I went very conventional with the propulsion system. I think some of what I proposed made it into the final film. It would actually fire energy out of some kind of core as it flew. In some of the

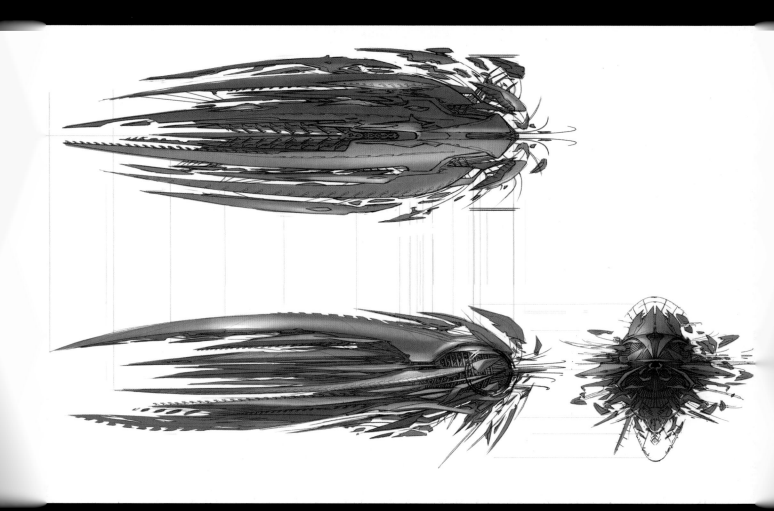

By December of 2007 Clyne had produced a series of elevations which were sent to ILM.

sketches you can see small white bursts of fire coming out towards the back."

The script also called for shuttles to fly deep inside the *Narada* before landing and, as Clyne says, that posed all sorts of questions. "Where does a shuttle enter the ship? Does it enter from the

bottom? The top? The center? If it enters from the center what does that aperture look like? How does it open? How porous would the *Narada* be? How open would it be?"

Flying inside the ship meant that it couldn't simply have an interesting exterior; it also had to

According to Clyne, a lot of the work involved working out what the insides of the *Narada* would look like as various shuttles flew into it.

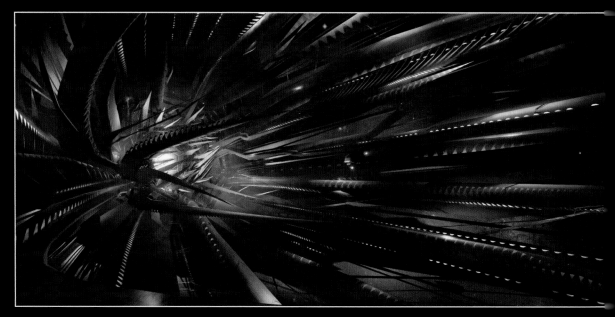

Inside the **NARADA**

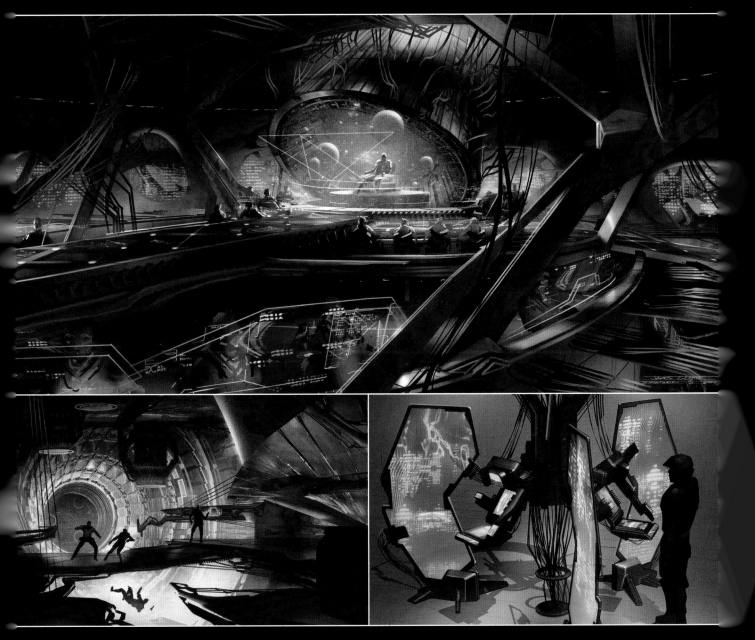

Scott Chambliss wanted the interiors of the *Narada* to be "a series of mysterious and unsettling abstract spaces that elicit and reflect emotional responses rather than rational ones." Thinking about Clyne's organic exterior which resembled the skeleton of an extraordinary creature, he turned to the Spanish architect Gaudi for inspiration, incorporating the kind of strange organic that had a been a signature of his work.

Clyne remembers that he found designing the interior much more challenging than designing the exterior. "Scott would constantly throw in these very unconventional approaches to things. We knew we needed a bridge. We needed some larger control area spaces where they could land a ship and there would be a fist fight, but in terms of the specifics like what would the floor look like? What would a control computer look like in a Romulan *Narada*? We tried a lot of unusual things. It was very back and forth.

"For example, Scott sent us this art installation and you can see it in this image where the captain is sitting under this inverted cone. That was a challenge because a cone didn't really seem to fit into this world, but working it over and over again we found that it could be a really simple showcase shape that we could add a lot of detail around. I think in the end that was helpful in creating this new look.

"In the end we found multiple tiered platforms played well because they did some stunts revolving around those platforms where they had Kirk jump from one down to another."

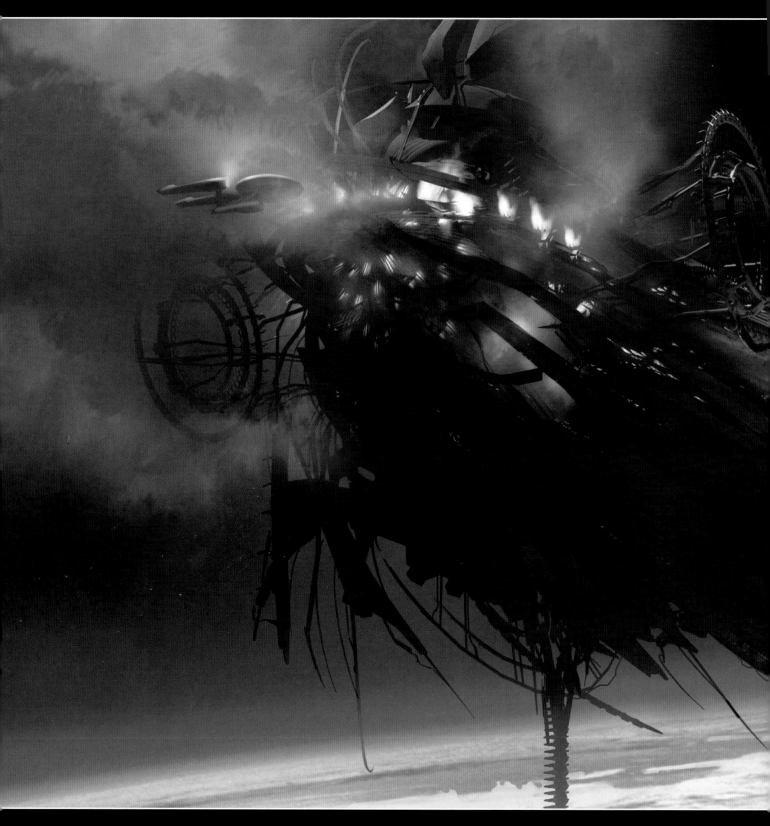

make sense as you entered it. Because of this, Clyne was determined that the ship would have a sense of structure. "You can see there's kind of a triangular lattice work underneath the skin. We did play around with the structure underneath it. What's holding all these seemingly random pieces together? I didn't want everything to feel like a small, thin, skinny blade or needle. I wanted to give some backbone to it."

Exactly how 'porous' the Narada was proved to be something that would continue to evolve, and Abrams and Chambliss would later ask ILM, who

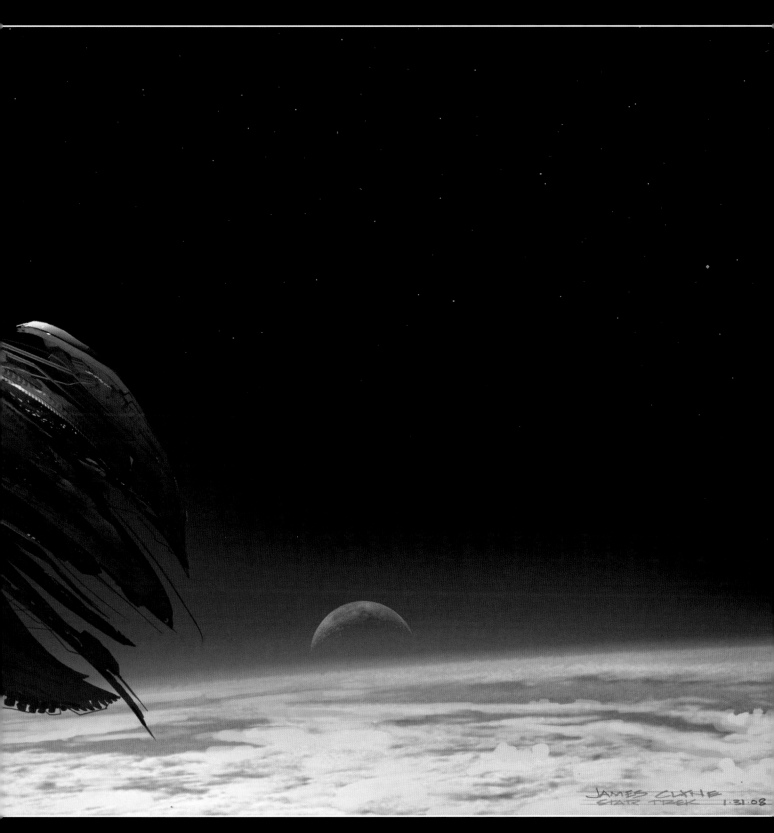

JAMES CLYNE
STAR TREK 1:31:08

built the CG model of it, to remove parts of the ship to make it less symmetrical and to create more negative space so that you could actually see through the ship.

The script also called for the *Enterprise* to sneak up on the *Narada* and this was something that

Clyne felt needed some explanation. "We were trying to figure out how the *Enterprise* could get close to the *Narada* without being detected. We played with the idea that it cloaked itself with this kind of mist, or atmospheric cloud. And I proposed this idea that the *Enterprise* would jump right into

▲ Clyne suggested that the *Narada* might cloak itself with a cloud, and the *Enterprise* could surprise Nero by warping into this.

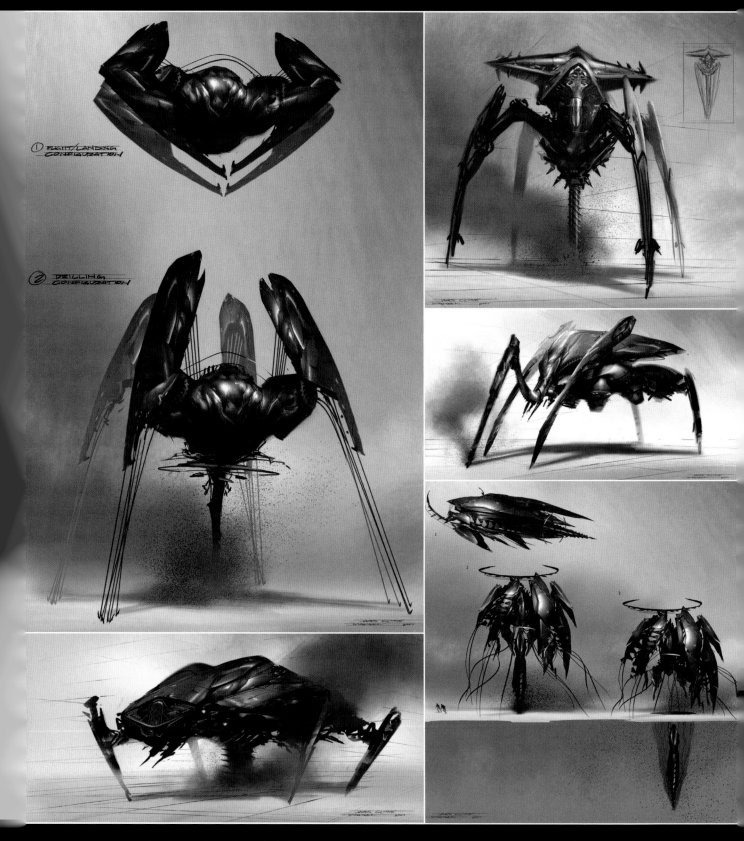

① FLIGHT/LANDING CONFIGURATION

② DRILLING CONFIGURATION

▲ At one point the *Narada* used a separate vehicle to drill into the surface of planets and Clyne produced several concepts for this.

that cloud and hide in it."

Clyne produced a concept showing this, but ultimately it was decided that this wasn't necessary and the *Enterprise* could simply appear from warp.

The other major element that the script called

for was the drilling platform that the *Narada* would use to tap into the surfaces of Vulcan and Earth with catastrophic consequences. As Clyne remembers, the exact nature of the drilling platform went through some major changes. "In

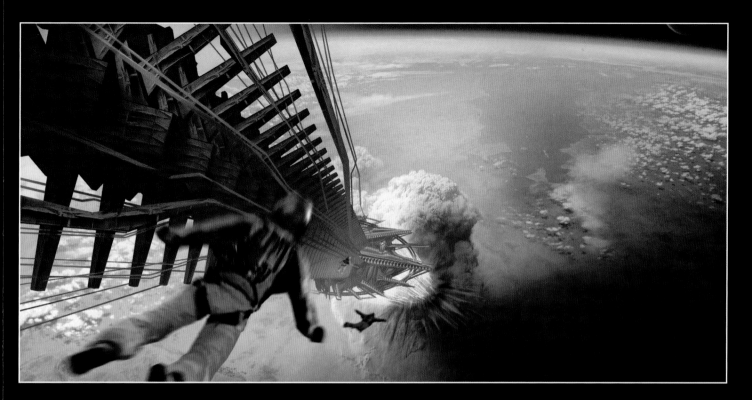

an early draft of the script it called for the drill machine to be its own vehicle. I created a few designs for it, which were shown to JJ."

Clyne's sketches show an almost bug-like ship with insect-style pincers that would grab onto the surface, allowing the drill to penetrate the surface. However, as Clyne was designing, the script was evolving. "JJ liked the direction we were going in, but he was working in tandem with the writers and

the whole thing on the drilling platform became more of this moment. So we changed it so the actual drilling apparatus was directly connected to the ship itself, which made more sense for what they needed in this specific action sequence."

The revisions to the script called for Kirk and Sulu to fight a team of Romulans on the top of the drill platform in a major set piece. This involved a major rethink, not least because the top of the drill

▲ As the script evolved it was decided that the *Narada* would extend the drill from its body and that Kirk and Sulu would attempt to disable it. The drill platform was designed to make the battle as dramatic as possible.

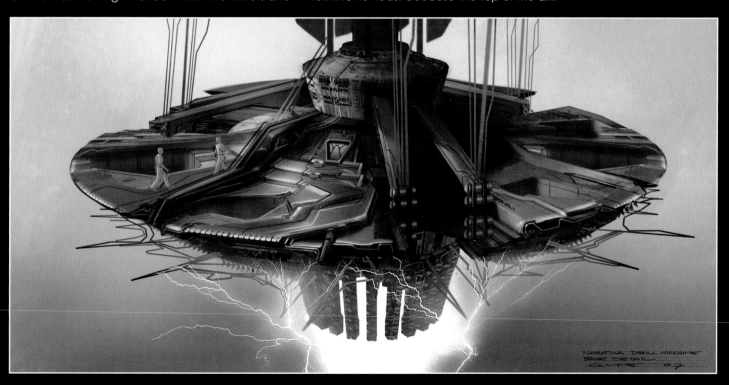

Hey Roger & Shari-

Had a discussion with JJ about the turntable model below, and here are the resulting requests (Some of which he said he shared with you all already, but were not included in the note Shari emailed me about your discussion:

- We 'd like to change the top symmetrical "spine" elements on the ship. In my lame scribble below, the red upper spine piece should be larger as as shown. The green lower one should be smaller as shown, thereby ditching the symmetricality of them. The blue area represents the opening

hansonsranch CGCHQ-00618

move this piece proportionally closer to the ship, please.

EXT HANSONS/TOP VIEW

74

between, where the ribs you've got on the model can plunge into.

-JJ felt the ship also needs more negative space, so that you can see further into and sometimes through the entire ship. It was beginning to feel a bit blob like.

-We'd also like to tailor the outer silhouette shaoe of the ship, as indicated by the yellow line.

Thanks very much,

Scott

▲ As Clyne's concept artwork shows, the *Vengeance* was always destined to meet its end crashing into San Francisco. As part of the sequence ILM had it crashing into Alcatraz, as a nod to one of JJ Abrams' TV series.

platform had to be built on a soundstage. "The platform itself had to be designed for actors and stunt men to have a sword fight on," Clyne explains, "so it had to be a certain size. It couldn't be 500 feet in diameter, although it got quite large. They wanted holes around the platforms that actors could possibly fall into. I built something quickly in 3D to give a general sense of the layout.

▲ ILM's model of the *Narada* was one of the most complicated they had ever built and it had to interact with a black hole. As a result the VFX sequences took days to render.

Once they were happy with that we decided to add details."

One of the last elements to be added to the *Narada* was its weaponry, which would be used to destroy the *Kelvin.* "Pretty late in the game there was a demand to think about the kind of weaponry that it used," Clyne recalls. "JJ didn't want traditional Federation phasers; he wanted something different. It was one of the few one-on-one conversations I had with him regarding the *Narada* specifically. I threw out the idea, and I sketched it out right then and there, that maybe the missile splintered off halfway on its travel towards an enemy object, and it would create an effect like a cluster bomb. It was a really terrible sketch but he liked it."

MASSIVE MODEL

The *Narada* was built as a CG model at ILM, by Bruce Holcomb's modelling team. The staff at ILM theorized that its extraordinary shape was at least partially the result of its journey through time.

For ILM one of the biggest challenges was creating a model that would convince the audience it was six miles long. They understood that the only way to achieve this was to make it incredibly detailed. The model they built was one of the largest ever constructed and rendering a single frame showing the entire ship could take as long as 24 hours.

And having built it, they also had to tear it apart as Nero attempted to escape from the black hole. This part of the sequence was handled by a team led by James Tooley, and ILM described it as being more like smashing skyscrapers apart than making a conventional pyrotechnic effect. Like everything in the movie, the effects for the *Narada* were bigger than anything that had come before.

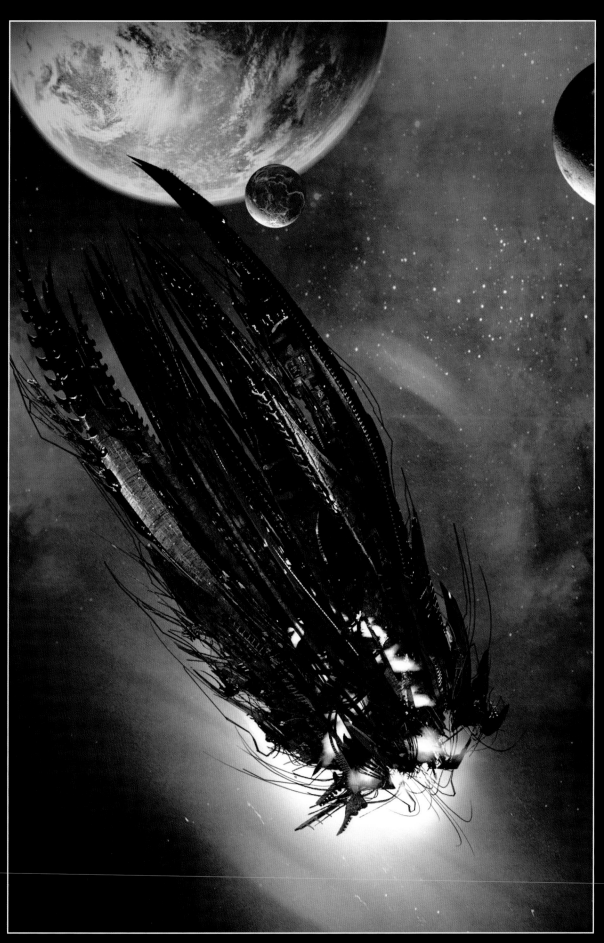

◄ The *Narada* was a
massive vessel. The VFX
team eventually settled
on making it 30,737 feet
long (and three inches).

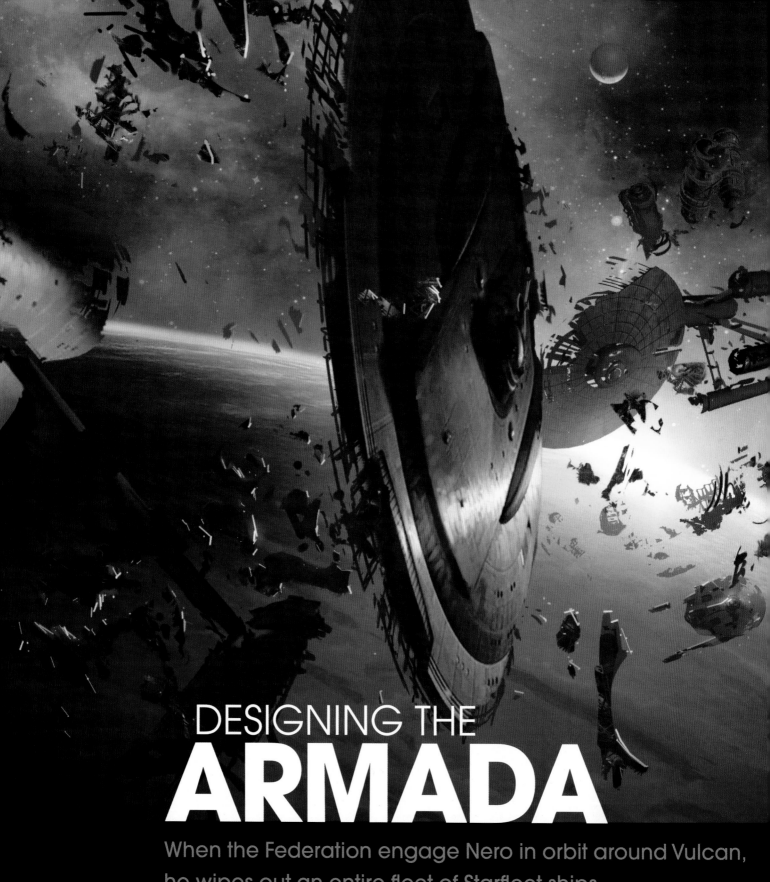

DESIGNING THE
ARMADA

When the Federation engage Nero in orbit around Vulcan, he wipes out an entire fleet of Starfleet ships.

In one of the pivotal moments in the 2009 *STAR TREK* movie, Earth receives a distress call from Vulcan. The Federation responds by assembling a fleet of starships that heads off to aid one of their founder members. The *Enterprise* is delayed and

by the time it arrives at Vulcan, the rest of the fleet has been destroyed.

In any other *STAR TREK* film the VFX team could have drawn on a library of existing ships, but this was a new era for *STAR TREK* and everything had to

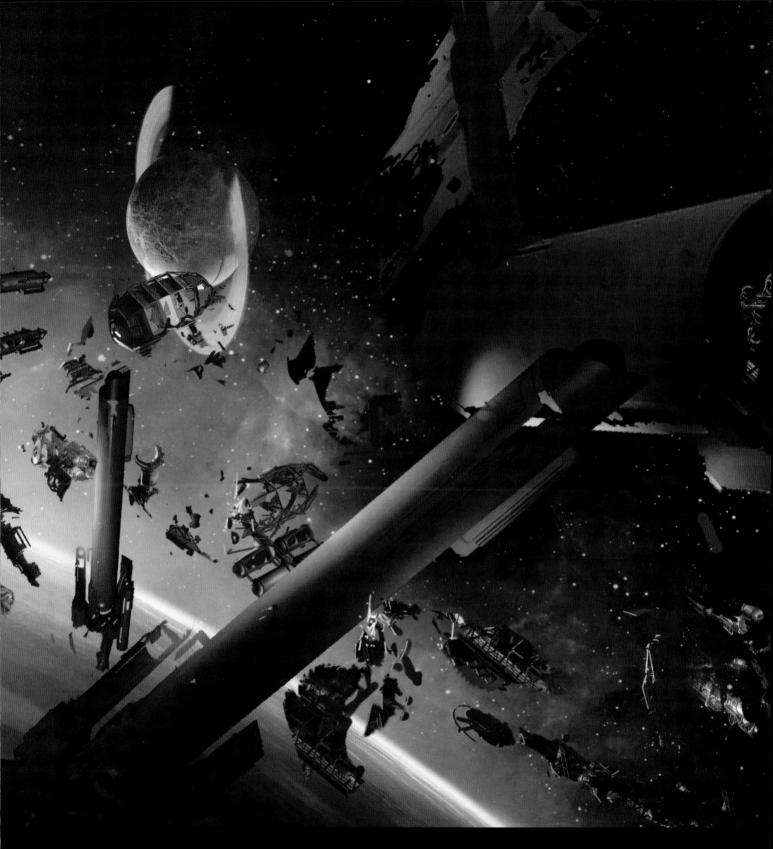

be created from scratch. Director JJ Abrams was determined that the *Enterprise* and the *Kelvin* should be unique designs so there was no question of having other ships of the same class. As ILM's Alex Jaeger remembers, Abrams asked the VFX team to come up with some new ships to create the sense that there was an entire fleet.

Jaeger was well qualified for the job since a decade earlier he had created the fleet of ships

that took on the Borg in *FIRST CONTACT*. However, as he says, time was short and there wasn't a massive amount of budget allocated to the task.

"We wanted to see a bunch of other ships that we hadn't seen before. I remember this happened pretty quickly because they wanted to sort of get these plugged in to make animatics. JJ's attitude was, 'Don't spend a whole lot of time, just come up with a bunch of quick silhouettes.'"

▲ This James Clyne concept art shows the *Enterprise* arriving in the middle of the wreckage of the rest of the fleet. The other ships would barely be seen but they still had to be designed.

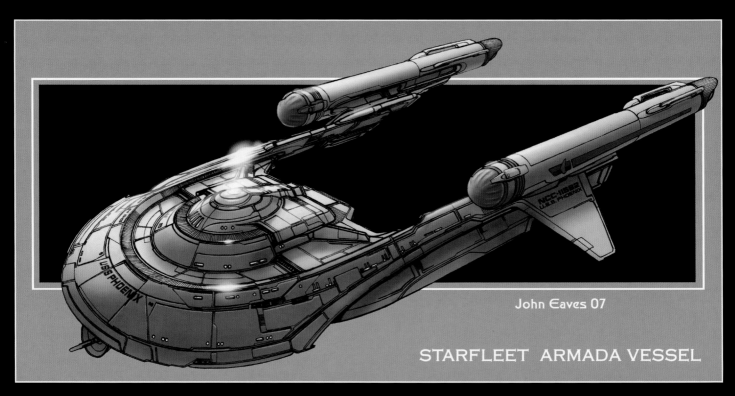

John Eaves 07

STARFLEET ARMADA VESSEL

▲▼ Before ILM designed the ships in the fleet, the art department took a pass with John Eaves contributing these two designs.

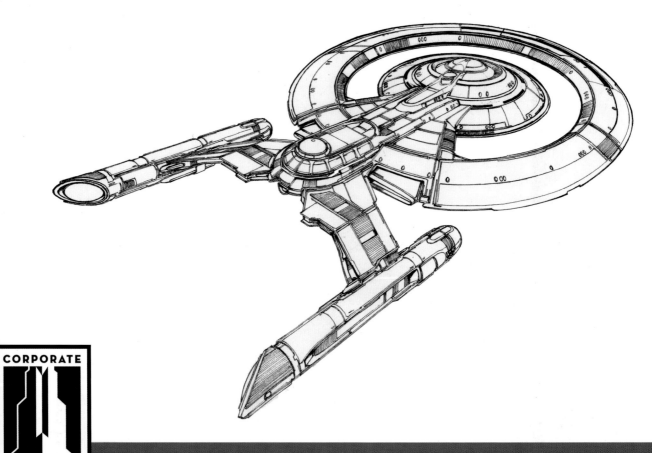

CORPORATE
HEADQUARTERS

STARFLEET ARMADA VESSEL CONCEPT #2 JOHN EAVES 8-07

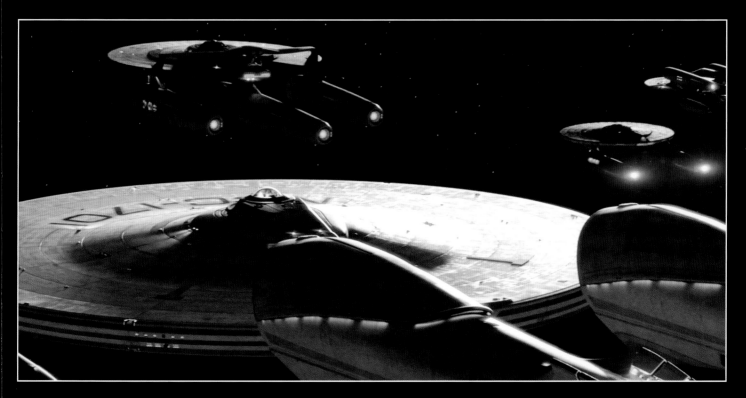

As Jaeger explains, he did have some materials to work with for the armada. "We had the CG models for the *Kobayashi Maru* and the *Kelvin*, so we used that as a sort of kitbash set. I took all those parts and rearranged them into some familiar configurations."

FAMILIAR PIECES

Jaeger took the 3D models apart, isolating the familiar elements of Starfleet designs such as saucers and nacelles. Then he produced quick sketches showing different ways in which they could be recombined to make new ships. "It was a bit of mix and match. It was just me playing around with the shapes. I was basically thinking, 'This one has two nacelles, this one has four, this one has three. How can we rearrange it so they don't all look the same?' Once I got a sketch that I liked I would go in to 3D and kind of configure it to make sure it still looked okay."

Once he had the basic shapes in place, Jaeger started to make more extreme modifications so that his new ships would look more distinctive. "For some of them I just did a basic 3D render of a configuration and then created variations of that by painting on top of it. I would do things like cutting into the dish – maybe it was half a dish or it had a scallop taken out of the front or the back."

As Jaeger worked he was careful to make sure

that none of his designs looked too sophisticated. As he explains, they were not intended to be the heroes of the picture.

"The goal was to make the *Enterprise* definitely look like the newest, sleekest of the ships. So with these ones I kept the more blocky forms and the sort of intersected junctions as opposed to the swept junctions. We had a kind of roll bar, like on the *Reliant,* which ended up on most of them. "

When it came to the exterior finish, Jaeger didn't bother to give his designs a final polish. "I was trying to keep it quick and dirty and not paint in all the detail at those initial stages. Essentially, all I did was render those out and paint on top a lot of the panelling and all that detail. Part of that was because we didn't want to make it appear that we were spending a lot of time on these because we creating them on a budget!"

SELECTING THE FLEET

He produced approximately a dozen of these rough designs which he took to Abrams and production designer Scott Chambliss. "Initially we had quite a few more than ended up being approved. I got some hand drawn notes, some of them from Scott Chambliss and some of them straight from JJ – 'I like this one, I like this one. Don't do that!' They gave us some of the names. Then we went through and circled the ones we liked –

▲ Three of Jaeger's basic designs for new ships made it into the final film, when they are seen warping away from Earth. Variations of them would be seen in the wreckage around Vulcan.

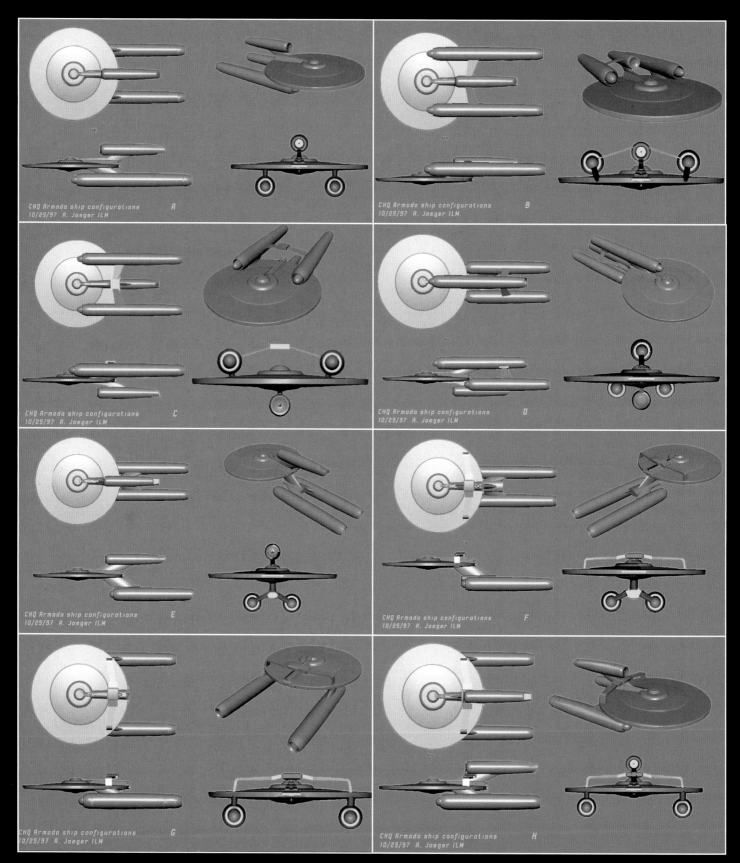

CHQ Armada ship configurations
10/25/97 A. Jaeger ILM A

CHQ Armada ship configurations
10/25/97 A. Jaeger ILM B

CHQ Armada ship configurations
10/25/97 A. Jaeger ILM C

CHQ Armada ship configurations
10/25/97 A. Jaeger ILM D

CHQ Armada ship configurations
10/25/97 A. Jaeger ILM E

CHQ Armada ship configurations
10/25/97 A. Jaeger ILM F

CHQ Armada ship configurations
10/25/97 A. Jaeger ILM G

CHQ Armada ship configurations
10/25/97 A. Jaeger ILM H

▲ Jaeger started by producing a series of quick sketches showing possible designs for
new Starfleet ships. They were all made with elements from the *Kelvin* and *Kobayashi
Maru,* both of which ILM had already built for other sequences earlier in the movie.

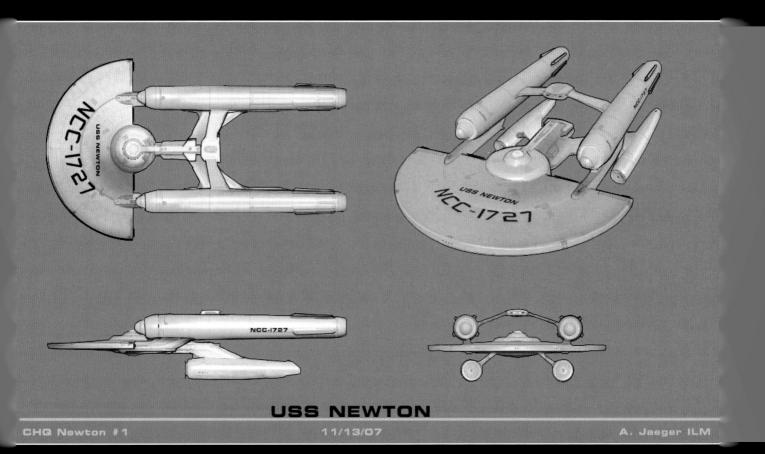

USS NEWTON

This is the *Defiant*, this one is the *Mayflower*, this one's the *Armstrong*, this one's the *Excelsior*. The *Newton* was probably – definitely – the most different of them all."

One of the most surprising things was that Abrams asked to see different colors for some of the ships, so ILM started to experiment, eventually deciding that some of the ships could be red and others black.

At this point, the designs were only being used in animatics – a form of low resolution animation that is used to plan out visual effects shots. As Abrams

was working out exactly what he wanted to show, he realized that he didn't need as many different ships as ILM had originally expected.

"At some point," Jaeger remembers, "once they got the cut they realized we were only going to see a few of the ships around the space station and then the next time you see them they would all be in pieces. So they basically said 'That'll do'. It was JJ's call to scale it back to just a couple of shapes. We ended up with three designs and then variations of the same thing in a couple of different colors."

▲ The *U.S.S. Newton* which has four nacelles and a half cutaway saucer was the most radical departure from conventional Starfleet design.

◀ The next time we saw the fleet it was in pieces, and it was almost impossible to reconstruc the design of the ships from the wreckage floating around Vulcan.

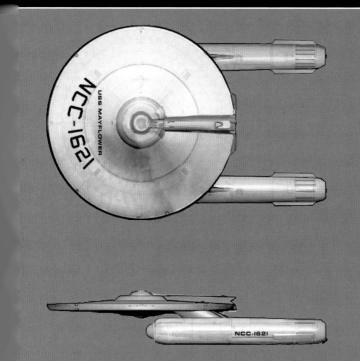

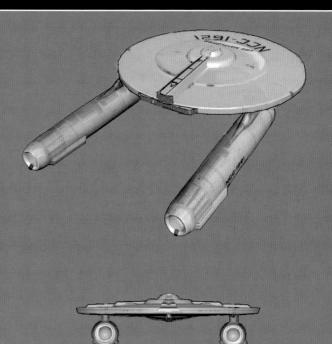

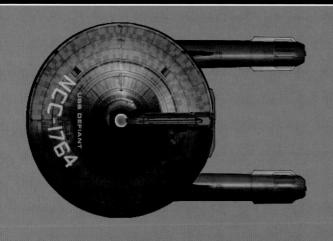

USS MAYFLOWER

CHQ Mayflower # 1 11/17/07 A. Jaeger ILM

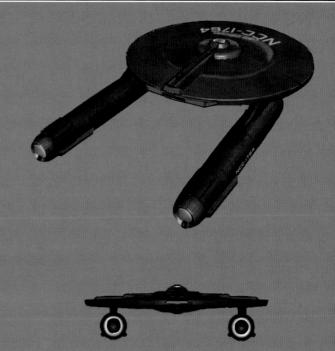

USS DEFIANT

CHQ Defiant # 1 11/17/07 A. Jaeger ILM

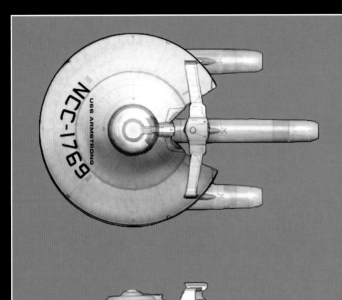
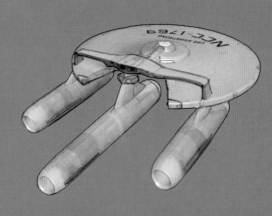

USS ARMSTRONG

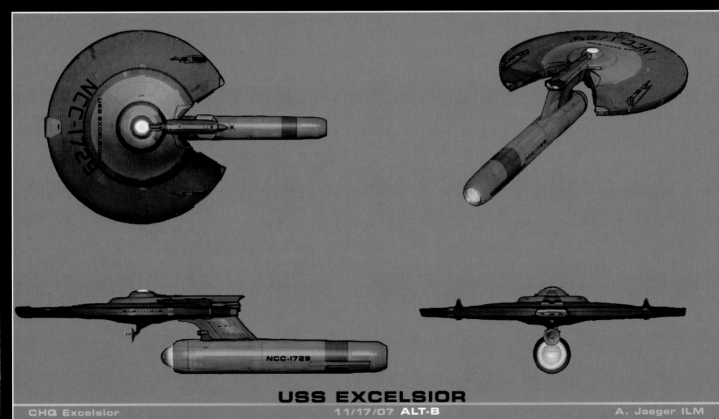

USS EXCELSIOR

DESIGNING THE
VENGEANCE

STAR TREK INTO DARKNESS' 'blackship' has a long and complicated history and countless unseen weapons...

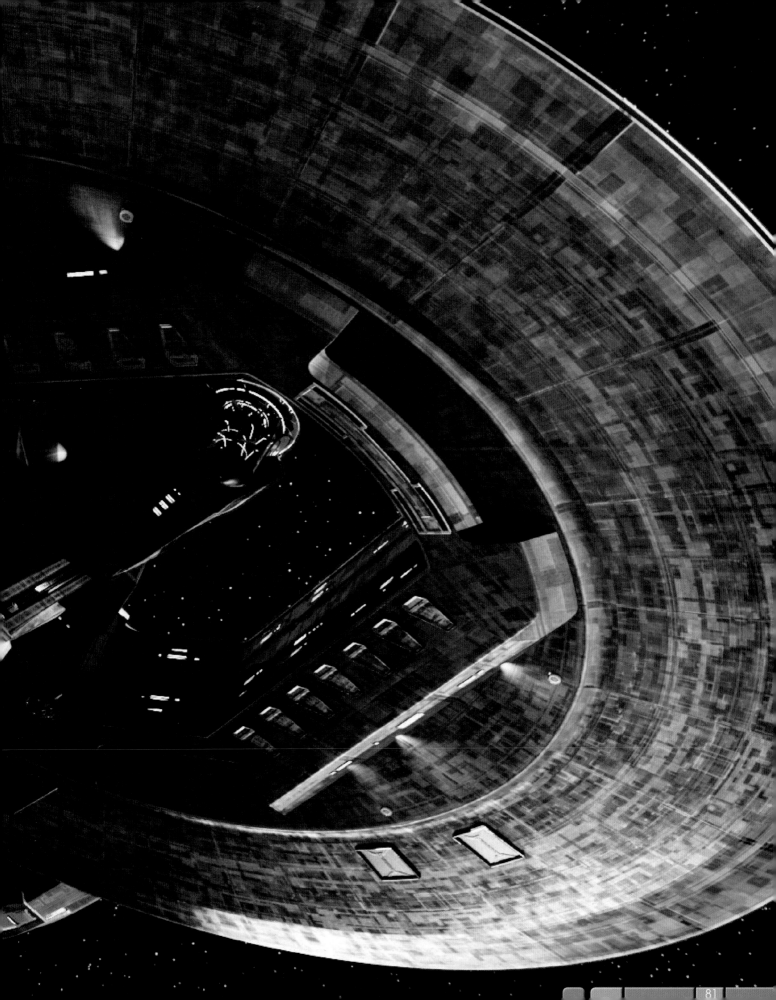

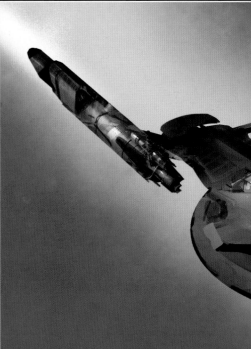

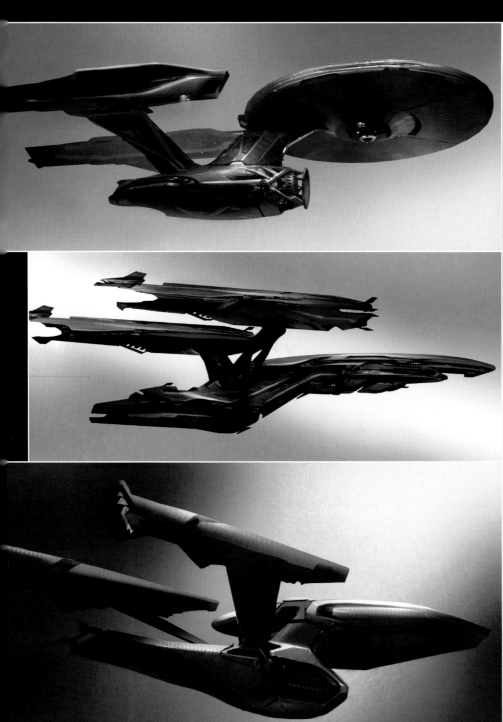

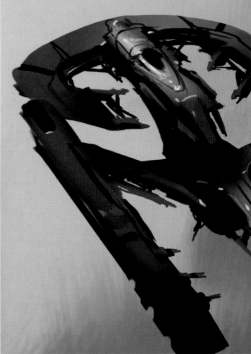

The *Vengeance* was always meant to be the evil *Enterprise* – a dark reflection of the ship we know so well. "The brief," production designer Scott Chambliss explains, "was that it was to be a seriously badass, militarized variation on the *Enterprise*. Boiled down to its simplest metaphor, the *Vengeance* was a very sophisticated mega-weapon capable of outmaneuvering virtually any adversary it encountered."

With this in mind, Chambliss outlined the broad

strokes of Abrams' vision to concept artist James Clyne, explaining that the new ship was to be the antithesis of the *Enterprise*, that it would be black and menacing and significantly larger than Kirk's ship. "But beyond that," Clyne says, "there really was no brief. It was just – start there…"

Chambliss did, however, offer Clyne some inspiration, but rather than showing him another space ship, he gave him visuals that suggested the kind of mood he was after. "Scott likes looking at

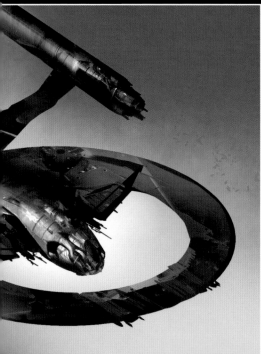

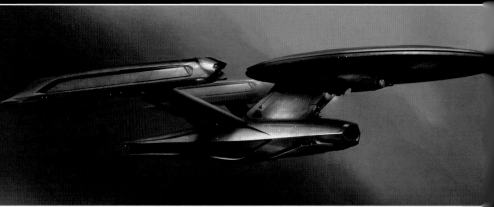

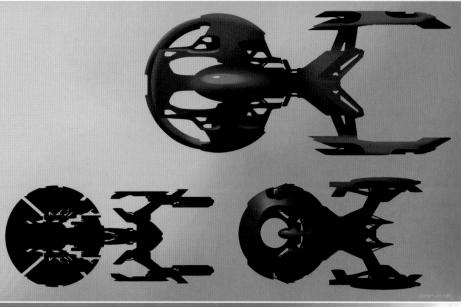

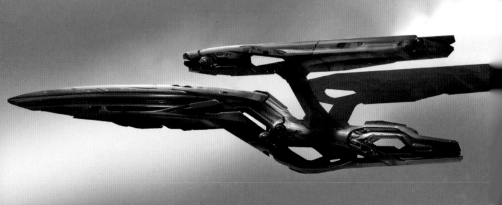

reference that isn't a one-to-one idea," Clyne explains. "He liked the idea of looking at these 70s supercars, specifically Italian cars like Lamborghini, which had these very sharp edges. We also looked at these elaborate Swiss Army knives that had a lot of different kind of form language that he liked. We used that as a jumping-off point."

"We took our time with this one," Chambliss says. "James did a few dozen very quick silhouette studies of how we could play with the *Enterprise*

shape, and we continued to narrow the selection and develop our choices until we agreed on the design you see in the film."

"They are very rough sketches," Clyne continues. "Quick, simple, rough sketches that don't really give too much away. I looked at some of the older *Enterprises* and tried to understand the proportions and how one shape linked in with another, but at this point we were still looking for a feeling so it was about playing with a silhouette."

▲ A selection of James Clyne's early 'sketches' for the *Vengeance*. From the beginning, Clyne was looking for ways to break up the familiar architecture of Starfleet vessels without losing their basic shape.

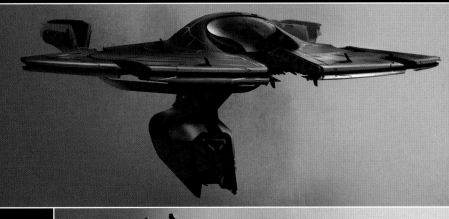

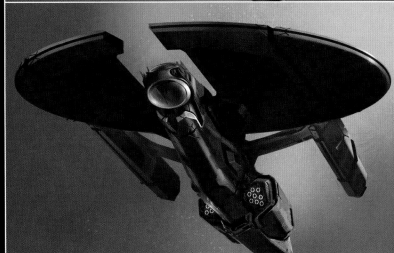

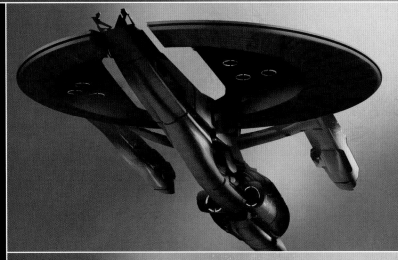

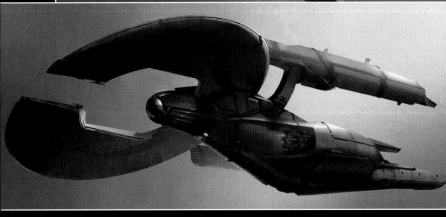

Clyne goes on to say that he wanted to move away from the deliberately artistic design of the *Enterprise*. "If you look at those early sketches, you can see I was thinking about the aesthetic of the military. If you think about the military all the style is based on function; it has nothing to do with looking one way or the other. And, out of that functionality, inherently comes a certain look. It's typically a blockier version. It's more brutal; it's more simple."

As Chambliss explains, at this early stage they hit upon a technique that broke up the smooth, artistic lines of the *Enterprise*. "We found the ship's personality by introducing negative shapes into the main disc." For Clyne it was about trying to make changes without losing the fundamental layout of all Starfleet ships. "The first thing that I tried to do was get away from the circular disc shape and that's why I started punching these negative holes into it. Not all of the designs had negative space. We tried versions where the saucer was very low profile with very sharp edges, but there was something about the negative spaces that everyone liked."

CYBERNETIC SCORPION

Working with Abrams, Chambliss and Clyne identified a handful of designs that showed the most promise. "By the time we were down to our final three or four selections," Chambliss says, "our favorite was obvious." The approach he's talking about was still some way away from the final ship. In this version, the saucer was open at the front and hollow in the middle, with the broken edges forming pincers like some cybernetic scorpion.

This approach also produced a new and different feature. When Clyne had hollowed out the saucer he had left the bridge in place in the center, connecting it to the rest of the ship with a wide corridor. "The bridge was kind of cantilevered out and that meant it became a better vantage point. The idea being that the military is all about functionality, and this gave you the most visibility top and bottom. It was trying to think of new and interesting ways that we can have a function on a Federation ship that was a little different."

◀ Abrams, Chambliss and Clyne identified one approach where the front of the saucer was open and the bridge was cantilevered out, as having the most promise. Clyne would devote months to developing this idea.

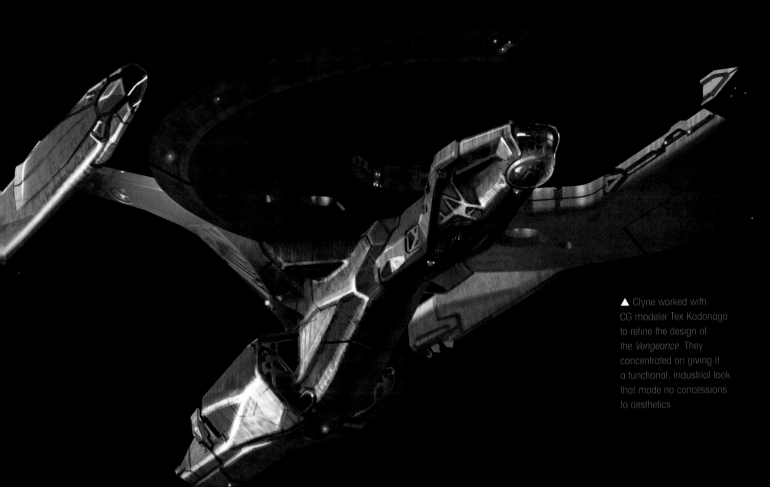

▲ Clyne worked with CG modeler Tex Kadonaga to refine the design of the *Vengeance*. They concentrated on giving it a functional, industrial look that made no concessions to aesthetics.

Working back from the saucer, the ship retained the basic layout of the *Enterprise* but its sweeping curves were replaced with hard lines and sharp angles, reflecting Clyne's desire for military simplicity. To imply that the ship was both bigger and faster than the *Enterprise*, the nacelles were bulked up and made proportionally larger.

CHANGING SHAPE

The *Vengeance* retained this shape for some time, but there was something about the design that wasn't exactly right. "We did a lot of artwork showing it in that form battling the *Enterprise*," Clyne remembers, "But the shape required months and months of different iterations. We did versions A,B,C,D all the way through the alphabet! Through the process it became a little more simplified. JJ, I think rightly so, wanted to make sure that we didn't get too far away from that classic Federation look. In the end we hit it with the best of both worlds where we closed the saucer off so it

was a perfect circle, but we kept those negative spaces in the middle. I think that makes it even more interesting because it fits in the world rather than being something totally different."

Throughout the process, Clyne worked with CG artist Tex Kadonaga, who took his designs, and produced 3D models. "I love Tex," Clyne says. "He's awesome to work with. I would just rush something out and then hand it over to him. Then we'd go back and forth and really massage it. Obviously ILM came in and rebuilt all our nasty terrible models and made it look beautiful. But we concentrated on making sure that what we handed over was 90% there."

That process of massaging the design continued at ILM where the ship was built by a team led by Bruce Holcomb and digitally painted by Ron Woodall and John Goodson and their team. One of the biggest challenges they faced was working out how we would actually see the *Vengeance*. From the beginning, Abrams had emphasized that

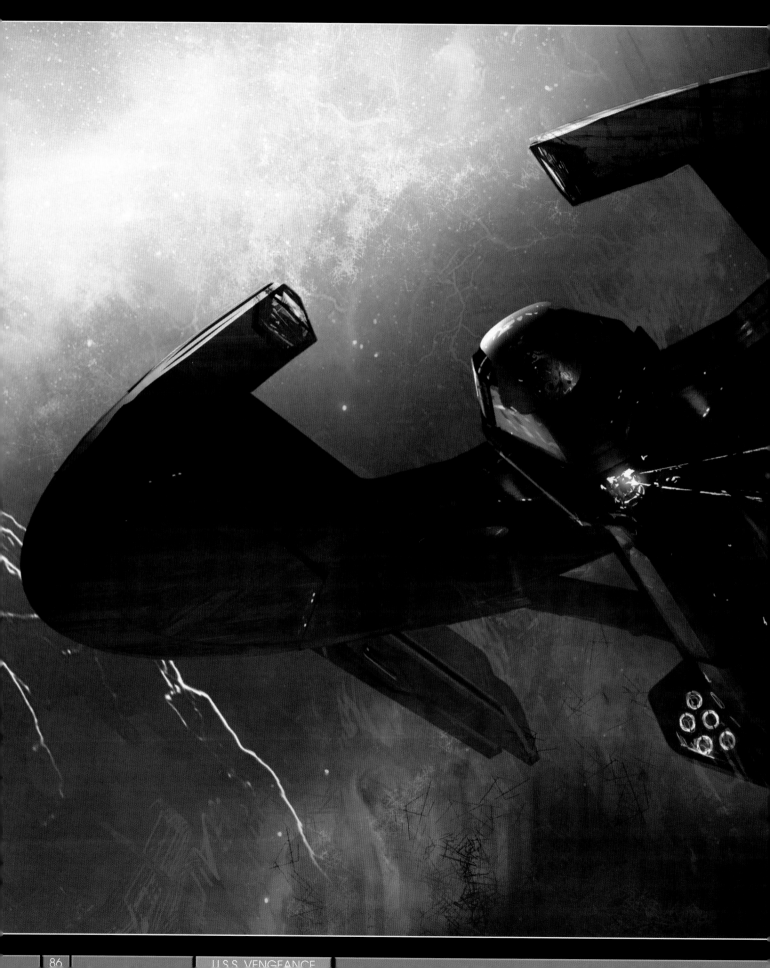

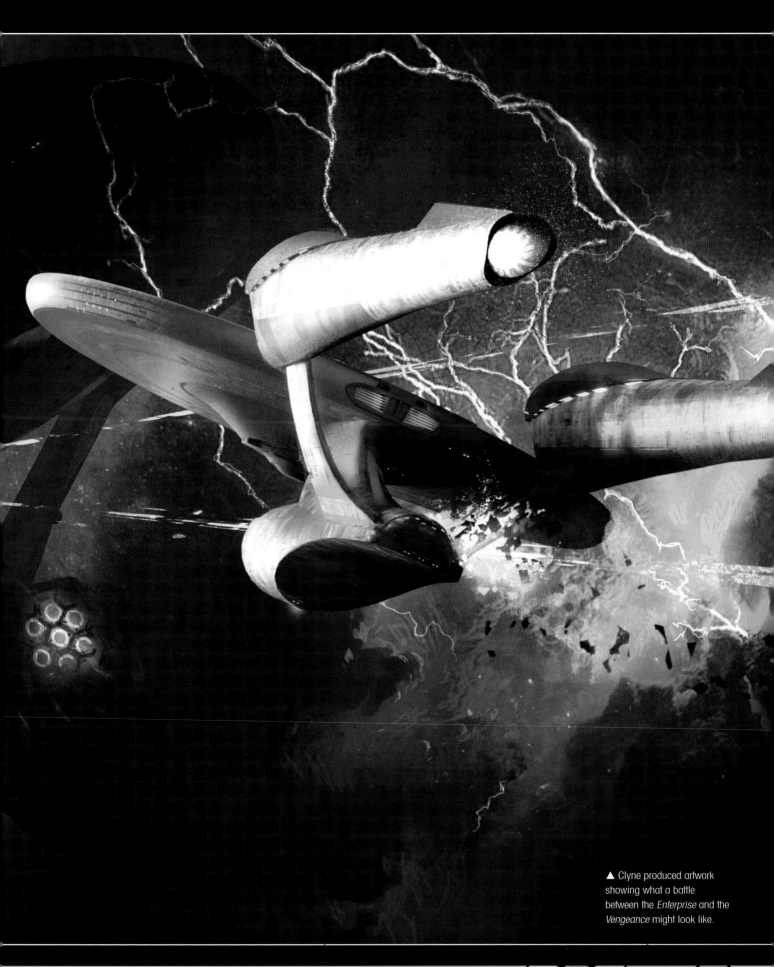

▲ Clyne produced artwork
showing what a battle
between the *Enterprise* and the
Vengeance might look like.

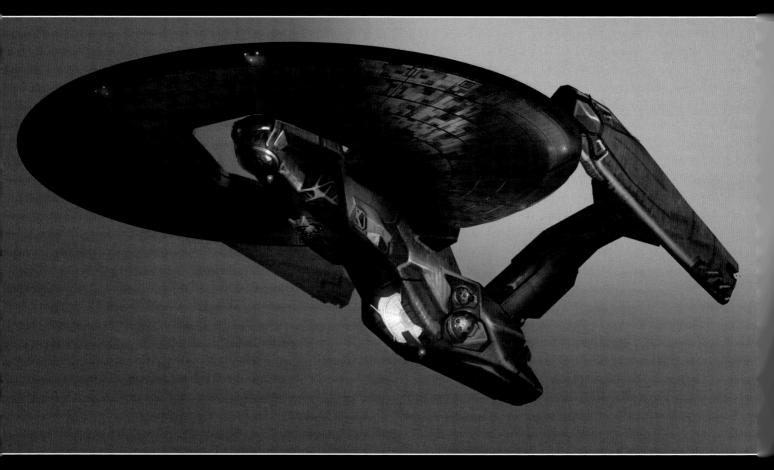

▲ The version of the
Vengeance with the
open-fronted saucer
survived for some time
and Clyne produced
several pieces of artwork
that showed it in combat
with the *Enterprise*.

the *Vengeance* was a stealth ship. "That meant,"
Clyne says, "that it had a kind of black-ops military
feel." The most obvious manifestation of this was
that the *Vengeance* was almost completely black.
And since space is also black this presented the
team with a challenge: how would people be able
to see it?

"Actually," Chambliss responds, "that was one
of its best qualities. A black ship in black space
becomes all about reflection, doesn't it? There's
no problem in picking out a shape in that way,
and there is visual excitement in the conceal, then
reveal of the light play. Think about this in another
context: does anyone ever have a hard time
seeing Batman at night?"

BLACK ON BLACK
Nevertheless, a considerable amount of effort
went into thinking about exactly how the
Vengeance would be made visible. As Goodson
recalls, the team started by talking about the
different approaches they could take. "Ron talked
a lot of 'what ifs' and tried to get a handle on
what it meant to have a black ship in space. Does
it disappear into the background? Does it have a

mirror finish that reflects the background?"

Eventually ILM decided to take their inspiration
from the modern stealth bomber. As Goodson
explains, this isn't the black color it might appear
to be. "If you see the stealth bomber it's kind of
blue and black and there doesn't appear to be a
great deal of surface detail. But someone took this
black-and-white photograph of it with the sun
coming across it, and it is amazing all the things
you can see that are different. It's because there
are subtle sheen differences, there are different
textures, and things are painted different. When
the light comes across it, you read that detail."

DARKNESS REVEALED
ILM took the same approach to the *Vengeance*
– instead of painting it a single color they created
a variation of the Aztec pattern on the *Enterprise*
and covered the ship in it. They then went in and
gave the different panels different levels of
specularity (reflectiveness). This means that how
the *Vengeance* looks very much depends on what
kind of light you are throwing on it. In some lights,
it might seem almost invisible but in others it
shows up very clearly and the Aztec pattern

VENGEANCE Bridge Design

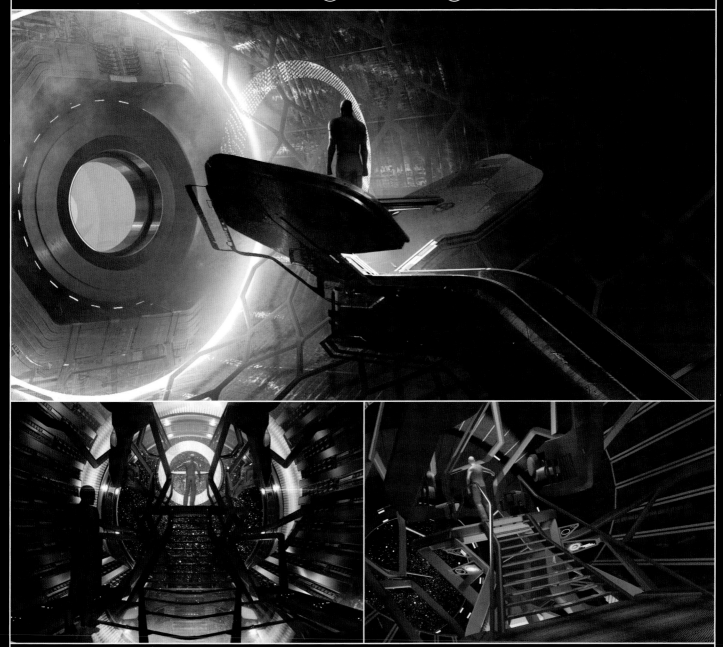

According to James Clyne, one of the best things about Scott Chambliss "is that early on, he has no inhibitions about what something should or shouldn't be." There was nowhere this had a greater effect than in the design of the *Vengeance*'s bridge. "Originally," Chambliss explains. "I wanted it to look and operate in a very new way from anything we'd seen before. We developed three or four different approaches before JJ decided he wanted to stay pretty close to

the *Enterprise* bridge sensibilities."

Clyne goes on to explain that at one point they had planned to completely abandon the conventional bridge layout, "Some of the early ideas involved the ship being on multiple levels – you could see several floors up and several floors down. It was an open space rather than the confined cylindrical room that we're so accustomed to. It was more of a spider webbing of a structure."

But ultimately, Abrams decided that

since the *Vengeance* was a dark reflection of the *Enterprise,* its bridge should be too. So Chambliss had art director Kasra Farahani work out how to convert the *Enterprise* bridge. "We made some clever design choices to help disguise the *Enterprise*, which in the end seemed quite successful. My only regret is that we didn't see more of this set on film."

Chambliss adds that no work is ever wasted, though. "I changed my attitude before returning to the Starfleet world!"

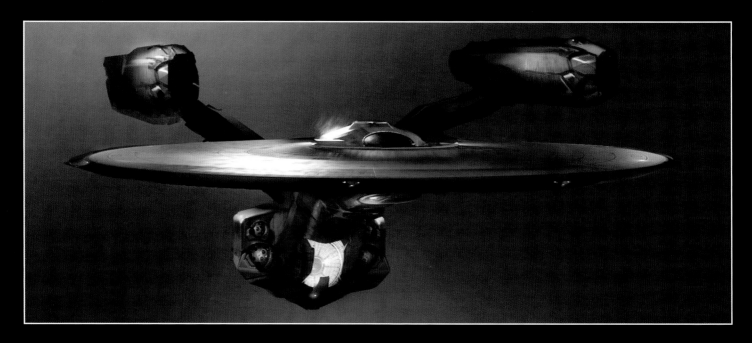

looks as if it has a very high contrast.

"There is color variation in it, but it's not tremendous," Goodson reveals. "Mostly what you're going to read are the specular changes. There's kind of a silverish streak that might be 70 per cent reflective and then a black area that's 40 per cent reflective. That gives you that reflection sheen difference and that is the thing that shows up."

The Vengeance's stealth technology didn't end with the paint finish. As Holcomb explains, the

ship's surface was designed to reflect scanners. "The idea was that if they were shooting some kind of scanning beam at it then it would bounce off the plate work. We wanted to make it so there were no real areas that any kind of scanning beam wouldn't bounce off. It always had to be a 45 or a 90-degree angle or it was completely flat."

The team was also aware that years of STAR TREK lore had established that ships emit all kinds of radiation that can be detected by enemy technology. "There was the question of how it

▲▼ At Abrams' request, the art department closed up the front of the saucer, making the Vengeance look more like a conventional Starfleet vessel. Clyne points out that in his artwork, the ship was almost always shown against a black background – Abrams had asked for a black ship, and making it visible was always an issue.

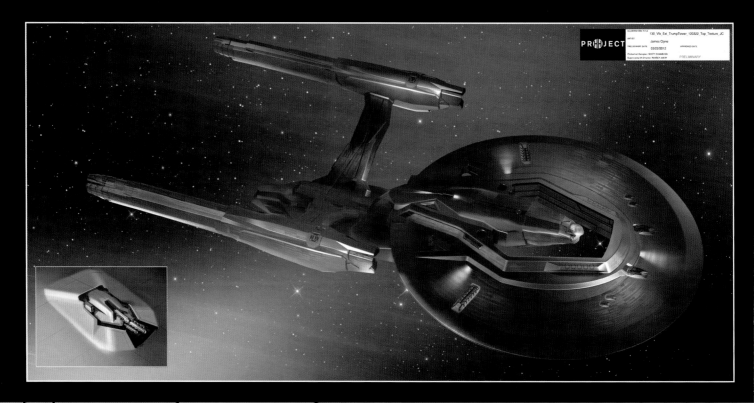

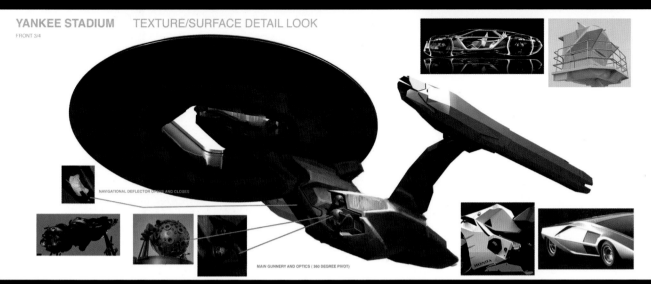

YANKEE STADIUM TEXTURE/SURFACE DETAIL LOOK

FRONT 3/4

NAVIGATIONAL DEFLECTOR OPENS AND CLOSES

MAIN GUNNERY AND OPTICS (360 DEGREE PIVOT)

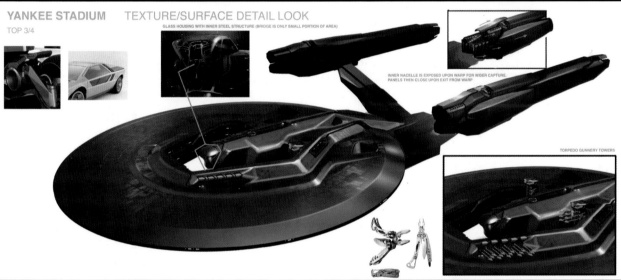

YANKEE STADIUM TEXTURE/SURFACE DETAIL LOOK

TOP 3/4

GLASS HOUSING WITH INNER STEEL STRUCTURE (BRIDGE IS ONLY SMALL PORTION OF AREA)

INNER NACELLE IS EXPOSED UPON WARP FOR WIDER CAPTURE.
PANELS THEN CLOSE UPON EXIT FROM WARP

TORPEDO GUNNERY TOWERS

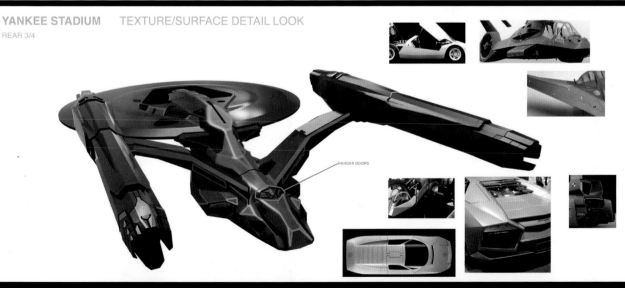

YANKEE STADIUM TEXTURE/SURFACE DETAIL LOOK

REAR 3/4

HANGAR DOORS

▲ Although Clyne and Kadonaga produced their own CG model of the *Vengeance,* the final, detailed version was left to ILM. When the art department started to work with ILM they provided a series of sheets that showed the design inspiration, in particular, the detailing on Lamborghinis, and some of the features such as multiple photon torpedo launchers that they planned to include.

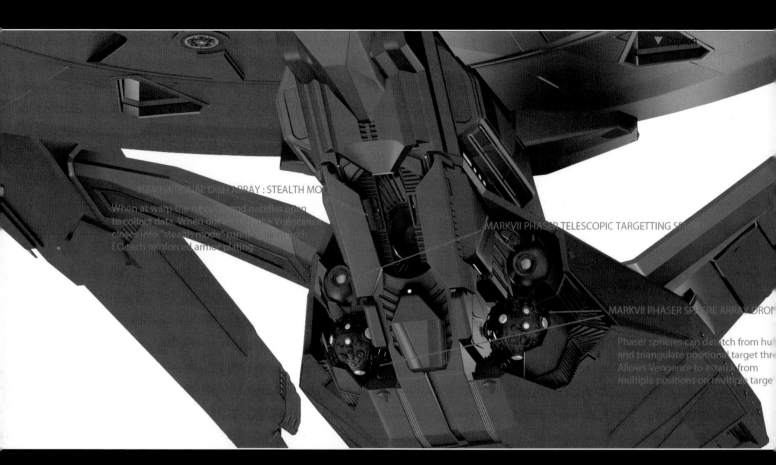

▼ Caption

NAVIGATIONAL DISH ARRAY : STEALTH MODE
When at warp the navigation and nacelles open
to collect data. When out of warp the Vengeance
closes into "stealth mode" turning silent with
1.0 inch reinforced armor plating.

MARKVII PHASER TELESCOPIC TARGETTING SPHERES

MARKVII PHASER SPHERE ARRAY DRONE
Phaser spheres can detatch from hull
and triangulate positional target through
Allows Vengence to attack from
multiple positions on multiple targets

▲ ILM devoted a lot of effort to designing the *Vengeance*'s weapons systems and to working out how it would hide itself from other ships.

would hide itself navigating through space," Clyne says. They decided that the ship needed a way of shielding as many different sources of energy as possible.

As Holcomb explains, "We came up with this great idea that when the ship was at warp, the nacelle covers were open and the navigational dish was exposed, but when the ship dropped out of warp everything would close up."

"Some of the ideas," Clyne continues, "spawned from movies like *Das Boot* or *The Hunt*

for Red October – these big, military-class submarines had all these really fancy tricky and fun ways of hiding themselves."

UNSEEN WEAPONRY
It was also a given, Clyne says, that the *Vengeance* would be heavily armed. "Obviously guns were an important part of it from an early stage! JJ wanted to see various ideas of weaponry. But it being a very large ship, I didn't want some massive 700m-long gun on it. I wanted

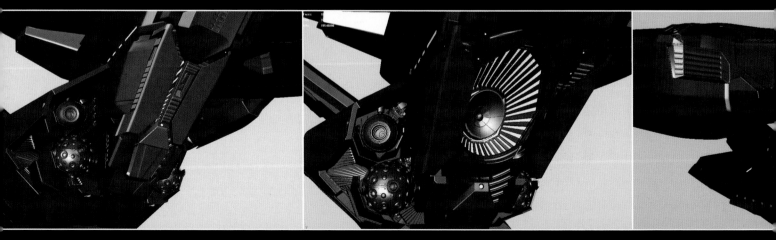

▲ One of the ideas that ILM developed was that the *Vengeance* would have to hide itself when it wasn't travelling at warp. One concept they developed with Clyne was that the navigational deflector would be covered up when it wasn't needed, reducing the emissions an enemy could detect.

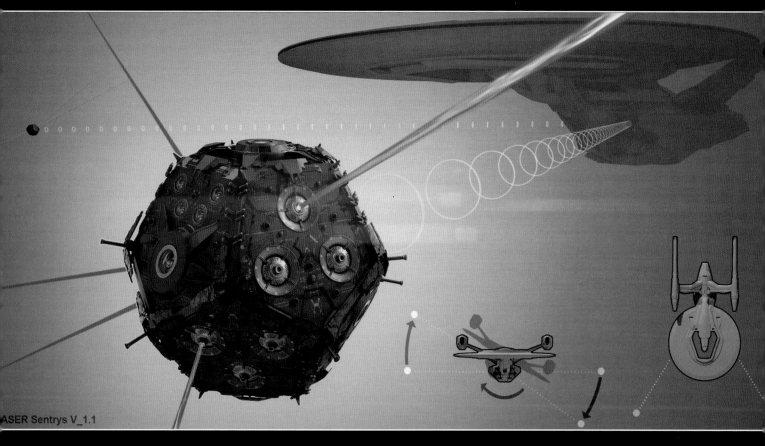

ASER Sentrys V_1.1

to keep it all tucked away and more stealthy. My thinking was that stuff like that would pop out in a surprising way."

PHASER BALLS OF DEATH!

Most of the work on the weaponry was done at ILM and Holcomb admits they may have gone a little too far. "You never got to see the ship long enough for it to show off some of the cool things that we came up with!" Specifically, Holcomb's team designed several weapons systems that either didn't make it into the movie, or appear so fleetingly that you would be hard pressed to know they were there at all.

"We designed eight to 12 different kinds of weapon systems," Holcomb laughs. "One of the coolest things were these phaser balls. There were spheres on the side of the navigational dish that were always part of the concept drawings. We dreamt up this idea that they were phaser drones that could detach from the ship. You'd have the main ship and then you'd have these two balls

▲ One of Holcomb's favorite weapons systems were a pair of phaser drones that were designed to detach themselves from the front of the ship and attack an enemy before returning. One of them makes a fleeting appearance, but they were barely seen.

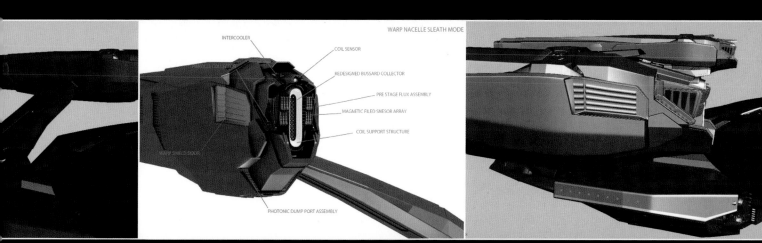

WARP NACELLE SLEATH MODE

INTERCOOLER
COIL SENSOR
REDESIGNED BUSSARD COLLECTOR
PRE STAGE FLUX ASSEMBLY
MAGNETIC FILED SNESOR ARRAY
COIL SUPPORT STRUCTURE
PHOTONIC DUMP PORT ASSEMBLY

▲ ILM and Clyne also provided the nacelles with cowlings that would conceal their energy when it wasn't needed. In this case, the idea was that the front of the nacelle, which housed the Bussard collectors, would open up when the ship needed to travel faster than light speeds.

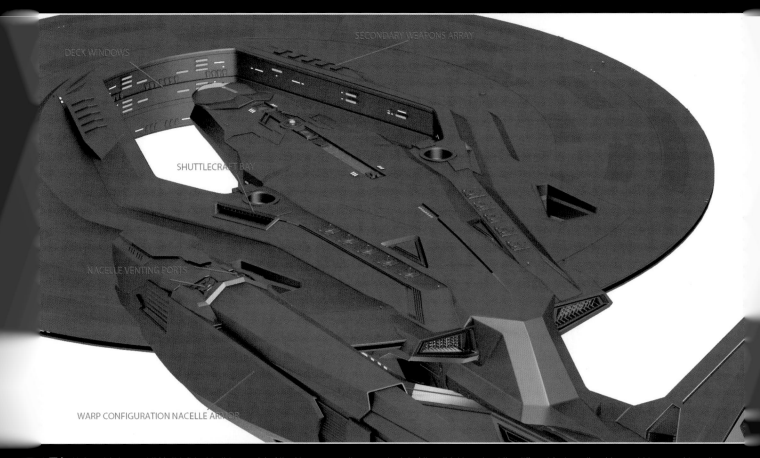

DECK WINDOWS

SECONDARY WEAPONS ARRAY

SHUTTLECRAFT BAY

NACELLE VENTING PORTS

WARP CONFIGURATION NACELLE ARMOR

▲ ▼ ▶ Holcomb's team at ILM didn't just build a model of the *Vengeance* – they spent a lot of time thinking about the different features the ship would have and how they would work. As part of their work, they produced a series of annotated renders picking out various features.

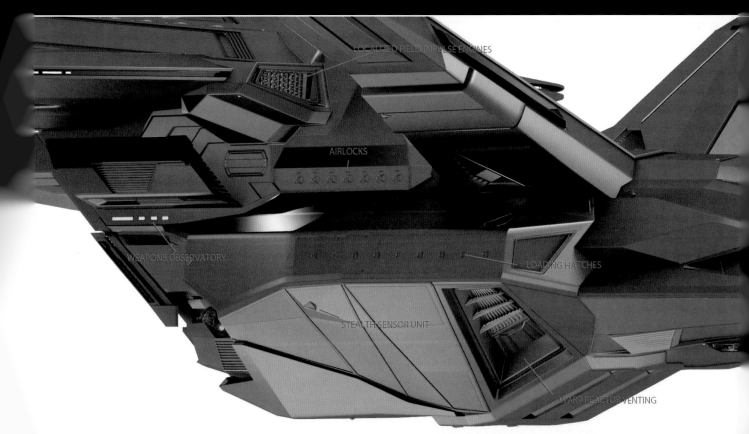

LOCALIZED FIELD IMPULSE ENGINES

AIRLOCKS

WEAPONS OBSERVATORY

LOADING HATCHES

STEALTH SENSOR UNIT

WARP REACTOR VENTING

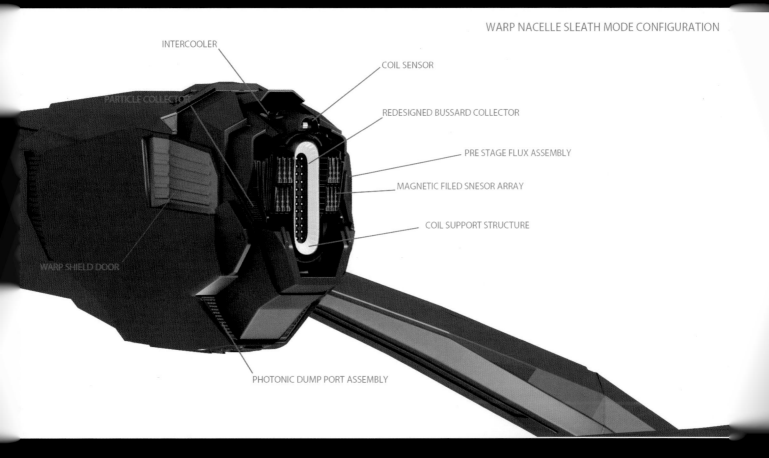

INTERCOOLER

COIL SENSOR

REDESIGNED BUSSARD COLLECTOR

PRE STAGE FLUX ASSEMBLY

MAGNETIC FILED SNESOR ARRAY

COIL SUPPORT STRUCTURE

PARTICLE COLLECTOR

WARP SHIELD DOOR

PHOTONIC DUMP PORT ASSEMBLY

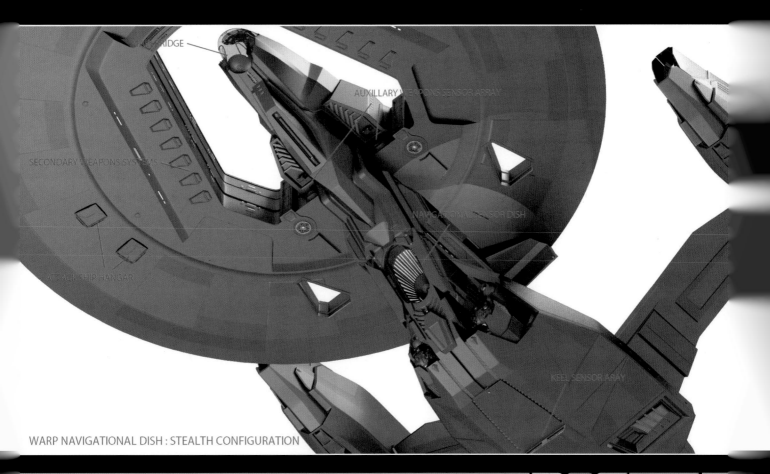

RIDGE

AUXILLARY WEAPONS SENSOR ARRAY

SECONDARY WEAPONS SYSTEMS

NAVIGATIONAL SENSOR DISH

ATTACK SHIP HANGAR

KEEL SENSOR ARRAY

WARP NAVIGATIONAL DISH : STEALTH CONFIGURATION

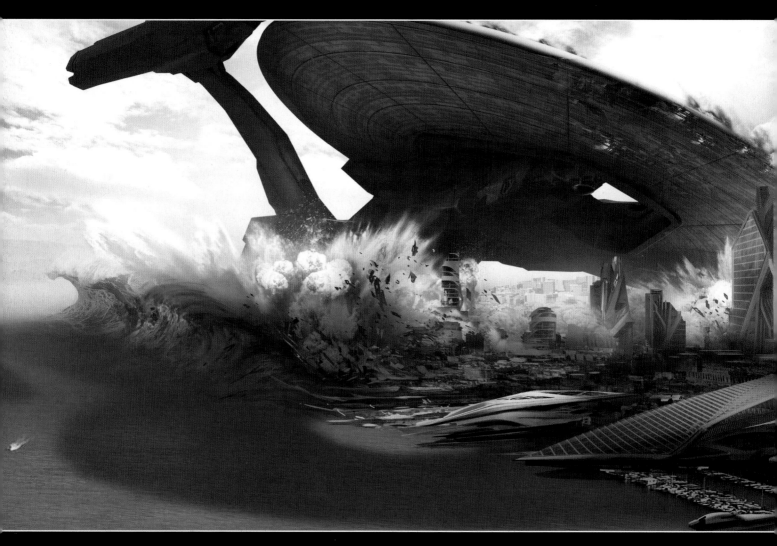

▲ As Clyne's concept artwork shows, the *Vengeance* was always destined to meet its end crashing into San Francisco. As part of the sequence ILM had it crashing into Alcatraz as a nod to one of JJ Abrams' TV series.

flying around triangulating their fire on the *Enterprise* from three different directions. We thought that was really cool. But that never came to pass. We did use them, but you never knew what it was! There's this one ball that does go flying past the *Enterprise* and fires a torpedo at it. We called them the drone phaser balls of death!"

The *Vengeance* also had massive rail guns that dropped down from the underside. "The rail guns are really neat. One of the biggest conversations we had were to do with these things called arcing phasers where you could see the beam bending. Originally the reason why they were arcing is they were fired at warp. Of course, when you're at warp you're traveling faster than light. These phasers could even travel faster than that and that's why you got this kind of bending and warping effect. It was this gag that JJ liked visually so we kept it even when we weren't at warp.

"Then we had these solid projectile weapons we never got to use. They were these big spinning disc

things that were shot by the rail gun. They didn't have any energy and the idea was that they would go straight through the ship without having to deal with any kind of electromagnetic shielding. And we had the neutron torpedo that when you launched it, it would launch all these other torpedoes as well."

But in the end most of these ideas were left on ILM's computer screens and never made it to the movie theater. Despite Holcomb's enthusiasm the *Vengeance*'s battle with the *Enterprise* is actually relatively short. "I remember being told quite a few times, 'Bruce, the movie's not about this ship! We're not going to see it that much' and then they blew it up, which was really sad!"

MASSIVE SHIP, MASSIVE CRASH

To be more accurate, Abrams crashed the *Vengeance* into San Francisco and this influenced how big it was. Abrams had always said that he wanted the *Vengeance* to dwarf the *Enterprise*,

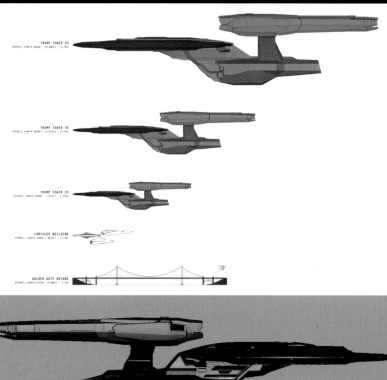

but how much bigger would it actually be?

"We did some different variations showing here's our *Enterprise* and here's the *Vengeance*," Clyne remembers. "Here's two times, three times, we even went up to eight times which was miles long."

"Initially when it came to us," Holcomb recalls, "it was around 4,000 feet long. I got this image where it was the size of the entire Golden Gate bridge! We had to reduce that. We put it nose to nose with the *Enterprise* and it was just so big that we reduced it down to just double the size of the *Enterprise*. When we had it at a little bit less than 4,000 feet it became super expensive to crash it into San Francisco, just because of the amount of stuff that we crashed it into."

Even after it had crashed, the story of the *Vengeance* wasn't over. As Goodson explains, it's one thing to paint a ship to be seen in space from a distance, but another when you see it in broad daylight on the surface of a planet. "Right towards the end we had the shots where the ship has

crashed and Khan has to jump out of the viewscreen. That hull was just painted the generic texture and it wasn't good enough."

Fortunately, Goodson had visited the East Coast that Christmas. He had found himself with a 30-minute window and had taken the chance to visit the Space Shuttle Discovery at Dulles Airport. "I'd gone in and got some great pictures. I was fascinated with the level of surface texture – it's got thermal blankets, and tiles and scorching and just all kinds of detail."

So six weeks later, when they needed to paint the hull around the viewscreen, he was able to take those images and map them into the surface of the ruined ship linking Abrams' blackship with a very real 20th-century space craft.

The *Vengeance* had emerged from the darkness to end up broken and battered in the San Francisco bay, but it ushered in a new era for *STAR TREK*, and left a seasoned Captain Kirk ready to start his first five-year mission.

▲ The size of the *Vengeance* was in flux for a long time with the art department suggesting that it could be as much as eight times longer than the *Enterprise*. The final agreed scale pegs it as twice the length of Captain Kirk's ship.

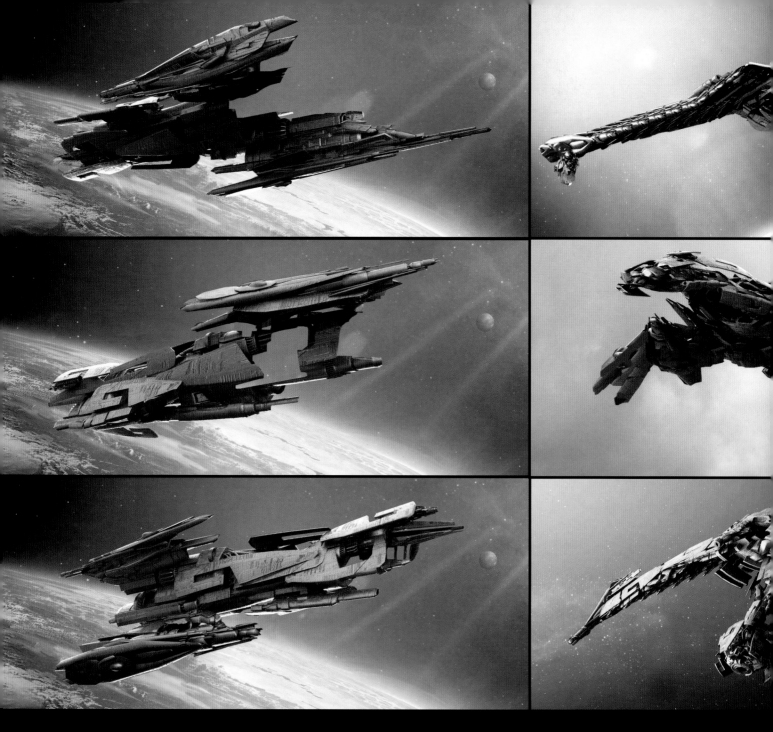

DESIGNING THE
D4 BIRD-OF-PREY

STAR TREK's new Klingon fighter had a long journey before becoming the most hawk-like of all the birds-of-prey...

he JJ Abrams *STAR TREK* movies have always been about reinvention, about taking the franchise's most familiar elements and updating it without losing its essence. So it was almost inevitable that the Klingons would play a

major role in *STAR TREK INTO DARKNESS,* and when it came to their ships, as with everything, the question was always how much to keep and how much to change. The final ship would be designed by James Clyne, but along the way the art

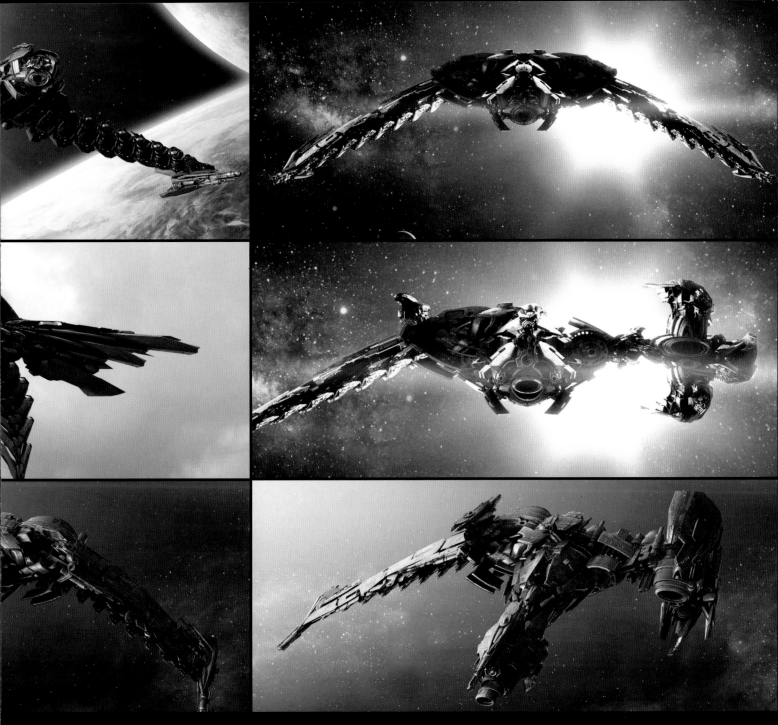

department explored some very different ideas. "It went through a lot of different iterations with a couple of other artists," Clyne recalls. "What I love about (production designer) Scott (Chambliss) is that he's always trying to think outside of the box. I think he was trying to do something that's not exactly what we're all used to with the Klingon stuff. He wanted something a little unconventional, asymmetrical."

The first designs Chambliss asked for were created by Harald Belker and are unlike anything we had ever seen before – strange, three-towered ships with no obvious means of propulsion. In fact,

they were so strange that when Belker left, the team decided to roll back and try something slightly more familiar.

The next set of designs were worked up by Steve Messing, who began by returning to the familiar shape of Nilo Rodis's classic bird-of-prey design. "As the process went on," Clyne remembers, "they kind of cut it apart. They were exploring different ways of looking at it. Does it have to be so symmetrical? Can you remove a wing and add something else? Remove all of the Klingon elements."

This lead to a series of designs that became

▲ Steven Messing's designs for the Klingon ships started out relatively conventional and include versions that are clearly related to the traditional bird-of-prey, but they also included radical departures that altered or cut out the most familiar elements.

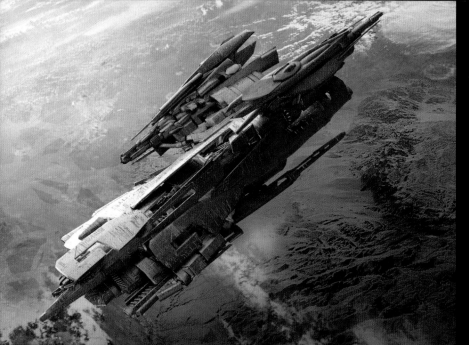

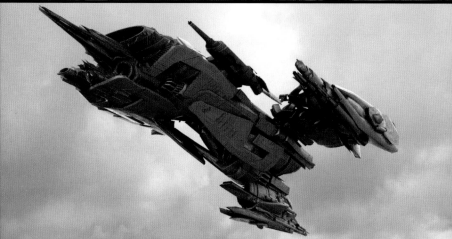

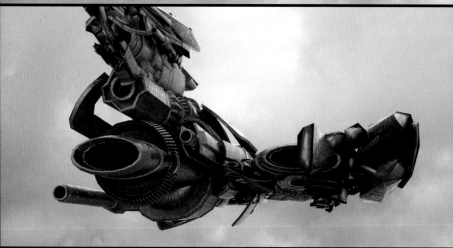

increasingly abstract. In some, one of the wings is rolled up to form a massive weapon, but in others the familiar bird shapes have all been cut down so much that they are barely recognizable.

Until this point, there had been plenty of time to play around with the design, but creating the sequence that featured the ships would take months and it started to become important to have a finished design. As VFX supervisor Ben Grossmann says, "We had so many big heavy shots that it was in, so if you don't have a complete Klingon fighter then you're having a bad day."

By this point, the art department was smaller and the design was passed on to Clyne. "It fell into my lap because I was one of the last men standing. I was simply still there!"

LOOKING FOR DIRECTION

Clyne's first designs were a variation of Messing's final cut-down ship and he describes them as being more like a sculpture, rather than a ship. They were still a long way away from the final design. Clyne thinks that one of the reasons the design wasn't quickly coming into focus was that it wasn't entirely clear what the ships were going to do. The only thing they were certain of was that it had to emit a pattern of lights. The production team were already filming the sequence where Kirk and Khan fight the Klingons on the surface of Qo'noS, and they had developed an interesting lighting rig that shone on the actors. "It was kind of an array of three or four lights. It could have separate little beams of light that could be used to search the ground and almost kind of create a vector of a location.

"Roger Guyett, the visual effects supervisor (and second unit director), needed an exact location on the ship that these lights were coming from. It was almost like we were doing things in reverse – designing the ship around the lights. There was a whole question about how this thing lit up. I came up with different patterns; there was like a searching, or a mapping of the ground."

In order to find a design that he liked, Abrams

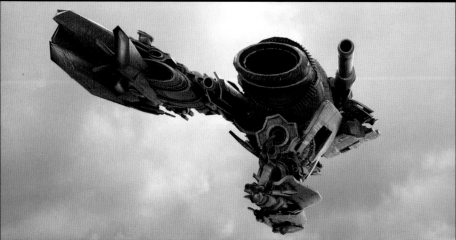

◀ In Messing's final designs all the recognizable shapes had been cut away to leave a core with the only slightest suggestion of traditional wings. This was where the design was when Messing left and the task was handed on to James Clyne.

HARALD BELKER: THE FIRST DESIGNS

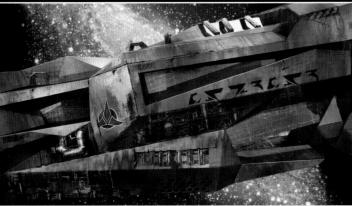

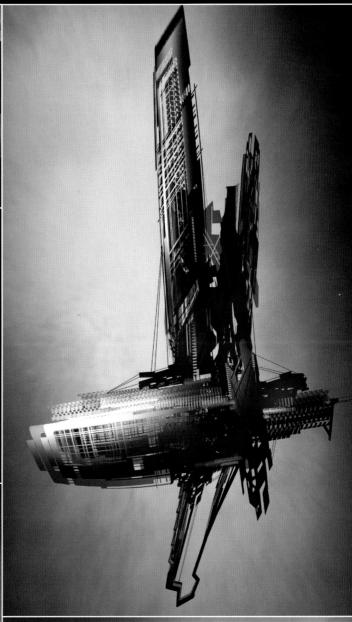

The very first designs for the Klingon ships were done by Harald Belker. "It started out," he says, "as a great challenge. There was great potential there to do something very different but true to the history of Klingon ships. The premise given by Scott was cool, that he wanted to explore a very deconstructed way of Klingon architecture and have that reflected in the ship as well. He told me that he wanted three towers in an arbitrary angle so I went off and rendered endless versions of it." But as he worked, Belker always felt that there was a problem with this approach. "It might be cool as a stationary object but flying around... to design a spaceship you need direction, symmetry, propulsion." The designs were eventually abandoned at a point when, Belker says, the Klingons were temporarily written out of the film. Belker left the art department around the same time and the baton was passed to Steven Messing.

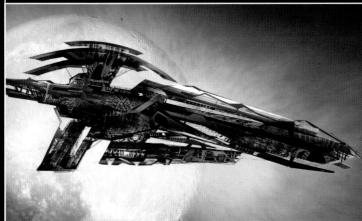

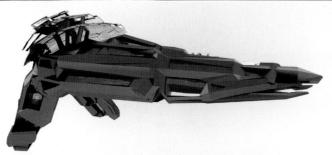

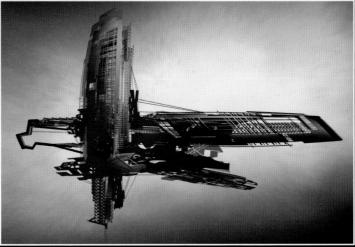

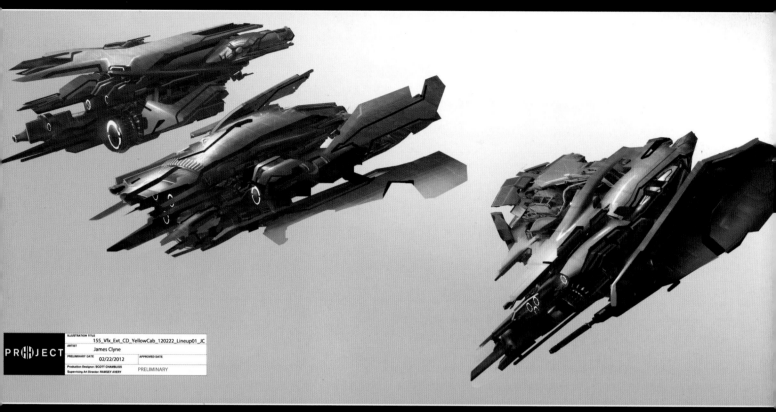

ILLUSTRATION TITLE
155_Vfx_Ext_CD_YellowCab_120222_Lineup01_JC
ARTIST
James Clyne
PRELIMINARY DATE
02/22/2012
APPROVED DATE

PROJECT
Production Designer: SCOTT CHAMBLISS
Supervising Art Director: RAMSEY AVERY
PRELIMINARY

▲▼ Clyne's first pass at the Klingon ship was a variation on Messing's design and he describes it as being very abstract, almost like a sculpture.

needed a clearer vision of exactly what the ship would do on screen. "For JJ," Clyne says, "it's about what is the scene, what's happening in that moment. Then you kind of design for that moment, not the other way around. But as you can see, Steve was using different backgrounds for the ship – it's in space or in a different world. That's because I think we didn't really have that scene laid down in concrete just yet. We were still

designing the world it lived in."

Things fell into place when Clyne finally came up with a look for the ruined surface of the Klingon planet. "The fun part about that was I built a very simple CG model. It was this kind of ornate lattice work of architecture. Scott thought it was cool and he said 'Go down to set where JJ's shooting'. I was able to have a couple of minutes with JJ with my laptop. I let him fly through this dumb model.

ILLUSTRATION TITLE
155_Vfx_Ext_CD_YellowCab_120224_Lightsource01_JC
ARTIST
James Clyne
PRELIMINARY DATE
02/24/2012
APPROVED DATE

PROJECT
Production Designer: SCOTT CHAMBLISS
Supervising Art Director: RAMSEY AVERY
PRELIMINARY

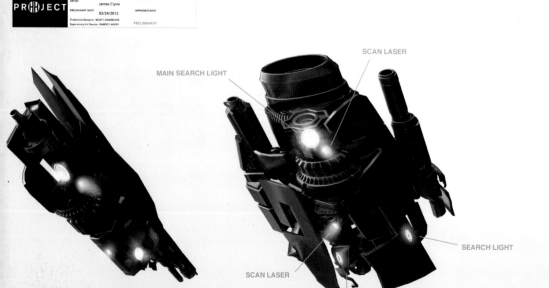

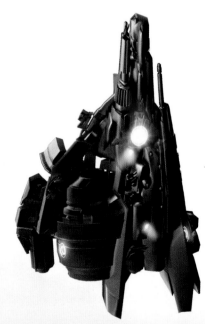

MAIN SEARCH LIGHT

SCAN LASER

SEARCH LIGHT

SCAN LASER

PIERRE DROLET: A FAMILIAR IDEA

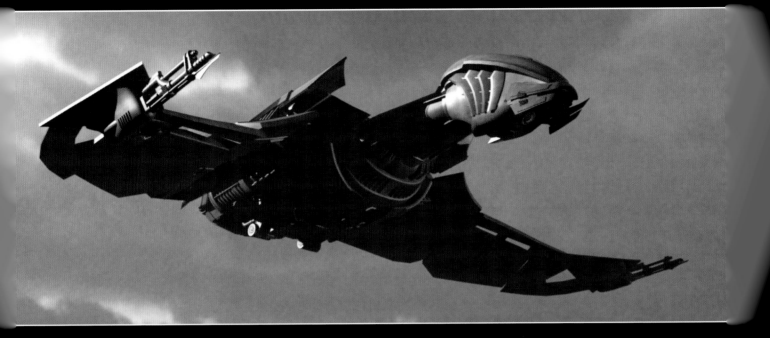

Although the *STAR TREK INTO DARKNESS* art department was designing the Klingon ship, the visual effects house that built it, Pixomondo, also took a pass at the design. The look hadn't been finalized and they realized that one of the people working for them, Pierre Drolet, was a veteran of the *STAR TREK: VOYAGER* and *ENTERPRISE* CG departments. They asked Drolet to see what he could come up with. Drolet's approach had much more in

common with Rodis' original design. He had only just started to block it out when Clyne's final design was approved so it was abandoned before he even completed it. "It was just a shape," Drolet remembers, "the front was not done. I knew where I was going with it, but I never got the chance."

"Pierre had done some great designs that were much more grounded in the original canon," Grossmann remembers.

"That was a good exercise to see what someone who has had more experience in the Klingon world would do. We asked him to take another fork on that branch so to speak."

Drolet left Pixomondo shortly afterward but he had enjoyed starting the design and a year or so later he decided to finish it off in his own time. The final version can be seen on his website, www.pierre-drolet-sci-fi-museum.com.

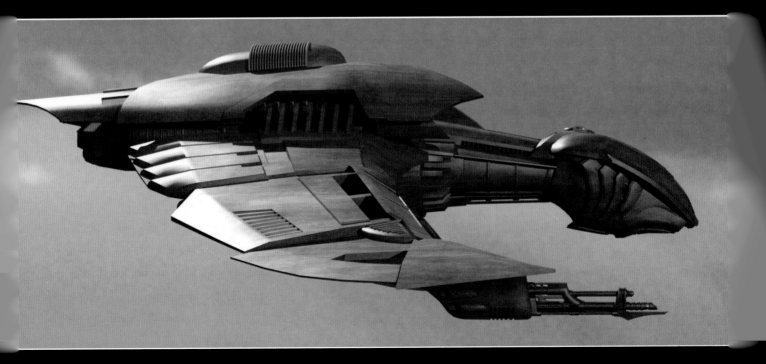

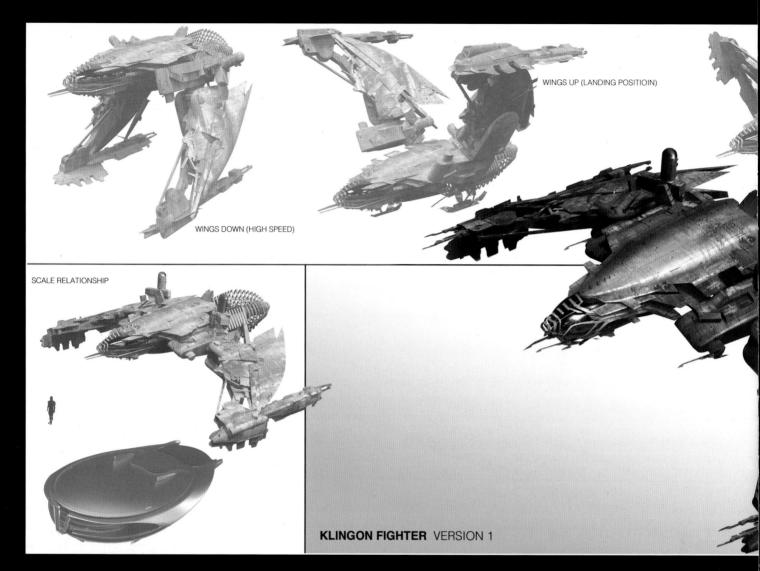

WINGS UP (LANDING POSITIOIN)

WINGS DOWN (HIGH SPEED)

SCALE RELATIONSHIP

KLINGON FIGHTER VERSION 1

▼ Clyne knew that the Klingon ship would emit lights that would have to match up with a lighting rig that had been installed on the soundstage. The idea was that the lights would become a kind of scanner and he worked up several different looks.

It wasn't even really textured much, it was just a hodgepodge, but it created a fun environment for the sequence. JJ responded to that idea and thought it would be really fun to fly through. I'm sure the script called for this exciting dogfight, but we had no context for it until I kind of came up with this very simple lattice work structure."

And for Abrams this clarified what he need.

Since the Klingon fighter would be moving at high speed, dodging through buildings and canyons, the silhouette had to be instantly recognizable as a traditional Klingon ship.

KITBASHING IN CG

Clyne returned to the drawing board or, more accurately, his computer and started to design a

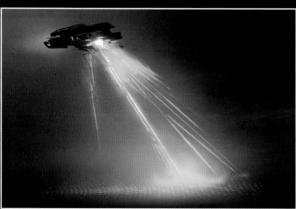

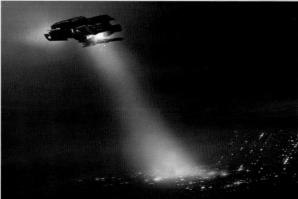

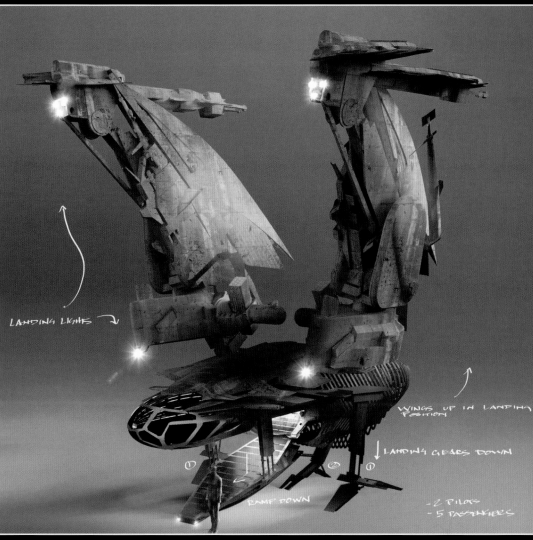

HOVER MODE

LANDING LIGHTS ↓

LANDING GEARS DOWN

WINGS UP IN LANDING POSITION

RAMP DOWN

- 2 PILOTS
- 5 PASSENGERS

▲ Clyne's final approved concept sketch, which was given to Pixomondo, was made by mashing several different elements together in 3D software. The design included suggestions for how the ship could land and the wings would move.

new take on the bird-of-prey, but he didn't work with conventional drawing tools. Instead, he "kitbashed" the design in much the same way traditional model makers had done on *2001* or *Star Wars,* only instead of using physical parts he used CG ones. "It was an exploration. In that kind of mental state you're not thinking about every shape or form, you're kind of just looking for something. I might have played with three or four of these models. I'd just kind of lay them out in my 3D package and I'd mix and match pieces. For example that kind of thorax – the bee shaped thing on the back – that is a Santiago Calatrava piece of architecture. I just threw that in there and it became something else. There are some pieces off of an aircraft carrier that was part of the body that I just squashed.

"I would have never thought of doing it that way had I sat and thought about it and sketched it. I would have probably come up with something

that made a little more sense! But because I was doing it this way, it gave the design a little more interest and uniqueness."

A REAL BIRD OF PREY

As he pushed pieces together, Clyne kept thinking about the idea of a real world bird of prey rather than slavishly following the established Klingon design. This lead him to alter the proportions and the way the ship moved. "They wanted the ship to be very maneuverable and I thought, 'The wing articulation on the original Klingon bird-of-prey just goes up and down. How can we up that articulation?' You could use those wings as a braking mechanism, or maybe they're independent of each other. They almost become more bird-like in their anatomy where they can shift their wings accordingly."

Of course, he was also careful to make sure that the new design still matched up with the

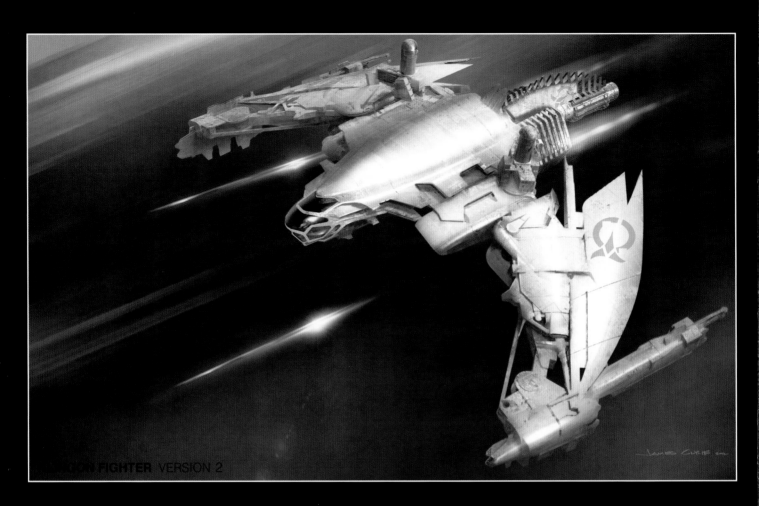

KLINGON FIGHTER VERSION 2

lighting rig that had been used on the stage.

Within a day and a half, Clyne had found a design that everyone was happy with. The next stage was to hand it over to Ben Grossmann and the team at Pixomondo. "The visual effects guys brought it to life," Clyne says. "They really made it real. I met with them a couple of times but when you have a good visual effects company like them, you really kind of trust they'll do the right thing and put in the time to make it work. They were able to spend time to refine a lot of the shapes and make sense of it all which was great."

HAWKS VS SPARROW

And, as Grossmann says, even though they had finally settled on a design, the Klingon fighter still had a long way to go. "We got James's concept but a concept is just a sketch. Enrico Damm, Patrick Schuler and Adam Watkins are the guys who put that thing together. We changed the way the thing flew. We changed the way the thing landed. We tweaked out lots of stuff but kept the basic broad strokes of the design the same."

Like Clyne, Grossmann and the Pixomondo team were driven by what the Klingon ships had to do. Most importantly, they knew that they would be involved in an exciting dogfight. "We designed them so we could create a chase sequence that was based on the idea of hawk and sparrow. You have a small sparrow that is rather defenseless, then you have these hawks that are larger. The sparrow is going to be weaving through this forest, dodging branches and trees to get out of the way of the hawk and avoid getting killed. You need the hawks to be maneuverable enough to keep the chase close and to make things scary."

FLIGHT SIMULATION

Clyne's concept had implied that the wings could move in several directions, and, as Grossmann explains, his team thought it was important that their movements were convincing and served a purpose. "We just kept adding more and more articulation to the way the body and the wings moved. At one point we went too far – the wings could rake forward, they could almost

▲ Once Clyne had established the basic look of the Klingon fighter, he produced a version showing it with subtly different details.

▶ The CG model of the ship that was used to create the sequences in the film was made at Pixomondo, where the team went to a lot of trouble to work out how a ship like this would operate in a planet's atmosphere.

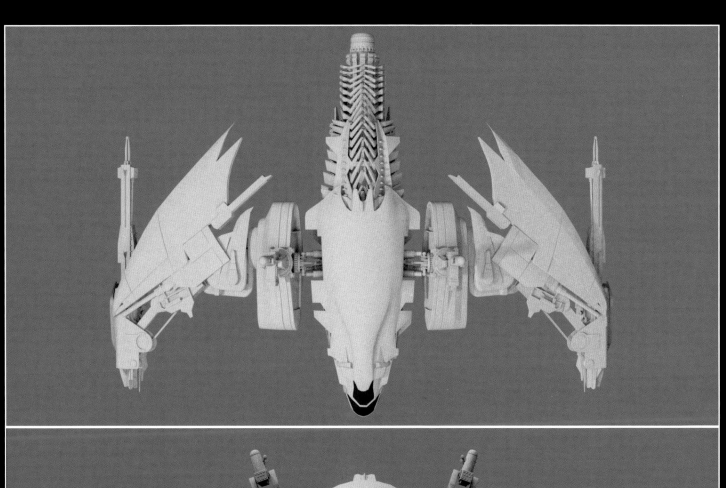

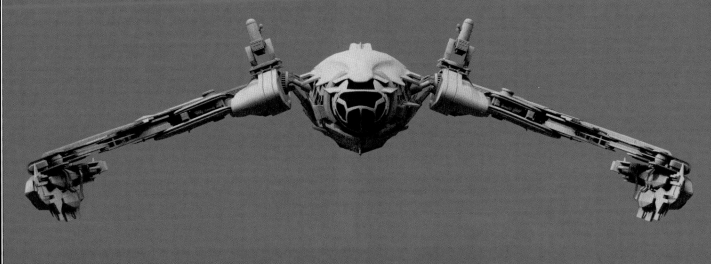

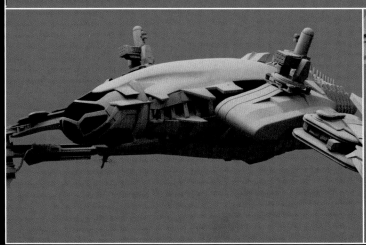

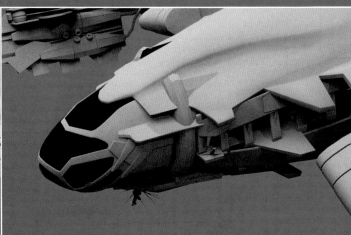

Wing Mechanism Intakes w/ cockpit flourishings

**Rib siding encasings so it feels
like you can see the interior guts
of the ships drive intakes.**

Side Pieces Combined

▲ Clyne's concept drawing established the basic look of the ship, but left plenty of room for interpretation and the team at Pixomondo spent a lot of time working out what the ship would look like in detail.

do a full 360 and they could move individually. "We ran simulations, to find out in what scenario you would want to have asymmetric movement. You can do it, but it makes the ship look like it's in trouble so that's how we decided to play it – when it gets hit then the wings move into asymmetric articulation, but if it's not getting clobbered, we just kept it symmetrical. The wingtips can move

forward if it's going into high speed mode."

The team also ran simulations looking at what kept the ship in the air and where the propulsion came from. "We worked a lot on the propulsion systems," Grossmann remembers. "JJ would always ask, 'How do these things fly?' Well, how does anything in *STAR TREK* fly? It's always tricky when you say, 'Do we have these ionic thrusters or do we have air propulsion?'

TOO REALISTIC

"We originally did major simulations of what the ships would look like if the wings were individually articulated and there was air thrust coming out of the bottom of them. The problem with that is that if you're doing thrust from the bottom of the wings, even in addition to the main tail engine, you want the wings to tip forward as you're flying. Then it moves more like a helicopter and less like a plane. In the end, we decided that the air thrusters weren't such a great visual element and it started to create too many confusing metaphors: how do the ships float all the time? We only turned on those retro thrusters in one shot when the ship is going to crash into the camera."

Grossmann recalls that Abrams was deeply

▶ Pixomondo didn't just want to make a ship that looked cool. They wanted to make it convincing and they devoted a lot of thought to the interior layout, even though it would never be seen.

RIBS EXPOSED

RIBS HIDDEN

JETPOD EXAMPLE

WING MECHANICS GO HERE

MOCKUP MODEL

HIND VIEW

involved and took great interest in every element of the design. "He got pretty granular with things. At one point we had too many accent lights – you have navigation lights, identification lights – so we turned that down. When we were looking at the landing mechanism, we decided that compositionally we didn't like the idea of them landing on their wingtips, which would make them very tall. So we folded the wings up into a V shape when they landed."

MORE KLINGONS

One of the biggest changes came about because of a decision Abrams made about the action involving the actors. Clyne's original design was for a two-man fighter but in order to add excitement to the fight on the ground, Abrams wanted teams of Klingon warriors to rappel out of the back of their ships. As Grossmann explains, that meant altering the proportions of the design to accommodate them and adding hatches to the underside so they could get out. "We had to fit those guys in there, so we made some adjustments to the body shape. It started to look like a blue whale, where it feels like it has a big belly and a small head. We did a lot of iterations on tweaking the body so it had more of a hawk's aerodynamics with a stronger head."

The team also worried about how the passengers would actually accomplish what Abrams wanted, but in this case Grossmann told them they'd have to accept that Klingons would tolerate things that humans would find impossible. "We had these shots of a fast moving fighter and we'd start to look at an x-ray view of the people sitting inside on benches to make sure that worked. These are the ports that are going to open. This is the rail system that their rappel lines are hooked on. I was like, 'Guys this is a shot about the outside of the ship flying around a corner and shooting. I appreciate that the guys inside are probably vomiting right now, but we have to do this!'"

REAL WORLD WEAPONS

As building the ship progressed, the Pixomondo team discovered something else that made them change the design. They hadn't realized that Clyne had developed his concept by using real world models, and that, as a result, the Klingon ship sported some very 21st century weaponry. "We

▼ Pixomondo's work went from big changes to tiny ones, including the exact amount of spacing that would be seen between the ribs of the 'thorax'.

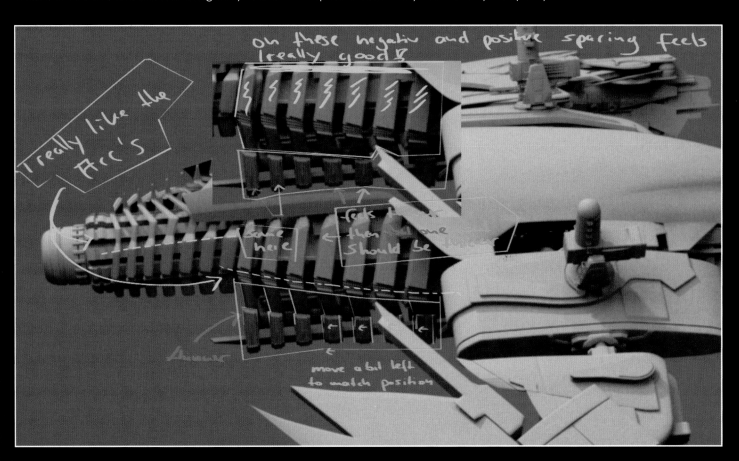

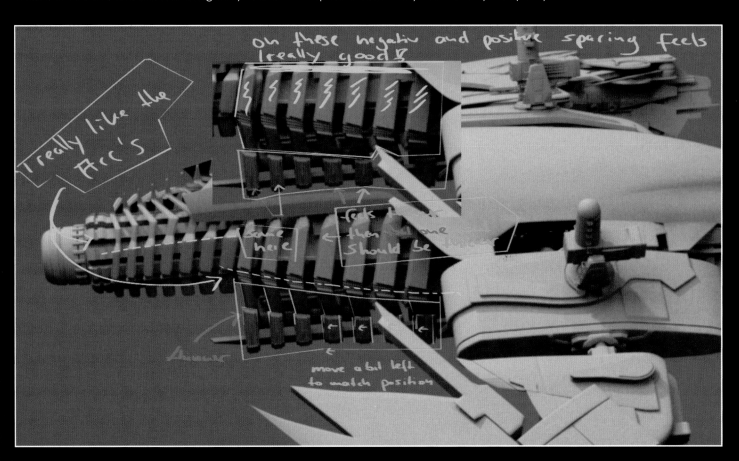

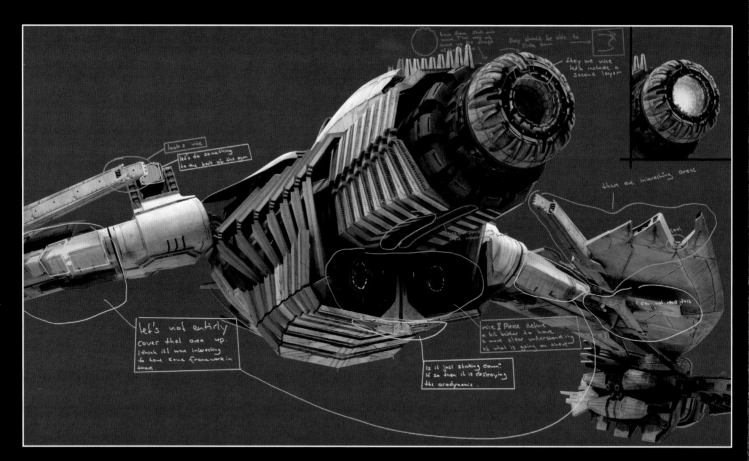

▲▼ As Pixomondo worked on the ship they filled in an enormous amount of detail that was missing from Clyne's original drawing, including the look of the engines, surface textures and how the wings would actually move in flight.

caught that late in the game," Grossmann laughs. "In James's concept the weapons on the wingtips were originally modeled after the Phalanx system on US navy ships. It's kind of like an R2-D2 droid-looking thing and it's designed to shoot down missiles with high rates of fire. That was the exact design of the device. As soon as we realized it, we changed all the guns on the ship."

The newly revised weapons were much more sophisticated than you might realize from watching the movie, since they involved an entirely new design of torpedo with a churning ball of lava at its heart that was carefully worked out in physics simulations. "We always called them photon torpedoes," Grossman says, "technically they're not because the scale of damage a photon

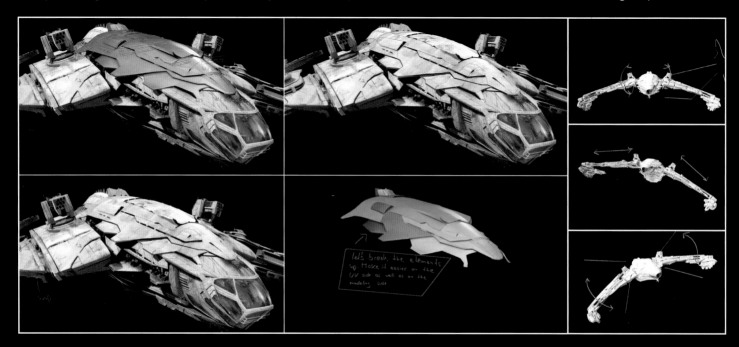

▲ **ANDREA DOPASO** Early on in the design process Andrea Dopaso produced a series of designs for the surface of the Klingon planet that were extremely alien and organic.

▲ **VICTOR MARTINEZ** The next round of designs were produced by Victor Martinez. They kept the idea that the planet's surface was unstable but pushed in a much more industrial direction.

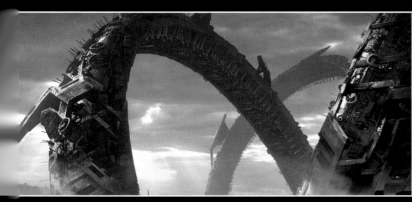

▲ **STEVEN MESSING** As well as taking his pass at the design of the ships, Messing came up with several concepts for the planet. If you look closely, you can see that some feature his early version of the Klingon fighter.

▲ **JAMES CLYNE** According to Clyne, the design of the Klingon ships only really fell into place once Abrams was confident about the kind of environment they'd be operating in.

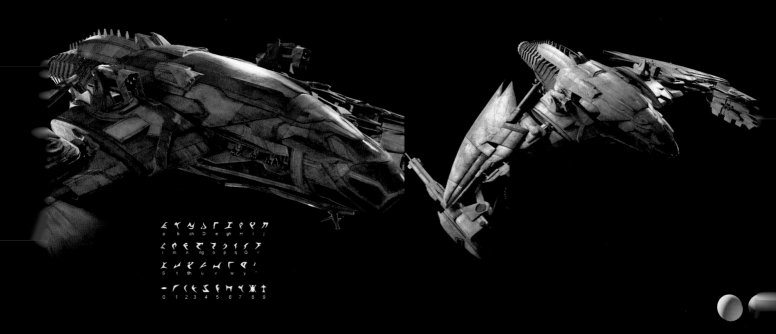

▲ This series of renders shows the surface textures that Pixomondo applied to the model from every angle.

torpedo would do on a planetary surface would be pretty ridiculous! That was the last design element that we did a lot of different iterations of. We did probably 30 or 40 different styles of what those torpedoes looked like. We went with green just to make things easier. We started out with a lot of traditional lens flare elements coming out of them. Then we took that out because JJ didn't want it.

"The effects department went in and built an entire physics system based around light rays. You had an unstable sphere, and that sphere was breaking and internally churning in on itself, kind of like it was a sphere of lava held together by a point of gravity in the center. Where two plates of the surface intersect it creates a blast of light that's escaping the point of gravity. They built this whole thing that was beautifully engineered, but in the end JJ felt it was too like the original look.

"So we did a few more iterations – should it be one projectile, should it be two? What if it was an atomic thing where it was photons and neutrons spinning around a core? In the end we decided that looked too crazy, so we simplified it down to three, and they were all spinning around a core. Then, of course once you did that you had to

▼ Because of the way that Clyne had built his model it included some real world details including a weapons system that was lifted from the US Navy, which had to be replaced at the last moment.

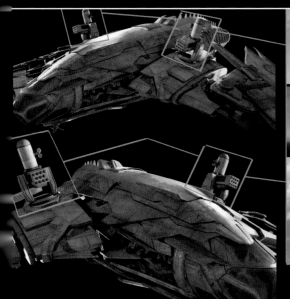

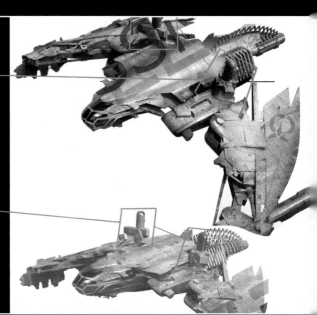

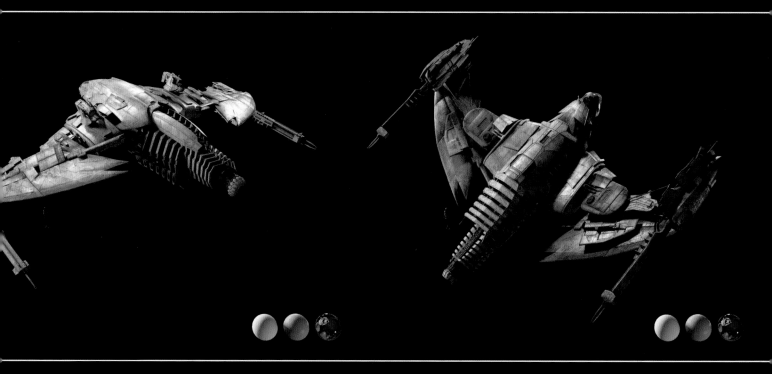

redesign the guns again so they had 3 barrels. They were all fluid simulated effects, dynamic renders emitting particles that were trailing vapors that were scaling down on themselves as they spun. It's amazing because in the movie you see them for something like 3 frames. We should have just painted them by hand!

Grossmann goes on to say that this kind of attention to detail was typical of the team's work on the Klingon fighter. "You really had to tear it out of their hands because any opportunity that the modeling team had to play with the Klingon fighters they would be back in there. I think originally it was supposed to take 30 days and in the end they spent nine months working on it!" The results though left everybody delighted and gave the Klingons a cool and deadly new weapon in their arsenal.

▼ The VFX team looked at renders of the model during the chase sequence to see where they should make final adjustments to the colors and textures.

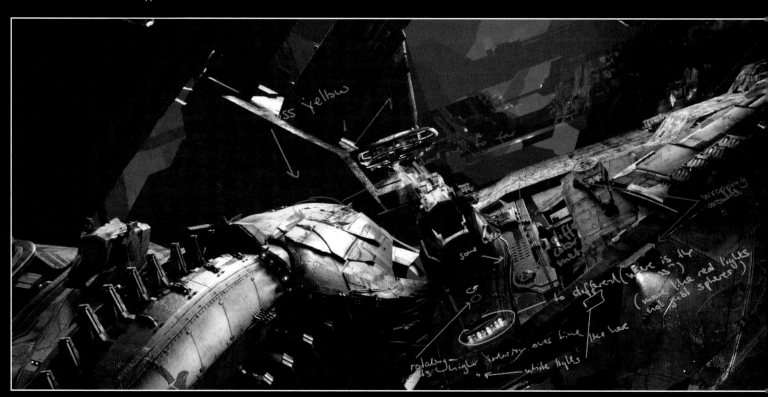

DESIGNING THE
FRANKLIN

STAR TREK BEYOND tore the Enterprise to pieces and gave Kirk
and his crew a primitive replacement: the *U.S.S. Franklin*.

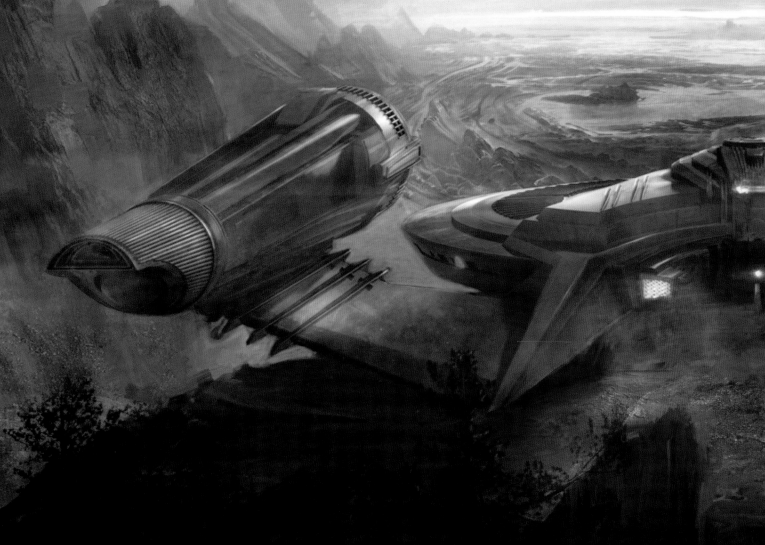

For Sean Hargreaves the design of a starship is always driven by the script. It's not just about making it look cool, you have to know whether it's going to land on a planet, or take a beating, or have massive doors so hundreds of people can board it. When it came to *STAR TREK BEYOND*, as is the case with many modern movies, the script was still evolving when the art department started work, and as a result the design of the *U.S.S. Franklin* evolved too.

"In the past," Hargreaves explains, "you'd have a script and it was pretty much what you would shoot. Now you get given a script and the script is almost like an outline for the story. Everyone agrees that is the story they want to do, but it's going to change."

Under the command of production designer Tom Sanders, the art department divided up the different things called for by the script. As the production's senior concept artist, Hargreaves was

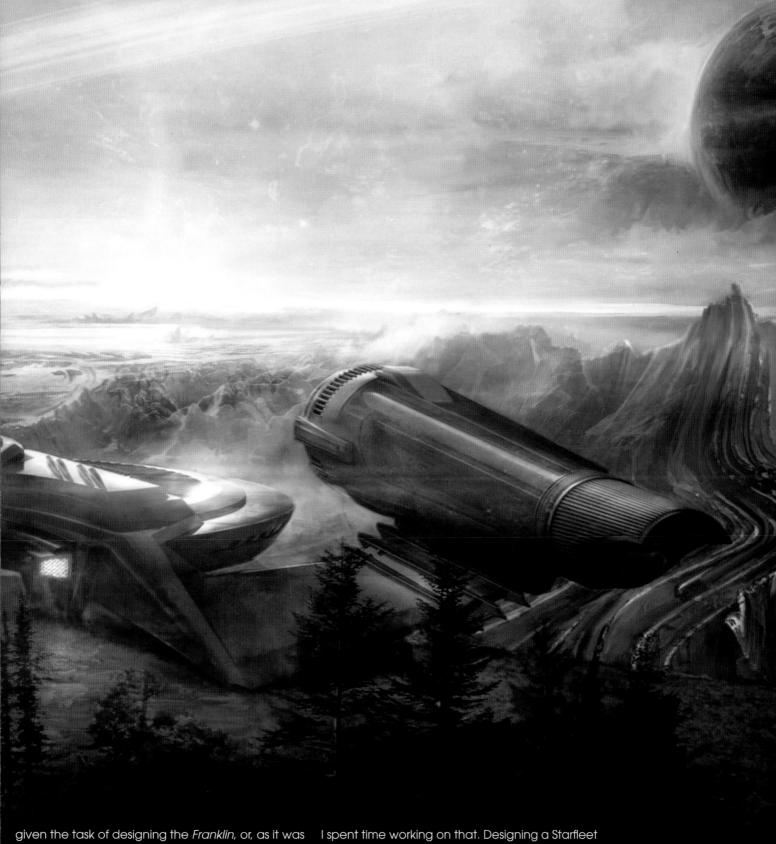

given the task of designing the *Franklin*, or, as it was then known, the *Pioneer*. In that early script it was a relatively small scout vessel that Scotty would find buried in the sand.

Hargreaves's starting point was that he was designing a Starfleet vessel, and, he explains this dictated his approach to the design. "I design in threes: What's the shape? What's the medium detail and what's the finer detail? Getting the shape right is always the most difficult thing, so

I spent time working on that. Designing a Starfleet ship's not that difficult – it's a saucer with a body, a neck, two pylons and two engines. That's the *Enterprise* and if you can take that and put it into configurations for other ships that's the *STAR TREK* world."

Hargreaves had watched *STAR TREK* when he was growing up in England in the 70s and had always been drawn to the simplicity of Matt Jefferies' designs. "The thing that I loved about

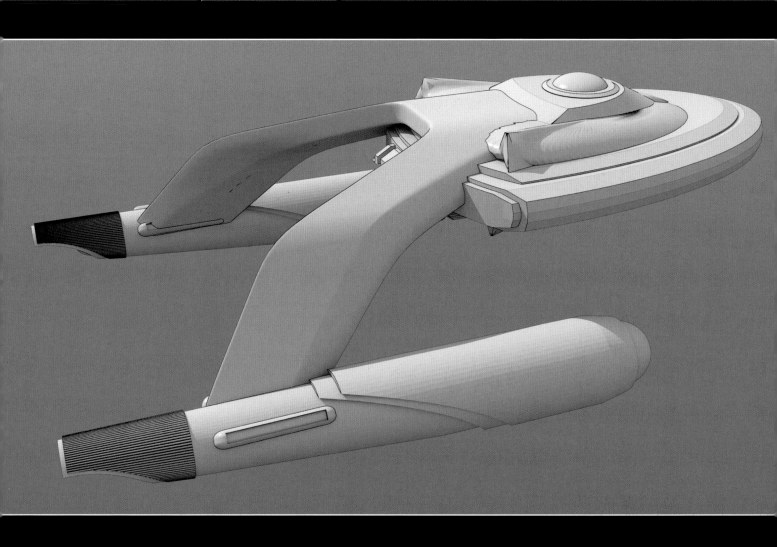

Jefferies' stuff," he says, "is he kept those things strictly apart. This is where the engines are, and this is where the engineering hull is, and these are the parts that join it together. That's why the *STAR TREK* ships look so different because that was his basic rule. And if you stay with that then you're going to have these ships that are really cool and different-looking."

FIRST THOUGHTS

With this in mind he started to sketch some initial ideas on paper before rapidly moving into 3D, where he could explore the shapes more thoroughly. "When you draw something you always think in 3D," he explains. "I always used to think 'I want to get my hand around the other side of this flat piece of paper.' 3D gives me that ."

Hargreaves produced a series of variations as he was looking for a shape that he liked. "It went through a bunch of things. I always say it's a case of getting the junk out of your system. So the more you draw, the more you design, you're getting the

junk out of your system and your mind's finding whatever it's going to find.

"I didn't want to do a streamlined, atmospheric-looking ship. I could have done one easily, but the challenge for me was to keep it simple, keep it Jefferies-like, and also keeping it in line with what the script was giving us."

The design that Hargreaves settled on was for a much smaller ship than the one that ended up on screen. At the time, the script called for the *Pioneer* to be a scout ship that had been buried on the surface of the planet. "I know about the shuttlecraft – how they have those similar pylons almost like a helicopter. So I went along with that."

The design he came up with had a shovel-shaped 'saucer' section with twin pylons coming of the back, sweeping below the ship until they connected with the warp nacelles. "We didn't want it to look like an *Enterprise* type ship," Hargreaves remembers. "It was a different kind of ship. It had more of that compact singular look, which was basically what they were looking for at

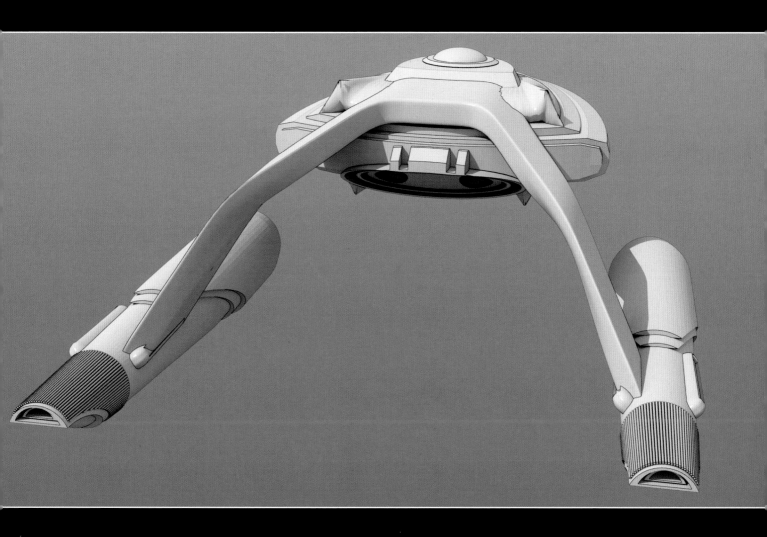

the time. And the way the pylons went right into the back of the underside of the hull was kind of interesting."

The fact that the nacelles hung below the ship was important, because the script called for it to land on the surface and to take off vertically. "Originally as the *Pioneer* it was going to be buried in the sand. They were going to find it in a sand dune. Scotty was going to just climb in the back and over time rig the thing together and it was going to take off. So these engines would also serve as landing legs."

SOMETHING 'OFF'

This version of the design met with enough approval from Tom Sanders and director Justin Lin for Hargreaves to continue working on it. But there was something about it that wasn't working. "As you're working through a design," Hargreaves says, "you'll drift away from things and you'll drift into other things. I was wandering around design-wise thinking 'Where am I going with this?' I was playing

around with that early design for a long time and trying to make it work.

"It had the *STAR TREK* design language, It had the main body, the arms and the pylons, and then the engine, so it had those three elements, but it was bugging me. I also wanted to make it more of that Federation world.

"For one thing, I always felt the main body was overpowered by the size of the engines. So I was fighting against that. When I made the body big the engines look a bit hard. It was a lot of proportional working out of stuff."

Hargreaves talked to Sanders about the design and they agreed that he should trying separating out the classic Jefferies' design elements to make them more distinct from one another.

"I came in one morning," Hargreaves recalls, "and I just went right back to basic shapes. I said, 'This will work, just go old school and sit down with a pen and paper.' These proportions work. These proportions don't work. Go back to basics based on what you've already done. Just work on simple,

▲ In the beginning, the *Franklin* was known as the *Pioneer* and was a much smaller scout ship. After exploring various shapes, Hargreaves settled on this design, which drew inspiration from shuttlecraft.

▶ The script originally called for the *Pioneer* to be found buried in the sand. Scotty would climb in through a hatch on the top and get the ship working again.

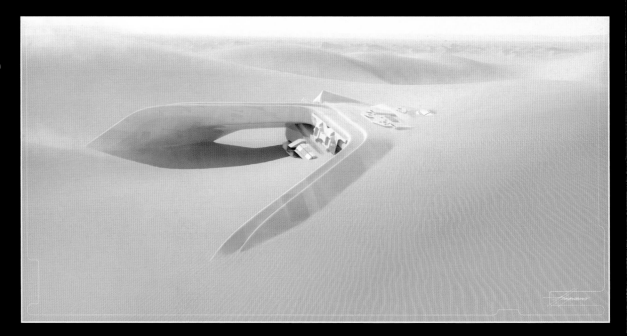

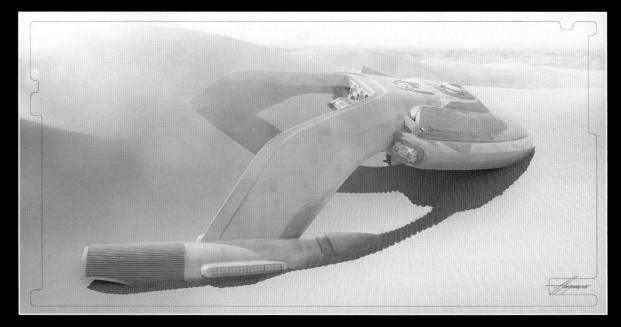

straightforward proportions instead of this blending stuff, where I'd been enlarging this 10% and shrinking this 15% and fiddling for days.

PRIMITIVE POWER

"That was my turning point. I'm a huge believer of sleeping on a project. You get to a point that you're very close to it, then you go home and sleep and you come back and you see it with relatively fresh eyes. You make big brushstrokes and you just destroy things that you spent days on and you come to a solution in an hour. That's really something special that happens. And that is what happened in the case of the *Franklin*."

Hargreaves' revised design was much more angular and all-importantly, it now had a classic Starfleet saucer. "I went back to primitive shapes, which were cylinders and discs. Giving it the saucer made a huge difference. It was about redesigning those three elements so they were more separate than they were before."

You can still recognize echoes of the original design in this new version: the nacelles still hung under the ship and the pylons still had the same basic shape, although they were now more angular. The shape of the original shovel-shaped 'saucer' was even preserved by being cut into the back of the saucer.

The redesign also helped to address one or the requirements of the script, which made it clear that the *Pioneer* (as it was still called at this stage) was an older ship that had been lost on the planet for some time. Making the design more angular helped to differentiate it from Ryan Church's design for the *Enterprise*.

"Ryan's *Enterprise* got very, very slick and it got away from primitive shapes. For me, all I said was 'I'm not going to do that.' The brief was that it's old and I went back to Jefferies' stuff just to harken back to an earlier era. I took it back to simplistic shapes. I don't say simplistic in a derogatory way, it's just not something that was more futuristically, sleekly designed as Ryan's ship was. It was more Jefferies-inspired."

ALL-IMPORTANT DETAILS

The new design was well received, so Hargreaves started to produce illustrations showing the ship in action. "I did an image of it lifting off vertically and that was what we showed around."

By now it had been decided that the *Pioneer* was not a scout ship after all, but a freighter, and this would influence Hargreaves's thinking as he was working up the surface details of the ship. "How you attack the details is very important," he says. "Evolution of design is an interesting thing. You start with something and as it's handed through other hands it changes. There's a point where it becomes not what it started as. It can be almost unrecognizable and that can be the overall shape or down to the little details. I felt that a lot of STAR TREK design had lost it in terms of the details, not in the overall shape but in terms of the feel of the STAR TREK world.

"So I brought back a lot of original Jefferies' little touches that I felt had been lost. The side of the saucer that Jefferies did was never vertical, it had a cant in, it was wedge-shaped so when the *Enterprise* went by the camera it had direction. All the saucers since then... the side is almost straight. It always bothered me so I brought that back.

"Then there's the spinning nacelles. I was determined to bring those things back because I loved them when I was a kid. I don't know what it is or how it's propelling the vehicle. To me that was the future. That was really cool to me and so I brought that back on the *Franklin*.

"I remember as a kid in 1979 when I saw

▼ Hargreaves wasn't entirely happy with his design and reworked it, giving the ship a traditional saucer. This illustration shows the revised *Pioneer* taking off with the aid of eternal rocket packs that Scotty had attached to the underside.

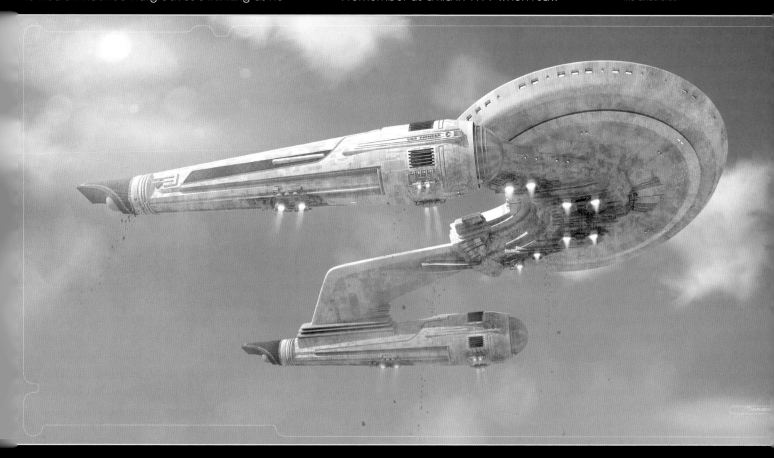

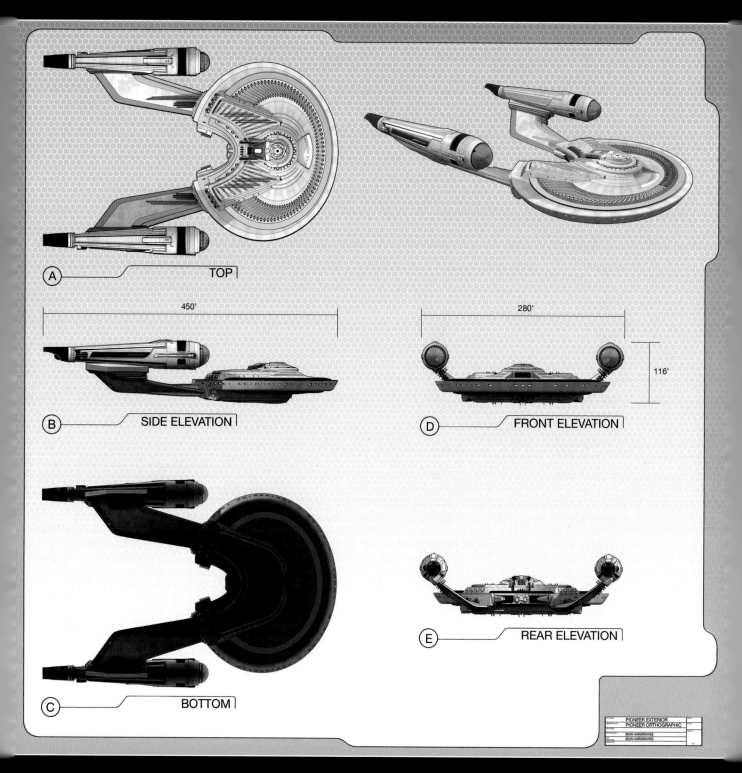

(A) TOP

450'

(B) SIDE ELEVATION

280'

116'

(D) FRONT ELEVATION

(C) BOTTOM

(E) REAR ELEVATION

PIONEER EXTERIOR
PIONEER ORTHOGRAPHIC
SEAN HARGREAVES
SEAN HARGREAVES

▲ These plan views show the next stage of the *Pioneer* from every angle. By now the nacelles had been flipped so they were above instead of below it.

THE MOTION PICTURE with that beautiful *Enterprise* – everyone knows I love that ship – but the spinning nacelles were gone. I just thought 'Aargh'. It was dead when it moved past camera. Also the tail end of the engines – they're a bit wedgy and I brought that back. Those things give a ship personality.

"It was all little details like that I tried to bring back on the Franklin and keep that original

Federation look but at the same time give it the tough kind of freightery look that we needed."

Hargreaves says that one of the other requirements from the script was that the ship looked as if it could take a beating. "Because of what happens in the script – all the battering and beating it goes through when it goes through *Yorktown* and also being attacked by the Swarm ships – they wanted to make it look like it was a

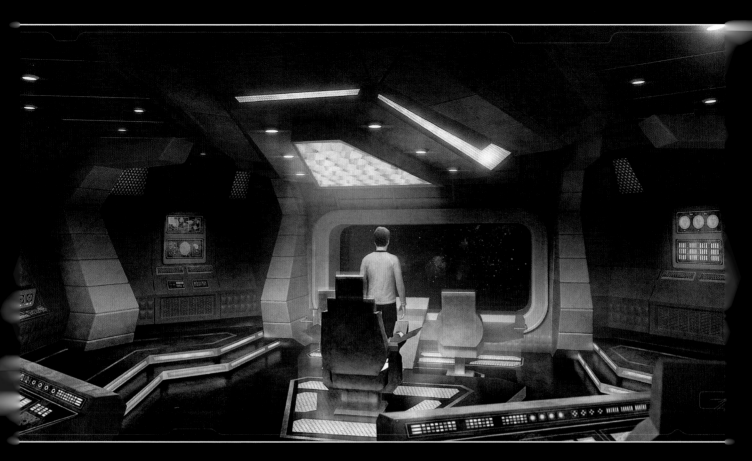

INSIDE THE FRANKLIN

The interior of the *U.S.S. Franklin* went through a number of changes as the script evolved. With each draft the ship became more important to the story and more sets were built. The design challenge was to create something that looked both futuristic and old.

Everything was designed to fit inside Hargreaves' design, with the 'window' of the bridge clearly visible from the outside. The bridge set was actually mounted on a platform that could shake when the director wanted it to. The transporter set was only added relatively late in the day after Justin Lin and the writers decided that it made sense for Kirk and his team to beam the rest of the crew onboard rather than have them trek across the surface of Altamid.

A small part of the exterior saucer was built for the scene where Jaylah takes Kirk and Scotty to the top and shows how she has used refracting shields to conceal the ship. Other sets included the mess hall and a small part of the engine room. One area Ron Ames points out we never saw was the cargo hold, where most of the *Enterprise* crew are during the film's third act.

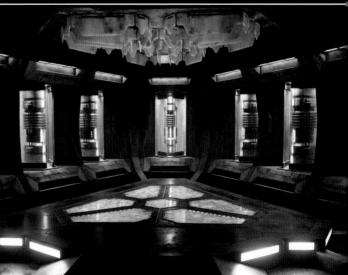

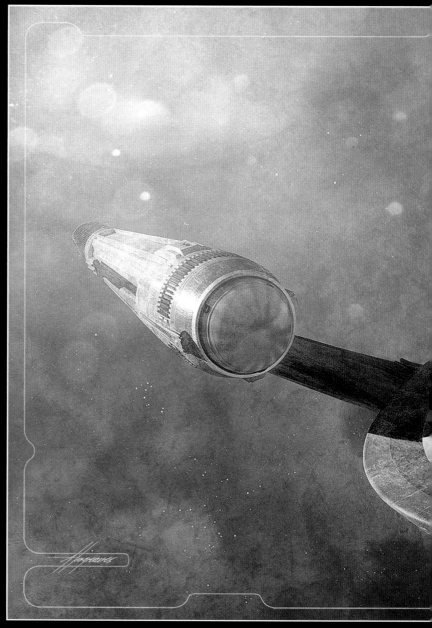

◄ The decision to move the nacelles was taken for a practical reason: the script changed. Now, instead of taking off from a sand dune, the ship would launch itself by dropping off the edge of a cliff. When the nacelles were underneath, they made it difficult for the ship to slide, so they were moved. „

tough little ship. It was built like a tank and had been through the wringer."

In order to achieve this, Hargreaves added some of the surface detail and concentrated on making all the shapes as simple as possible.

The script also called for something that didn't make it into the finished movie: when Kirk and his team have rescued the rest of the crew, they had to get back on board. "I didn't really know how they were going to load up stuff into the ship. I was going to do these doors that were going to be on the top."

As Hargreaves explains, these doors formed a ring around the middle of the saucer. "They were going to slide sideways, almost like on a single

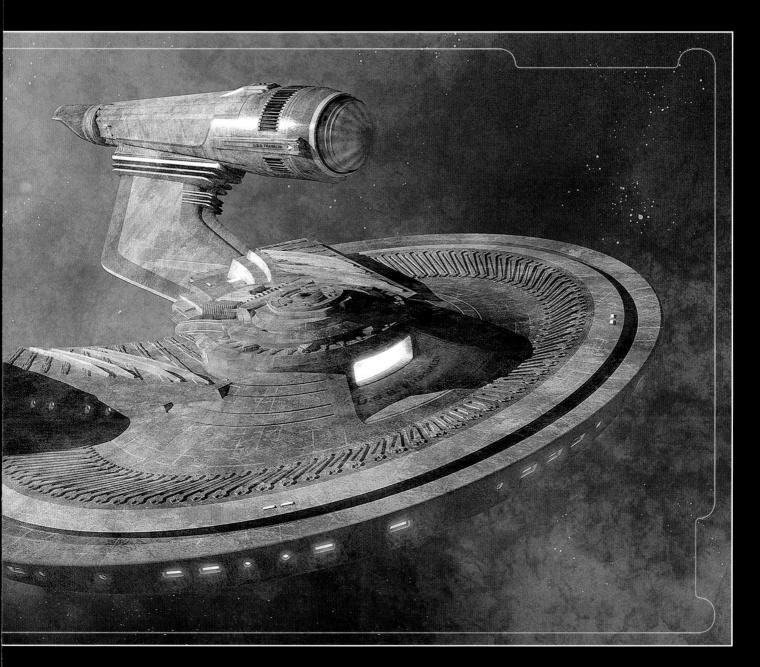

hinge. There would be arms that were like pistons or hydraulics that would push the doors aside as they would open up. It was complicated. That ended up not happening because they said 'They would just beam everyone up.'"

UNEXPLAINED DETAILS

Hargreaves liked the shape the doors made though, and felt that removing them would weaken his design, so instead of removing them, he added to them. "I modified the arms and hinges that would open the doors into this array. What I did was basically, I tripled them up. Originally it wasn't anywhere near as dense as that and it wasn't anywhere near as pronounced. They

were more of a lighter detail. I did that and everyone liked the look of it, which was great."

One of the things that still presented Hargreaves with a problem was that the ship had to land. "It was fiddly," he says. "It would land vertically and take off vertically. I did variations of it with landing struts, which would open up and they would come down as it was landing."

However, as the script continued to evolve the way the ship took off changed completely. "As time went by, the script changed. Now it was on top of a mountain and it had to fire up and then slide down the side of the mountain."

This presented Hargreaves with a new problem: instead of having to support itself with landing

▲ Once he had built the 3D model, Hargreaves put it in a variety of environments. By the time this illustration was produced, the ship had finally been renamed the *Franklin*.

123

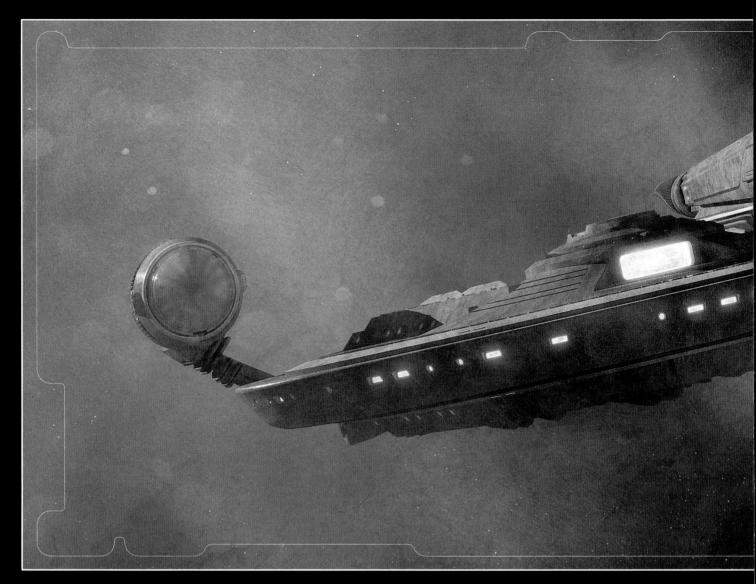

▲ Hargreaves produced illustrations that showed the *Franklin* from a number of key angles, so the team could see how it would look in action.

gear, the ship, now renamed the *Franklin,* would have to slide across the surface of a mountain.

"I felt that the orientation of the engines wasn't going to work for what they wanted," Hargreaves says. "So I just flipped them upside down. I literally had them on a different layer in 3D and I just did a 180 and said 'How about that?' and they loved it. I do like both designs, but the one we ended up with looks like it's having fun. It's got its arms up and it's on its way. So it ended up fine."

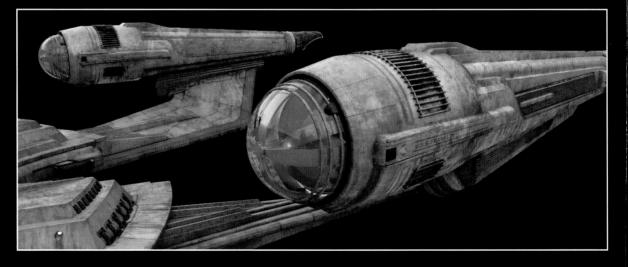

▶ Hargreaves believes that details are a vital part of a ship's identity and wanted to hark back to elements of Matt Jefferies' design for the original *Enterprise.* One of the things he wanted to bring back was the spinners at the front of the nacelles.

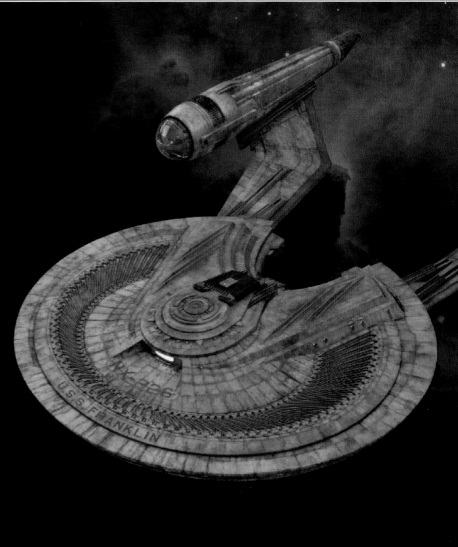

With the design finally approved, Hargreaves handed his model on to the visual effects team. By now all the details had been worked out. "I've always made sure that my design or vision is very, very clear from my end all the way to the final product. I consider myself a strict designer. It's my responsibility to carry the design through. I like to detail the heck out of my 3D models. If I just do some sketches and hand them off to someone else it's their responsibility to fill in the blanks that you didn't fill in. So I try and make my sketches and all my 3D stuff as clear as possible. That way there's no questions about what they're going to see."

Although Hargreaves' model was incredibly detailed, there was still a lot of work to be done. As VFX and associate producer Ron Ames explains, every detail had to be considered again as the shots were finally composed. "We don't change Sean's design. We were quite loyal to it, but we

tweak it on a shot-by-shot basis and there was stuff that had to be added."

One of the first questions was exactly what kind of materials would be used in the construction of the *Franklin*. "There was a great deal of conversation around that," Ames says. "We wanted to give the idea that the technology had evolved. What materials would they have used? Was it aluminium like? Concrete like? Is it some kind or really tough metal that has a pebbly texture to it? It definitely evolved."

TAKING DAMAGE

Once that material had been decided on, the VFX team added a load of additional material that had literally grown over the *Franklin*'s surface during the decades it had spent on Altamid. "It had been sitting there for a couple of hundred years so it had dirt and rocks and trees growing

▲ The ridged detail on the top of the saucer started life as a series of cargo bay doors that would have opened up to allow the crew to board. When this sequence was eliminated from the script, Hargreaves redesigned them as an array. He admits to being uncertain of its exact purpose.

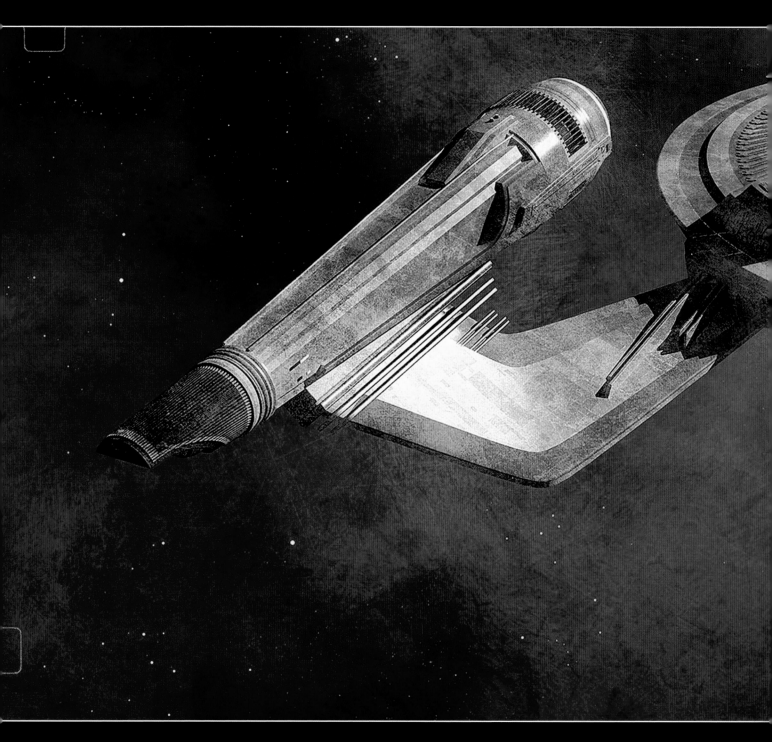

on it. It was kind of funky when it took off."

And no sooner had the *Franklin* taken off than it started to sustain damage. First of all as it falls over the cliff and then in the battle with the Swarm ships before it finally crashed its way into the *Yorktown* station. All of this damage was carefully worked out by the VFX team and recorded so that it could be tracked in each shot. "We added scrapes when it comes off the edge of the cliff," Ames explains. "Then you had to know where it had been hit by Swarm ships, so you build

a history of the damage and follow that through.

"I thought the way the *Franklin* behaved in the final battle and as it came into the space station was beautifully designed. It's beginning to fall apart and bits of it are coming off. It's really beginning to deal with atmosphere and hitting things as it's coming through the station and finally it comes up through the water. We really tried to make that as real as possible. I thought that was very successful and pretty cool."

In fact the *Franklin* sustained so much damage

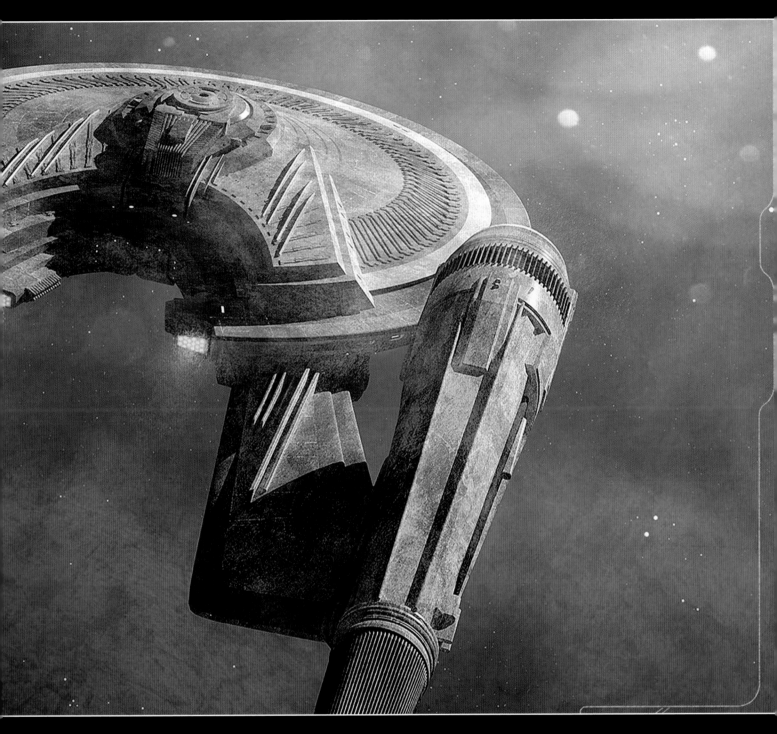

that the VFX team had to look at ways of making it seem tougher so you would believe that it could survive for as long as it did.

The *Franklin* even continued to evolve after the majority of the film had been shot. When the crew were editing, it was decided that in the battle with the Swarm ships, the *Franklin* should be able to fight back a little more than had first been planned. "Originally," Ames says, "the *Franklin* was designed without weaponry at all or minimal weaponry that was not functional. As the third act

was rewritten when we were editing, we had to add weaponry to tell the story, otherwise it would have been a sitting duck. So we took Sean's design and added firepower."

So just as Hargreaves had started the design process by asking what the script called for, the *Franklin* continued to evolve in order to tell a better story and make a better film, changing from a scout ship buried in the sand on an alien world into a tough explorer that ended its life crashed on the inside of a massive space station.

▲ Hargreaves was delighted with the final version of the ship, which he sees as very much a tribute to Matt Jefferies' original, simple design.

DESIGNING THE
SWARM SHIP

The fleet of tiny ships that tore the *Enterprise* apart were designed to cut, drill and tear their way through the hull.

The swarm of ships that destroyed the *Enterprise* called for something that we hadn't seen much of in *STAR TREK:* a fleet of small fighters. Director Justin Lin wanted them to reflect the kind of weapons that are used in modern warfare such as drones and cluster bombs. The idea was that they would cut Kirk's ship to pieces, latching on to the hull to allow Kraal's troops to board the *Enterprise,* rapidly overrunning it.

The first person to start work on the design of these ships was senior concept illustrator Sean

Hargreaves. "It was actually one of the first things I ever did for Tom Sanders, the production designer," Hargreaves recalls. "Tom said, 'We've got these swarm ships. When we first see them they are clustered together and look like one big ship, then they all separate.'"

Hargreaves began by thinking about what the ships would look like when they were connected to one another. "We asked, 'How do they join together? Is it like chain mail?' All this kind of very complicated stuff. We went through a bunch of

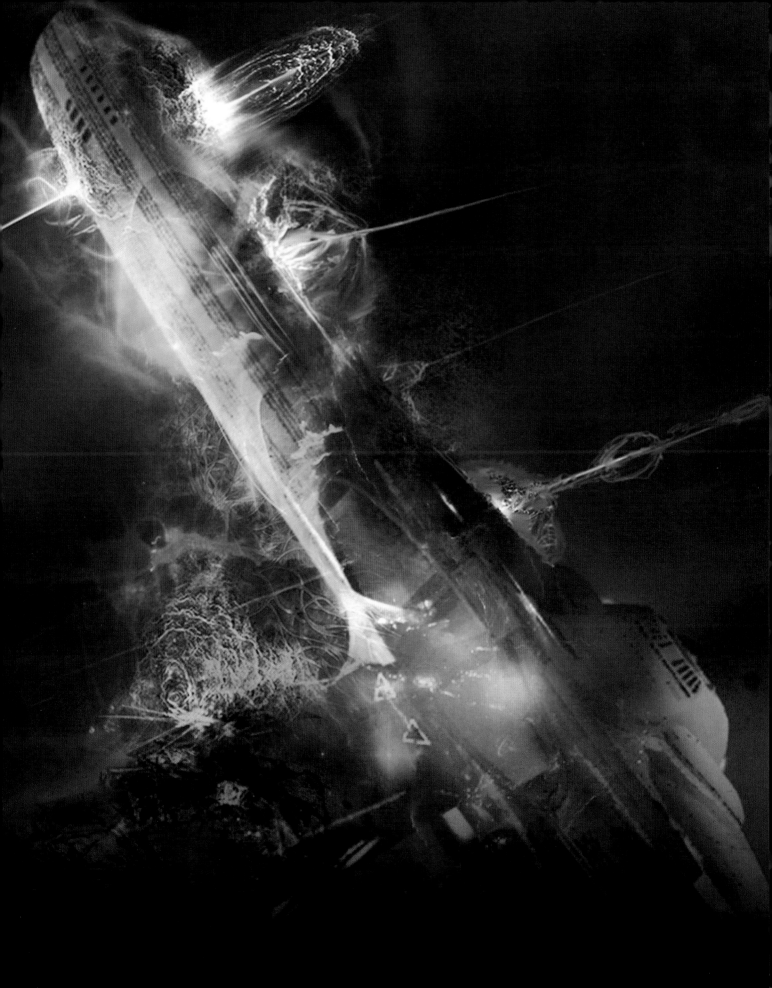

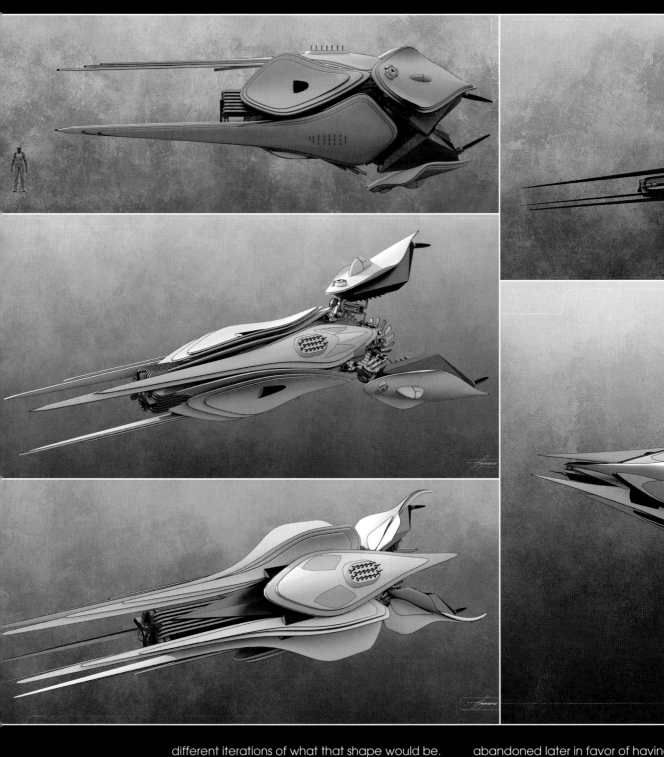

different iterations of what that shape would be. Tom had this idea that it would be a gigantic tube, almost like a huge whale shark, when it has its mouth open. It engulfs the *Enterprise* and then all hell breaks loose. That didn't happen in the film but the first thing I did was to work on what that would look like."

At this stage, the idea was that the swarm of ships would actually be physically connected to one another until they mounted their attack, although this was something that would be

abandoned later in favor of having them fly in close formation.

Hargreaves remembers that he was faced with several challenges. "There was a bunch of hurdles that we were dealing with. It was tricky because you're dealing with a lot of different tiny elements. You're dealing with them in scale and trying to make it look interesting without it looking like a big blobby blob floating around space! Also, at the time the swarm ships were black, and black on black is a problem. All you

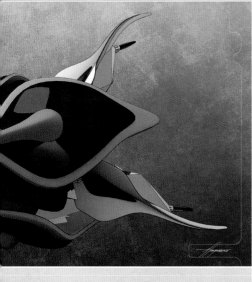

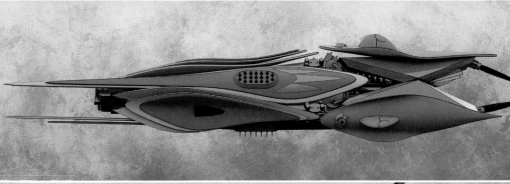

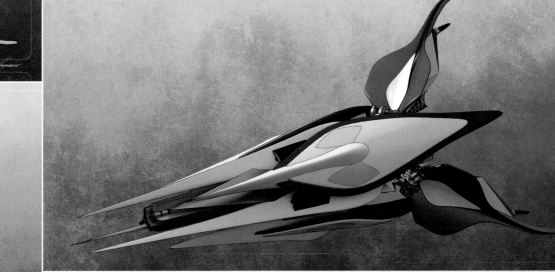

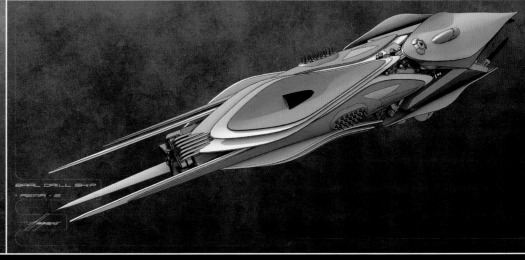

BALL DRILL SHIP

end up seeing is the speck of the highlights moving."

The formations that the swarm ships would use would become a major undertaking, with the visual effects house Double Negative studying the way that birds and fish swarm, before creating their own algorithms that resembled buzz saws and drill bits.

PRACTICAL DESIGN
Meanwhile, Hargreaves turned his attention to the design of the individual ships. He has a

background as an industrial designer so he started by asking himself how the ships could do what the script called for, regardless of what they looked like. "I knew it was going to pierce the hull and that the crew were going to enter the *Enterprise*. So I asked myself how it flew through space, how it picked up speed and then opened up the claws that penetrated the hull. Is it even a claw?"

The design Hargreaves came up with was for a small, streamlined craft with claws at the front that dug into the surface of the *Enterprise,* latching it on

▲ A selection of Sean Hargreaves' early concepts for the swarm ships. He already had an idea of how they would work, but he was looking for the best possible shape, so he was experimenting with the proportions.

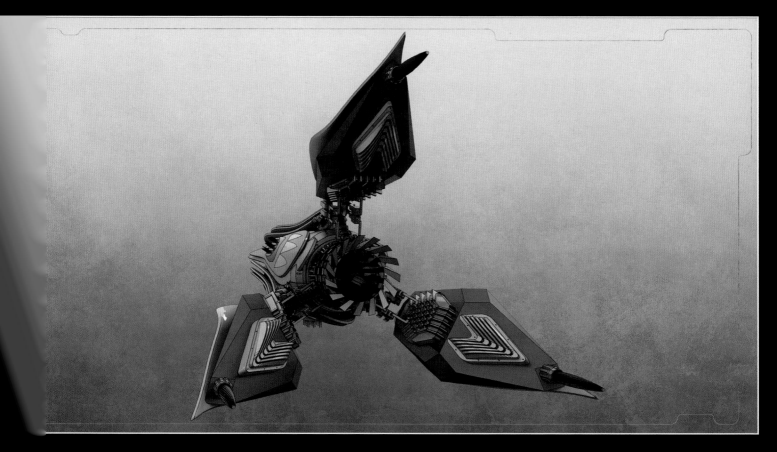

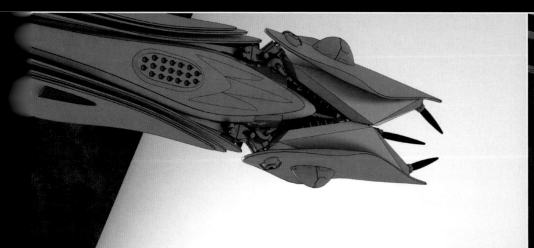

▲ Hargreaves' idea was that the front of the ship would open up to reveal a rotating drill bit that could tear through the hull.

▼ This sequence shows how the front of the ship opened up and three pincers latched onto the ship it was attacking.

like a lamprey. The next question was how the crew would get from their ship into the *Enterprise*. "They're obviously not going to go through space," Hargreaves says, "so they have to go through the ship. I thought it would be cool if there was a drill in the front of the ship that cut through the hull and then opened up. Then they came in through the center of it."

With these elements in mind, Hargreaves gave his design several panels around the outside that would move as the ship went through its paces. "When they're flying in attack mode they have the shields open and the claws are closed. Because the shield is open, you can see the guys inside. Once it accelerates to attack speed, the shields slide forward and close, and then the claws open for attack. There are three prongs that are like fast-moving drills that latch on and then screw into the ship and then the central bit drills into the ship. I did a bunch of step sequences of how it would look. Here it is flying through space, then here it is opening up. Here are the bad guys entering the ship. It took a while to figure that stuff out and get it through the approvals."

At this point Hargreaves' drawings show that he was imagining a larger swarm ship than the final version that ended up in the film. "The scale wasn't worked out, and no one knew how many bad guys would be in there. Initially, I did six guys and then it went to four. The scale went from quite long to something a lot shorter."

Once the idea of how the ship would operate had been approved, Hargreaves turned his attention to sketching out variations of the different elements, exploring different shapes and styles of movement.

"Once I got the engineering part passed, I was able to come up with these shapes pretty quickly," he remembers. "If you look at them they're all variations on a theme. There's nothing that is radically different between them. It's all proportional stuff and moving parts around. Some of them were very long and very art deco-like in

some of the detailing."

At this point there was still an enormous amount of design work to be done on the rest of the film, and, although Hargreaves's designs were well received, there were other things that needed his attention. "Towards the end of doing those variations and handing them off, I was off to other pastures. I went onto *Yorktown* after that. They handed the swarm ships off to Romek Delimata who developed the designs you saw in the film."

THE NEXT PHASE

Delimata remembers that Hargreaves' designs were only part of what he was handed. "Certainly in the beginning there were a ton of people working on it, not just Sean. Some of the concepts I was given had notes that said they were going in the wrong direction. There were other designs that had them looking like limpet-like things that sucked

▲ From the beginning, the idea was that the Swarm Ships would fly in formation. One of production designer Tom Sanders' early ideas was that they could be mistaken for a single ship, which surrounded the *Enterprise* before breaking apart.

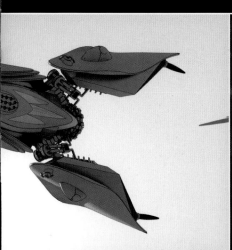

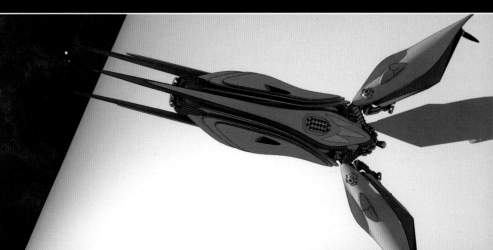

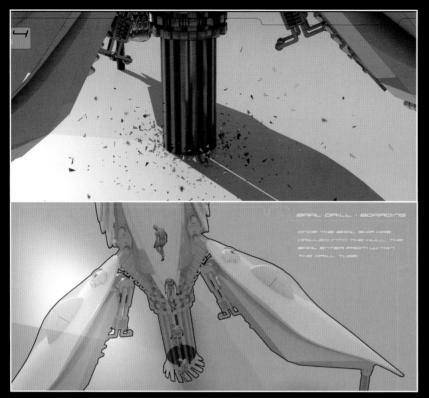

◄ Once the ship had latched on to the hull, a large drill bit would cut through the surface. The crew would then board the ship they were attacking by dropping through the center of the drill tube.

which he combined with elements from other people's designs before adding more elements of his own. "The root of my first sketch," he says, "came from what I saw in other people's designs, which, because I had missed the beginning, I thought was the direction they wanted to go with."

THE SWARM EVOLVES

This sketch shows the ship standing on three vertical prongs that are very similar to Hargreaves' claws. The drill tube in the center is still present, but this version of the ship also has a pair of insect-like wings. "You've got that sweeping shape on the top, which to be honest, I think looks very like components from Jabba The Hut's sail barge in *Return of the Jedi*. I was really worried about that, but I was also basing it roughly on the shapes that were on those other models, and I thought that was the direction we were going in. At this point, there was no real logic or intellect behind those particular things or purpose. I just thought, 'That's what they like.'"

Delimata's next concept shows the ship becoming less elegant and more mechanical. In it, Hargreaves' petal-like panels had been replaced

▼ Hargreaves' early designs were for a much larger ship than the version that ended up in the film. This drawing shows how the crew would sit behind the drill bit.

onto the side of the ship, but I guess Sean had done the ones that were most liked. I thought his concepts looked really good, so I took my lead from the shapes that were on them, but I didn't actually know if that was what they wanted." Delimata's first concepts are clearly an evolution of the ideas that Hargreaves had developed,

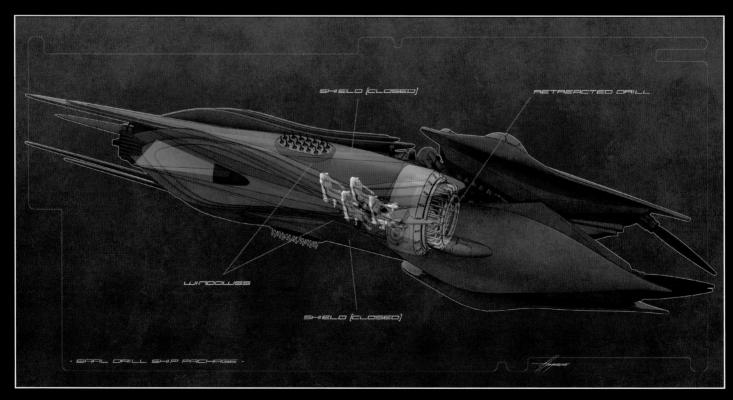

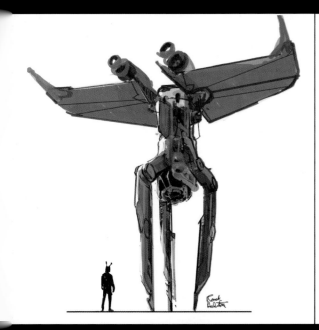

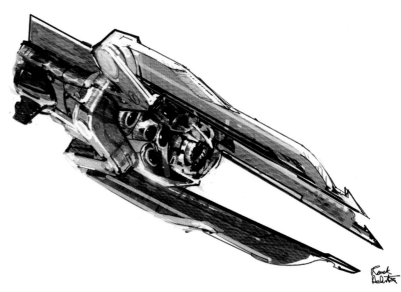

with large pincer claws with heavy joints. "These things would shoot out and grab onto the ship," Delimata explains, "then this spinning tube would come out and chop into it. It has a vicious look to it, like a scorpion. The spiky things would provide some kind of cushioning or suspension as it hit the hull of the *Enterprise*, but then the flexing section of them would provide a cushioning for the impact of the rest of the vehicle."

While he was working up this design, Delimata produced a highly colored version that was a radical departure from anything that had been seen in *STAR TREK* before.

"There was no particular reason for it," he laughs. "I think I thought it would make them look more interesting – as if they were made out of some kind of exotic material. Tom Sanders said 'I like the warpaint kind of thing.' I was surprised by that, and it did end up getting muted, but it still made them look like some kind of insect, which was cool."

Like Hargreaves, Delimata produced concepts showing how the swarm ships would operate

▲ The next phase of the design was handled by Romek Delimata, who started work by taking many of the elements from Hargreaves' designs but giving them a more mechanical edge, with large, obvious hinges.

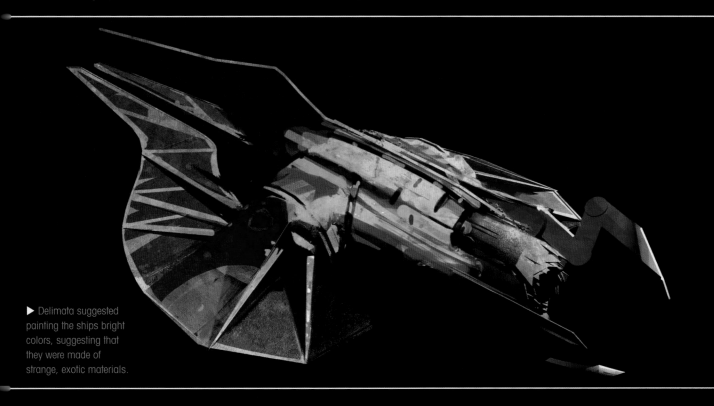

▶ Delimata suggested painting the ships bright colors, suggesting that they were made of strange, exotic materials.

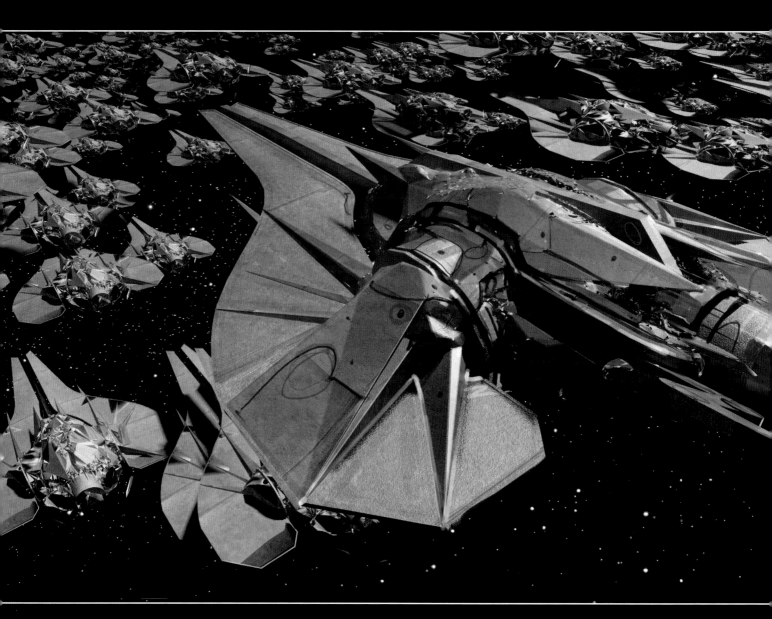

ALTAMID SWARM SHIP

▲ Delimata picked up the work exploring how the ships would fly in formation. The team did consider having them physically link with one another, but it was decided that they should just fly in close formation.

together in a fleet. "I was just thinking about swarms and flocking things, and if they came together into one point and penetrated at one point just how destructive that would be. If they acted together as a drill, they could just tear a chunk out of the *Enterprise*."

Delimata's early designs had elements in them that were clearly related to insects and he remembers that Sanders asked him to explore this further, and this led to him removing the drill tube in favor of something more organic. "Tom said to make them less mechanical. I remember coming up with the idea that this piece in the middle could shoot up and out like the face hugger in *Alien*. These pincers would clamp on in some way, and these skiff bits would form a seal, then that proboscis bit would shoot down through the vehicle and into the *Enterprise*. It was like an

inverted wasp sting, that came out the mouth and could spew the enemy into the craft."

Delimata's designs were for a smaller ship than Hargreaves' concepts. As he remembers it, this wasn't because he had been given any specific instructions, and he was simply being guided by what the script called for. "I had to guess at the size of it. I just thought, 'What's the action going to be?' I knew there needed to be enough room for Spock and McCoy because the script had them in there. I actually thought they would be smaller than they ended up being."

INSIDE THE BUG
When Delimata thought about the internal arrangement of the ship, he had to allow for the stinger tube that was going to pierce the *Enterprise*'s hull. His solution was to move the pilot

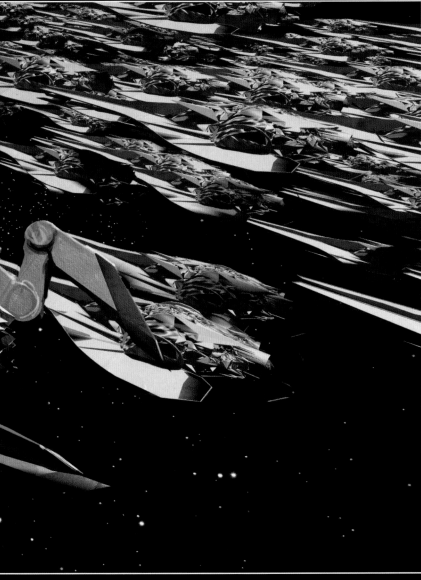

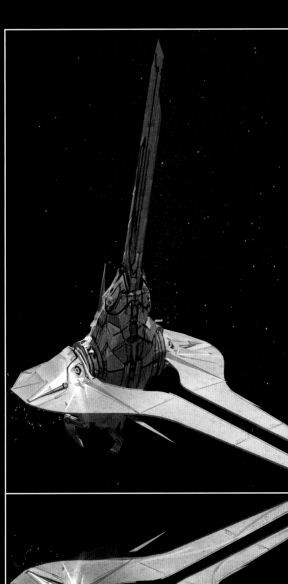

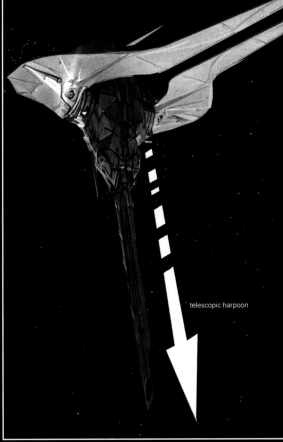

to the top of the ship, where he would be almost lying down with his legs straddling the tube.

Sanders liked the more organic, bug-like elements that Delimata was introducing and encouraged him to go even further in this direction. "As soon as he saw the more organic buggy look, he told me to keep going. So I tried something else."

For the next stage, Delimata experimented with using a piece of software called *ZBrush*, which is very widespread in the visual effects industry. However, he remembers he didn't get on with it, and found it extremely difficult to create smooth shapes. "The next batch of designs look really organic because I'm inexperienced with *ZBrush*! It's horrible software to learn. I spent a month and a half doing tutorials on it and ended up giving up on it. It was like playing with clay. It threw

▶ Delimata came up with the idea that the ship would have a tube running through the middle that would be used to puncture the surface of the ship they were attacking. This 'proboscis' would shoot through the body of the ship at great speed.

telescopic harpoon

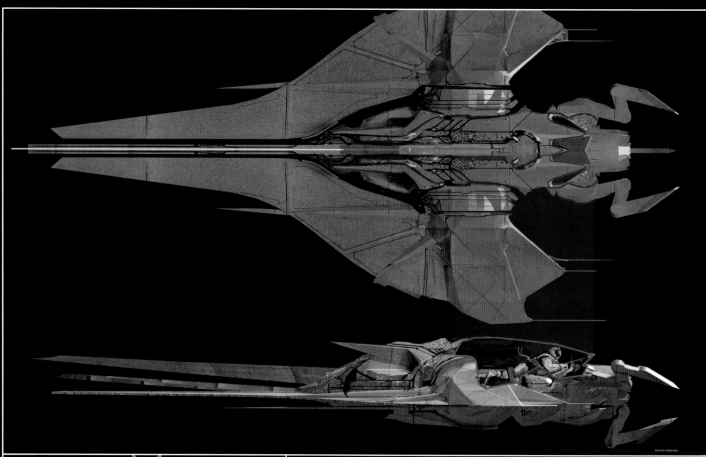

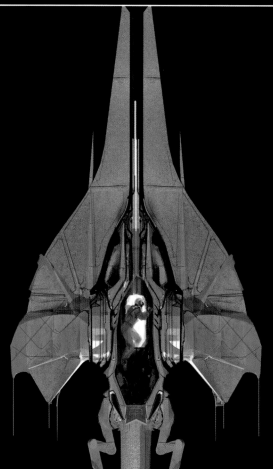

◀ ▲ By this stage, the swarm ship had become a smaller vessel, and these drawings show how the pilot would fit inside by straddling the tube that would allow him to enter the ship he was attacking.

interesting things up but the fact that they look so blobby was an accident."

Looking at these very "lumpy" designs, Sanders felt that the ship was now becoming too organic and bug-like, but he did like the overall shape that Delimata had come up with, so the next stage was to take that and to create a smoother, more metallic version of it.

THE JAWS OF LIFE
At this stage, one of the last – and most important – pieces fell into place. Until now no-one had been entirely convinced by the method the ships would use to rip holes in the *Enterprise*'s hull. "Somebody," Delimata recalls, "said they should be like the jaws of life. That's something that firefighters use. They are inverted pliers that you can use to bash through walls and then open up a space that you can walk through. The spinning thing got dropped in favor of this idea. The real things don't look like they do in my designs but the idea is the same."

Delimata set to work replacing the front of the ship with twin pincers that formed an arrow head. Once they had punched through the hull, they would fold back to tear a bigger hole.

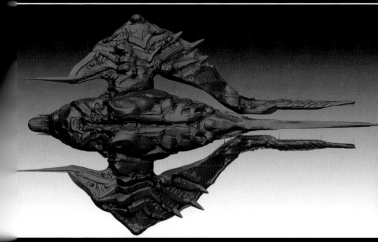

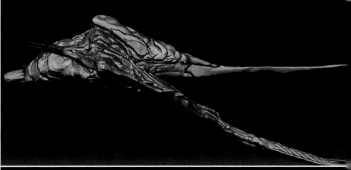

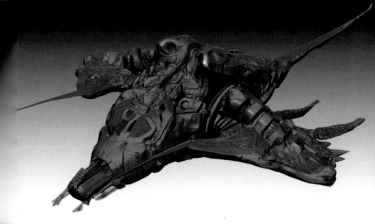

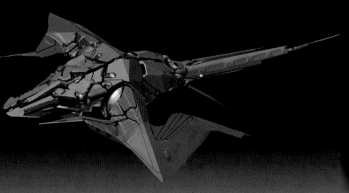

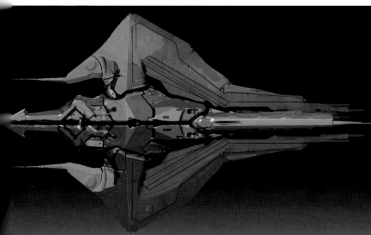

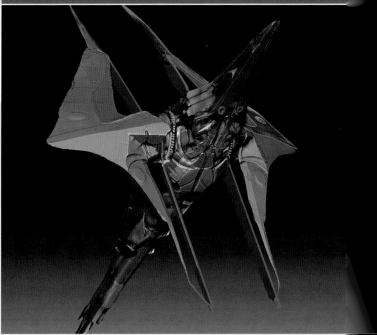

"I experimented a bit in 3D and I thought it would be better if they were double, or even triple-hinged, so they didn't just splay out. They would splay out and then bend back on themselves, which I thought looked really menacing. You could imagine them kind of crunching back on themselves and then crunching through the structure."

Once these pincers had torn the hull open, Delimata still planned to have a tube deposit the boarders on to the ship, and he still considered

using the shooting 'stinger' to deliver the crewmen, but although this part of the design was retained, it rapidly lost its function.

The final change to the design came when Justin Lin said that he wanted the swarm ships to shoot into the *Enterprise* like arrows. Sanders and Delimata's response was to look at the design they already had to see how it could fold up on itself to become a dart.

One final element was introduced that helped to tell the story, but that Delimata felt took away

▲ Sanders asked Delimata to make his design more organic so he reworked it using software called *ZBrush*. However, Delimata was new to the software and his designs were more 'blobby' than he originally intended. Sanders asked him to make the design less bug-like, so on the next pass he smoothed the shapes out.

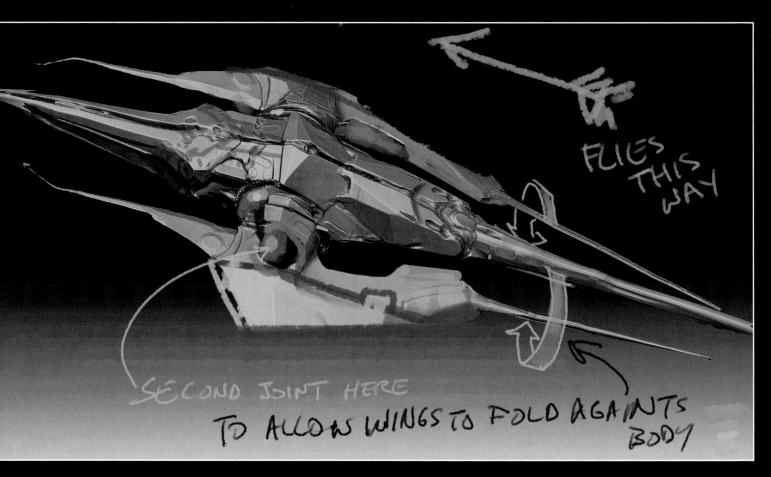

FLIES THIS WAY

SECOND JOINT HERE

TO ALLOW WINGS TO FOLD AGAINTS BODY

▲ The director, Justin Lin, wanted the swarm ships to look like a flight of arrows, so Delimata redesigned them so they would fold up to become darts.

from the menacing look of the design. "The cockpit suddenly got introduced. So I had to put a cockpit in. It was a pity – I felt it looked nastier without a cockpit."

What the cockpit did do was let the audience see McCoy flying the ship, as it careered through the swarm and through the 'streets' of the Yorktown Station as they pursued Kraal.

The design was now all but final and Delimata handed his model on to Robert Woodruff who

modelled the final version. Delimata then took Woodruff's model and used it to work out what the interior of the ship would look like.

AN OVERWHELMING SWARM

Meanwhile, the VFX team at Double Negative were still working out how hundreds of thousands of the ships would operate together. Programming and rendering so many individual models presented them with some real challenges. Their

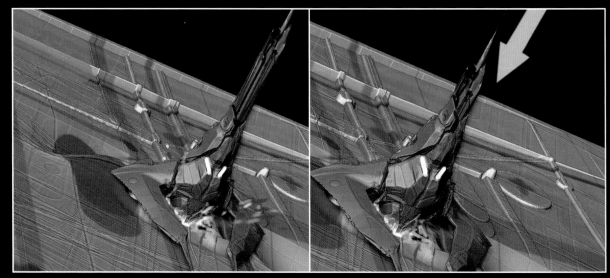

▶ Once the swarm ships had penetrated the hull, the wings would fold down to form a seal, allowing the crewmen inside to enter the ship without being exposed to the vacuum of space.

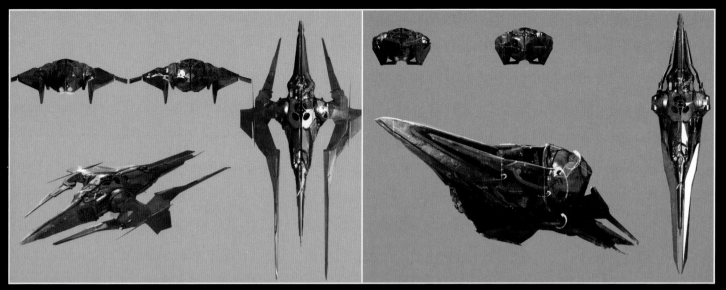

▲ These renders of the CG model that was sent to the VFX team show what the Swarm Ship looked like in flight mode (left) and what it looked like when it folded up to become the 'dart' that Justin Lin had asked for (right). Delimata also produced an animation showing how it changed from one state to the other.

▲ The drill bit was abandoned in favor of pincers that would penetrate the ship before folding back to tear a wider hole in the ship's hull.

solution was to produce different versions of the model, with higher resolution versions in the foreground and simpler ones being used further back in the swarm. Since it was impossible to program every individual ship, the movement of the swarm was driven by a series of algorithms that told most of the ships to follow a lead vessel that launched each wave of attack.

As Justin Lin had asked, the finished effect was of a terrifying, alien weapon that tore Kirk's ship apart, giving the audience something they had never seen in *STAR TREK* before.

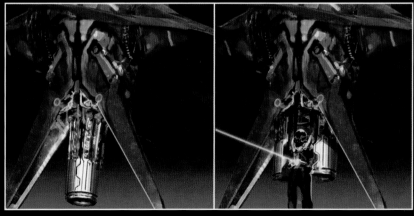

▲ Although it wasn't actually seen in the movie, the idea was that once the jaws had created an opening in the ship, a tube would allow the pilot to drop through.

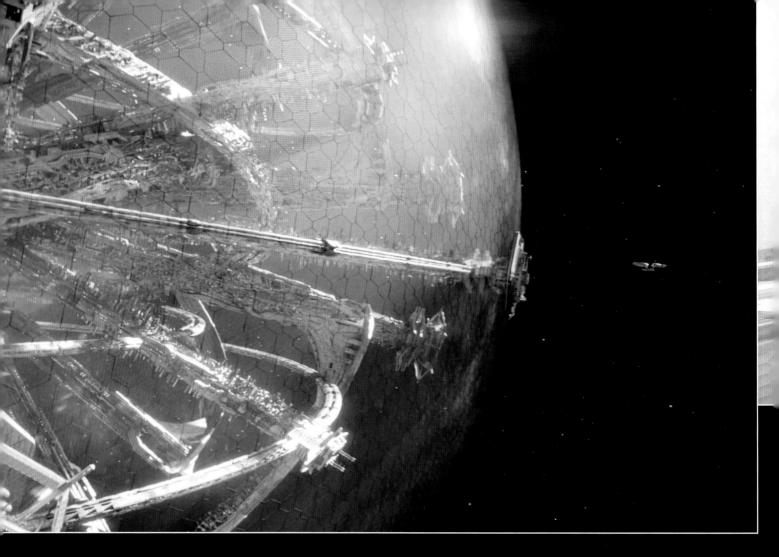

DESIGNING THE
YORKTOWN

STAR TREK BEYOND's Yorktown was a massive city that could swallow starships like a whale.

When Sean Hargreaves was given the task of designing the *Yorktown,* some work had already been done. As he remembers, there was a very basic 3D model that showed some ideas about how the station might work. "It was just very rough," he says. "The model was just a talking point to show the director and the powers that be something and ask, 'Is this what you're thinking of?' It was basically the central hub and these square arms that came off it, which just had cities plonked on them. They knew it went out to a sphere but they didn't know how many arms it had. The sizes weren't exactly locked down yet."

Hargreaves' job would be to take that basic idea and to turn it into something that made sense. Part of the idea behind the *Yorktown* was that the

▲ The *Yorktown* was something we hadn't seen before: a vast station on the edge of Federation space that looked like a vast crystal snowflake in a glass sphere.

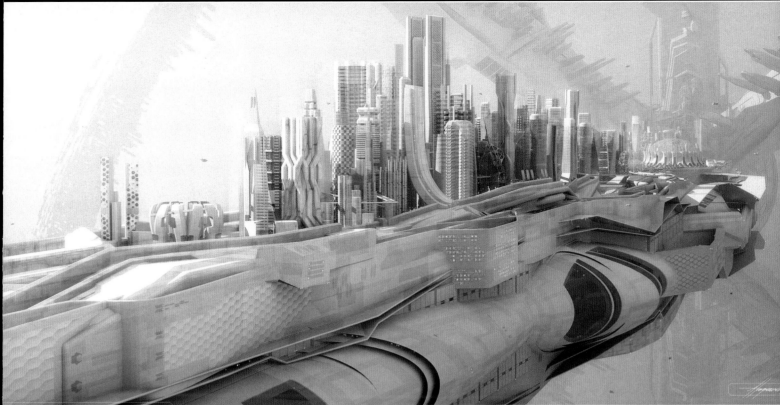

▲ Hargreaves only designed one of the *Yorktown*'s arms, which he gave to the VFX team to use as a template. He wanted to vary the kind of spaces on the arm to make it look like a real city.

cities on the arms would turn and twist, since in space there is no up or down, but no-one knew what this would look like. "As you see in the film it's all a little crazy," Hargreaves says. "It's justified, but that establishing shot is pretty dramatic. The gravity was the thing that helped us come to grips with how we were going to represent the station. So I started with that.

UP IS DOWN

"Originally the arms were going to be elliptical and sectioned. They wanted the buildings to be on a curved surface, as opposed to a flat surface. They were going to be perpendicular to whatever surface they were on, so you'd end up having these buildings that were like fans as they went all the way around the arm. We did some renderings based on that but it looked like the buildings were toppling. It got to be very, very confusing, so I said 'Let's just make the tunnel elliptical and make the exterior flat.'"

This approach meant that the buildings would only be on the top and bottom of each arm with gravity running through the middle of the arm.

▲ Hargreaves admits that they never worked out exactly how gravity worked where the *Yorktown*'s arms met, but he doesn't feel it surprising we don't understand 23rd century technology.

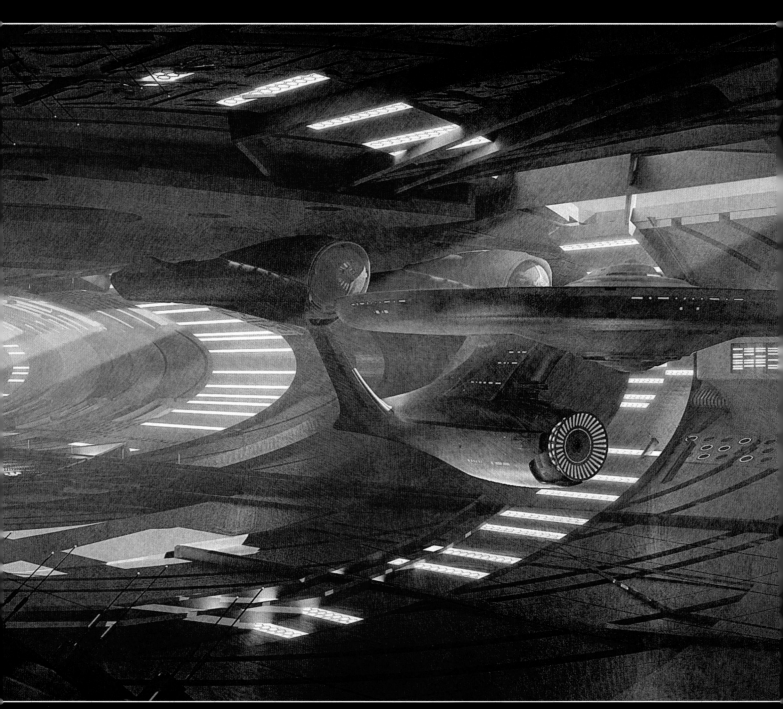

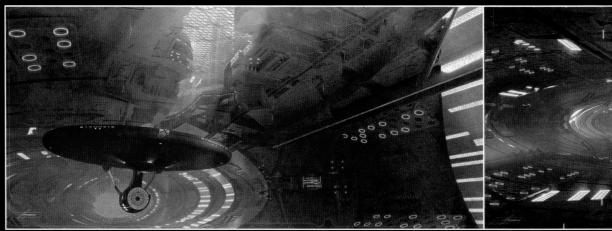

▲▶ Hargreaves suggested adding windows to the sides of the *Yorktown*'s arms, so ships could be seen travelling through them, and adding transparent areas in the 'ceiling' that were underneath the lakes and parks.

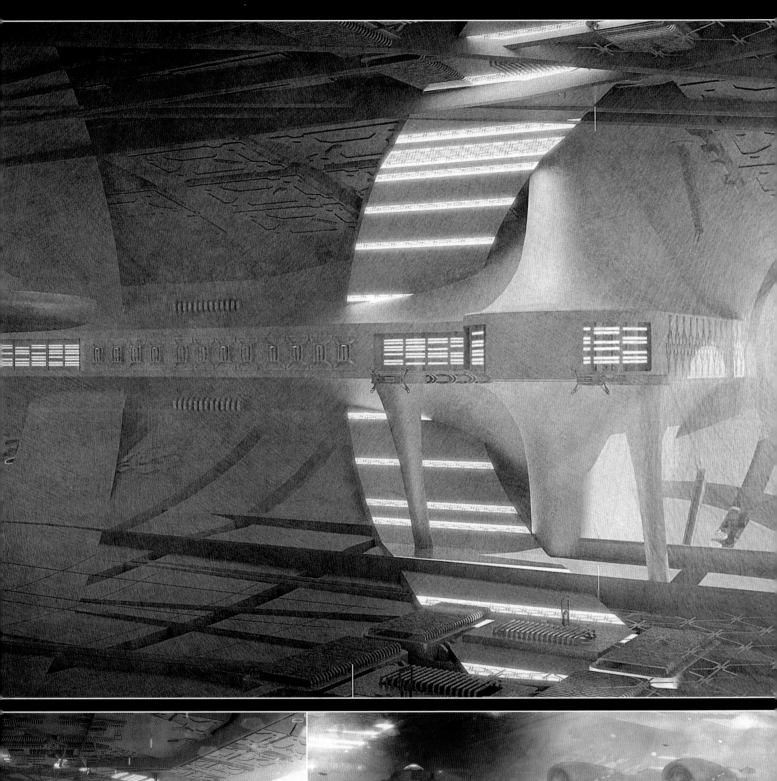
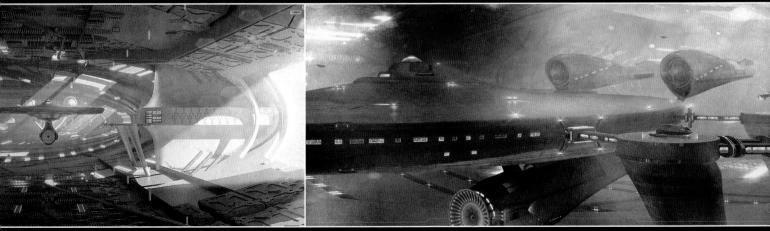

This still delivered the impression of something complicated and futuristic, but it was much easier to understand visually. And since some of the arms were at right angles to others, it gave the impression that almost any direction could be up or down, depending on exactly where you were. "It got very complicated when we got into the hub with the oxygen fan at the end because we had four buildings coming to a point. What happens with gravity there and how that works was a big discussion, because you have four gravity fields coming in. Does it pull a person apart? Does it make them fly? There's a point where you have to have a suspension of disbelief. That's why I love sci-fi because you can take it to a certain point and then there's the unexplained. If we knew how it worked, we'd have it now so there's always that aspect to it!"

A REAL CITY

When it came to the buildings along the arms, Hargreaves wanted to make sure that they looked like a real city rather than simply a futuristic conglomeration of buildings. "I don't start with the look. I start with the functionality of it. I said to Tom Sanders, my boss, 'It would be great to have all these different things along the arm instead of it just being city upon city upon city.' I said, 'You really need to have some breathing room as we're cruising through this city. It needs open areas.' They accepted that so I did a city plan. I worked out where along the arm the industrial area would be, where the manufacturing areas would be, where the food production areas like farms would be, where the recreational areas like parks would be and where the living and city area was.

"The industrial space was always going to be at the hub because that was where the big fight was at the end. That was where all the air conditioning and oxygen stuff was going on."

The look of the city itself was determined by a number of factors, not least of which was the fact that some of the sequence was actually shot on location in Dubai, one of the most futuristic cities on Earth. Hargreaves was given reference for the real buildings that would be used and had to incorporate them with his own designs for the rest of the city. "The brief was 'Here's Dubai, here's the architecture of the buildings. We can do some crazy stuff but we have to respect the buildings that we are shooting on location.' We combined those with the CG model and blended all that architecture in. So in my illustrations, there are basically some contemporary buildings of today, and there is stuff I threw in from being someone who really appreciates architecture."

▲ It was important to Hargreaves to vary the kind of things we saw along the *Yorktown*'s arms, and he created parks, farms and industrial areas.

Designing the outside of the *Yorktown* wasn't enough. The script made it clear that the *Enterprise* wouldn't simply fly above the *Yorktown*'s cities, but would fly through the arms that supported them. "This was a big scene because you really get to see the scale of *Yorktown*, but there was a problem. I said 'From the outside you can't see the *Enterprise*. You can only shoot it from within the tunnel. So why not have windows so you can travel along with it from the outside? You can see it moving and see the city above it. That way you get a true sense of scale.

"I was doing all my city planning, and I thought it would be kind of cool if the bottom of the lakes

▲ Hargreaves designed the entrance to the *Yorktown*, which gave a sense of just how massive the station was.

▲▼ Hargreaves was pleased with the elliptical shape of the *Yorktown*'s "tunnels", but found working out how to light them presented a real challenge. Part of the solution was to add windows, but he also created internal light sources.

and rivers were glass, like a framework that was sustaining the water. You could see into the tube through the water and the glass."

This last decision meant that when the *Franklin* was chasing Kraal through the station, it could be seen underneath the 'floor' of the city, adding an important element to the final stages of the movie. "I didn't think they'd go for it," Hargreaves smiles, "but they did. Justin was really open to stuff like

that. He's a real movie person. It's about moving a story forward. He's not like an auteur where he thinks 'This is the way I want it done.' He's very much open to ideas."

The finished *Yorktown* goes down in history as the largest space station ever seen in *STAR TREK* – a combination of city and planet, that took the movie's vision of the future to another level, and gave it a new sense of grandeur and scale.

In the closing stages of the movie, the *Franklin* makes it way through the vast corridors inside the *Yorktown* as it pursues Kraal's ship. It was Hargreaves's suggestion that it could also be seen from the outside of the tunnel under the surface of the city.

The interior of the *Yorktown* was made up of a series of interconnecting elliptical corridors and parabolic curves, creating organic shapes that Hargreaves thought were interesting.

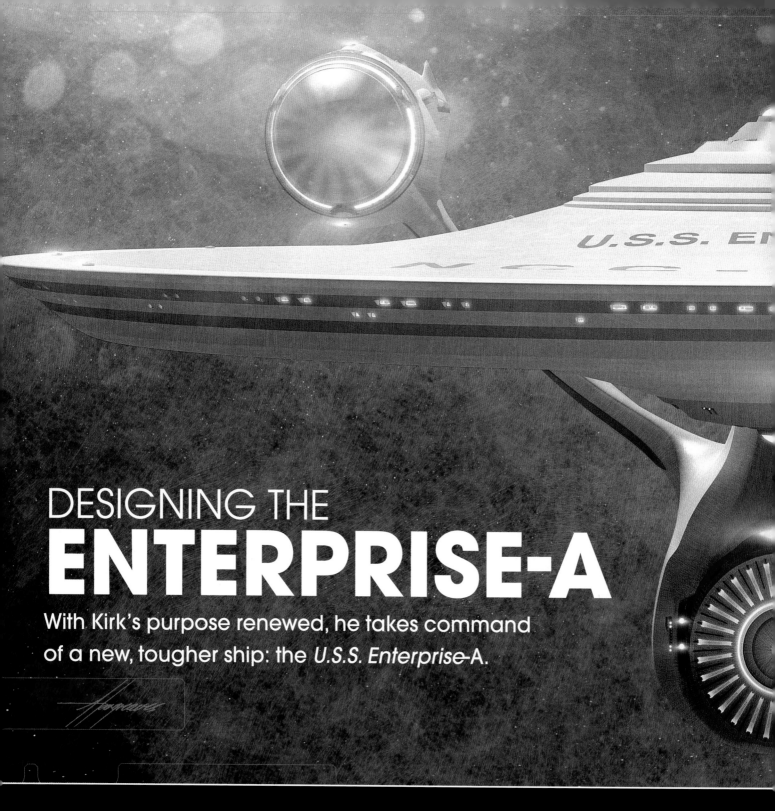

DESIGNING THE
ENTERPRISE-A

With Kirk's purpose renewed, he takes command
of a new, tougher ship: the *U.S.S. Enterprise*-A.

▲ Hargreaves' new
Enterprise kept the
elements of Ryan
Church's design, but
emphasized certain
shapes and made the
ship more robust.

S*TAR TREK BEYOND* ends with the construction
of a new *Enterprise,* a ship that is both
instantly familiar and different to what had
come before. Just how different isn't immediately
obvious since it is barely seen in the film. The
Enterprise-A is a new ship that was designed by

Sean Hargreaves, though, as he remembers, it
almost didn't happen. "The ship at the end was in
and then it was out. It went out twice. When it
went out the second time, I thought, "`I don't care.
I'm going to work on it anyway!' I just kept working
on it, even at weekends. I spent a lot of time on it."

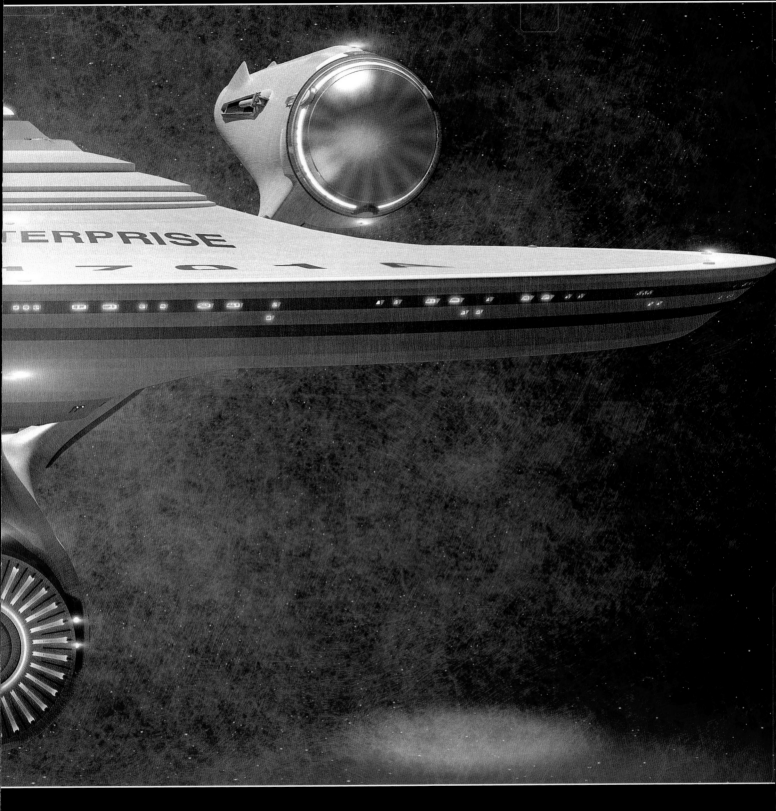

As he explains, the brief the director Justin Lin gave him wasn't to completely redesign the *Enterprise,* but to address some of the concerns about how easily it had been torn apart by Kraal's ships. "They didn't want me to totally disrespect that ship in terms of going in another direction.

Justin felt that this *Enterprise* needed to be more robust. The neck needed to be thicker and the pylons holding the engines needed to be much bigger because those were weak points. So he basically said, 'Make it wider, make it thicker.' "

As Hargreaves explains, rather than start

▲ All the most important elements of Hargreaves's redesign can be seen in the simple drawings that he produced for Justin Lin and Tom Sanders.

and see if it works. Sometimes it'll be 'Oh, this works'; other times it will be a complete disaster."

At this point, he didn't think about the details at all. Instead he focused on the most basic shapes. "I felt there were a lot of shapes going on that weren't speaking to each other. As you look at the front end of the ship as it's coming towards you, there are different shapes that go on. You've got the two blue nacelles and then the deflector. That's a triangle, that's three rings right there. Then you've got the body of the engineering hull and the body of each of the engines. The section through that is what we call a soft triangle. Which means the points of the triangle are very rounded but it's not a circle. There's a relationship of forms of all this kind of stuff that makes it talk to itself that makes it relate. That was one of things I was trying to accentuate – the ring aspect of these things."

drawing, the first thing he had to do was think about what he planned to do with the ship. "The way I design stuff is I do a lot of sketches in my head and I think about it a lot. Then I work myself up into a frenzy and I can't wait to get home and put it all down on paper or put it into the computer

DESIGN ECHOES

When it came to the neck Hargreaves was worried about making it thicker as Lin had asked. Instead he decided to increase its depth making it sweep back into the engineering hull. This gave him an

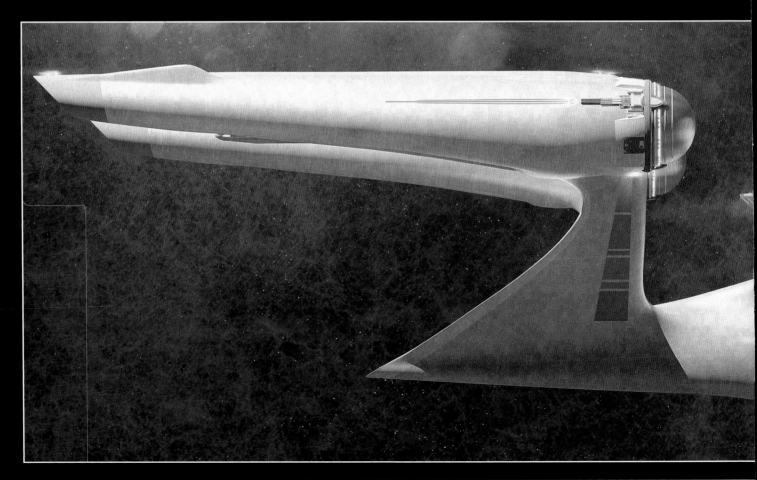

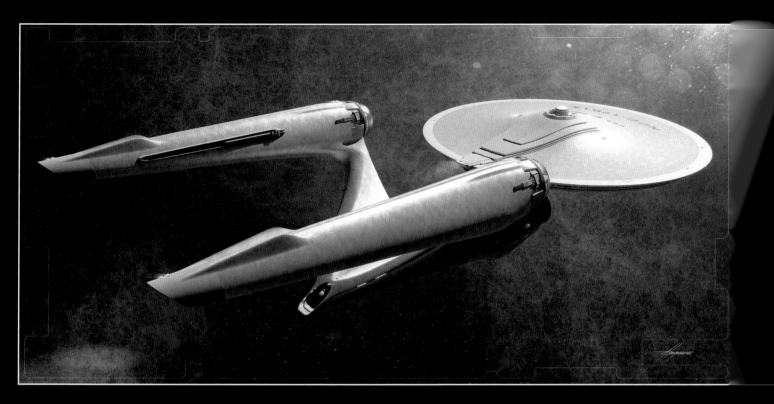

obvious triangular shape, which he replicated on the nacelle support struts. "It was basically a relationship of form of triangles," he explains. "The triangle of the neck… the triangle of the pylons."

However, when it came to the front of the neck, he broke away from the triangular shape.

"All of the profiles of the *Enterprise* have had a leading edge of the neck that's been kind of

▲ Hargreaves was a big fan of the simplicity of Matt Jefferies' original design and he wanted to keep his version as plain and 'clean' as possible.

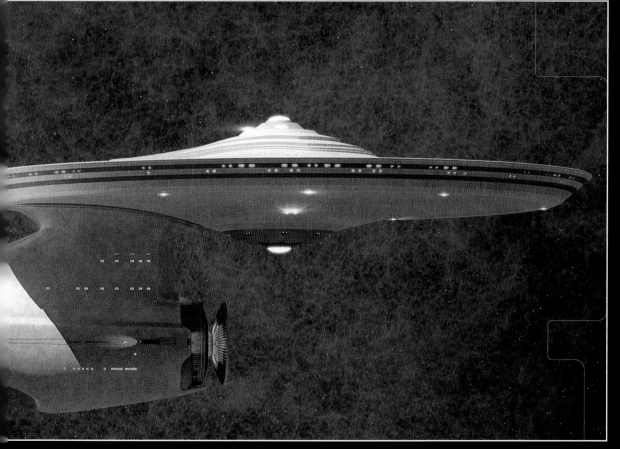

◄ Hargreaves created triangular relationships between the back edges of the neck and the nacelle support pylons. At the same time he straightened the front edges of both elements, making them more upright and therefore more aggressive.

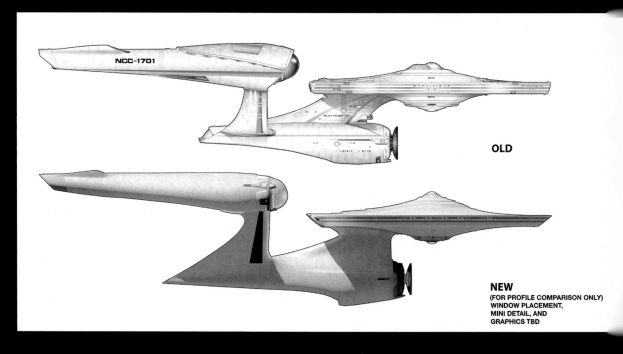

▶ This drawing shows the *Enterprise* from the beginning of *STAR TREK BEYOND* alongside the *Enterprise-A*, making it clear how the design has been changed.

▼ Hargreaves redesigned the Bussard collectors at the front of the nacelles to look more like the versions on the original *Enterprise*.

angled forward. I made a statement – I made it vertical. That made it look way more aggressive than it had in the past. I did the same thing with the leading edge of the pylons to relate to that."

In contrast he wanted to restore an element of Matt Jefferies' original design that had since been lost. "I loved the saucer that Jefferies had and how edges of it were canted in almost 45 degrees.

It had a beautiful line. So when that ship passes you, it looks as if it's actually accelerating. Over later years they took that away."

Only after he'd worked out what he wanted, Hargreaves finally sat down and produced two very quick sketches in red ink. "I had a profile sketch and then I did the plan view. I showed these to the production designer Tom Sanders and

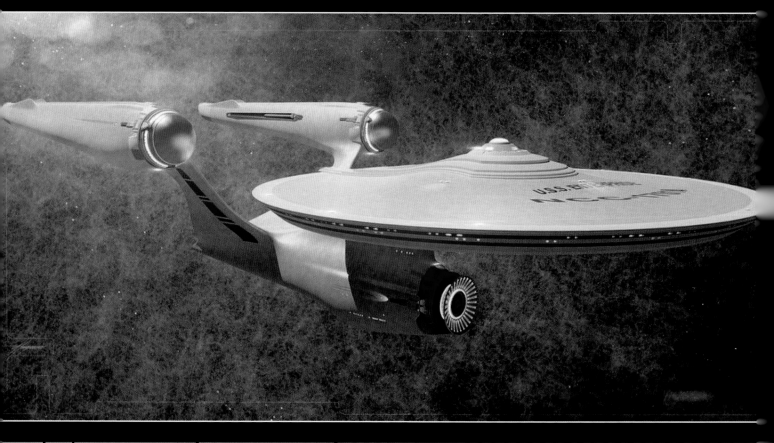

to Justin and they said go with that and see what we end up with. That basically was the origin for the look of the ship."

Now Hargreaves took the original model of the ship from the beginning of the movie and started to alter it. "They got the model from Double Negative for me. It was amazing. I just wanted the basic model but they then sent us the shooting model. It was over a hundred million polygons. It was a ridiculous amount of detail. You could go right into the engines and see all the detail.

"I took parts of that and modified it. It's a beautiful shape, lots of accelerated curves and little subtle shapes that are going on in the body, especially the engineering section. When you get quite close in there and you look around and the light's hitting it, it's a sculptural piece. It's quite beautiful. It took a long time for me to keep that beauty in there and just hold that simplicity.

"I loved Jefferies' earlier stuff which was very much to the point. Basically, I decided what I liked about that, which was the engines and the nacelles. So I cleaned up the engines. I put them on a diet. I took a lot of the detail out and went to basic speed lines and shapes and putting detail in certain areas and no detail in other areas. The

body of the engineering section I modified somewhat, but it's basically the same body I was given and the ship before it was quite curvy."

Hargreaves took the opportunity to restore another element of Matt Jefferies' design that he missed. "I loved the domed nacelles; I loved the spinning lights that were going on in there."

"The only thing I didn't fully finish was the shuttlebay. I didn't deck that out with all the detail and stuff like that and in some of the illustrations it looks like an egg. If there is anything I would go back in and work out, it was that."

CONTROVERSIAL CHANGES

Hargreaves is well aware that his *Enterprise-A* design would be too radical for some people, in particular the way he redesigned the nacelle pylons. "I knew that when I did the pylons that I was pushing it. I knew that people were going to be horrified and other people would be like, 'Wow that's cool.' Some people have loved it and some people have not liked it. Some people have kind of liked it and then grown to love it. Everyone has their opinion. I'm happy with it. It was a great honor to work on the film for one thing, but to do the *Enterprise* was fantastic."

▼ Seen from behind, Hargreaves's *Enterprise* reveals some surprising curves.

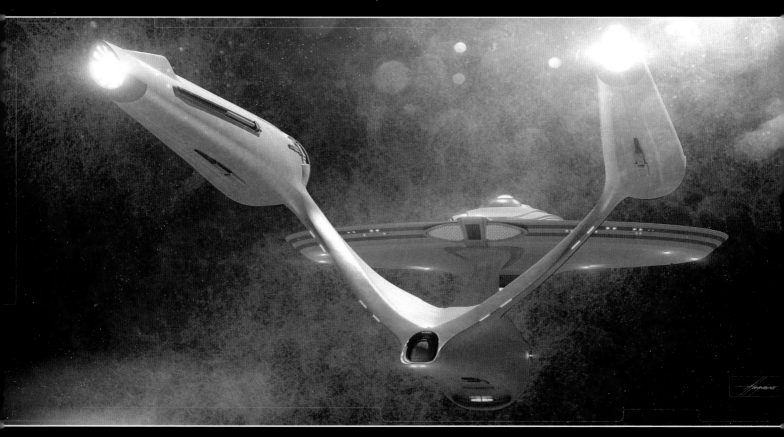

DESIGNING THE
FORGOTTEN SHIPS

Romek Delimata designed half a dozen Starfleet vessels for the
end of *STAR TREK BEYOND* that never made it to the screen.

A t one point, Justin Lin and the producers considered surrounding the new *Enterprise-A* with other Federation ships for the sequence at the end of the movie. They were never built, but they were designed. As Romek Delimata remembers, "At the end of it we were asked to come up with some ideas for background space ships. I didn't have a day off for six months and by then I was tired. When I was asked to come

up with ideas I just started bashing out space shippy things, coming up with a shape and then putting a texture on it."

Delimata ended up designing five different ships and a shuttle. Unofficially, he gave them simple names - Federation ship, of which there were two variations (one of which is named the *U.S.S. Challenger* in one of the sketches), tall ship, tube ship, long ship, and petal ship.

▲ At one point; the *Enterprise*-A wouldn't have been the only ship we saw at the end of the film - Romek Delimata came up with several options for other Starfleet ships.

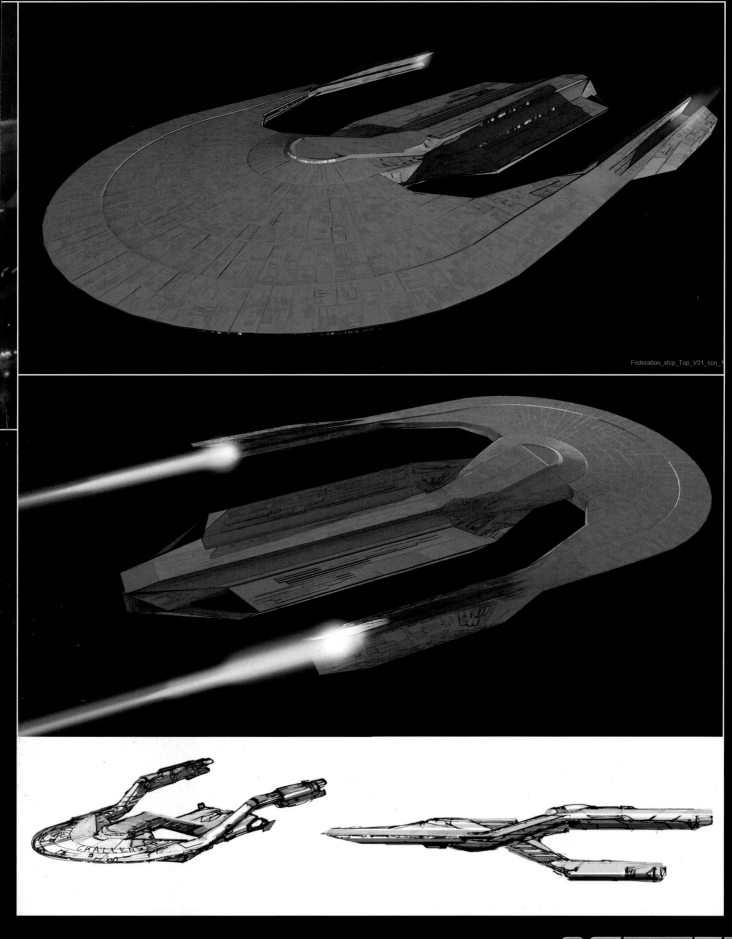

Federation_ship_Top_V01_con_1

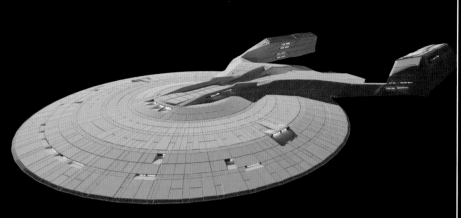

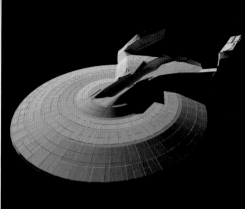

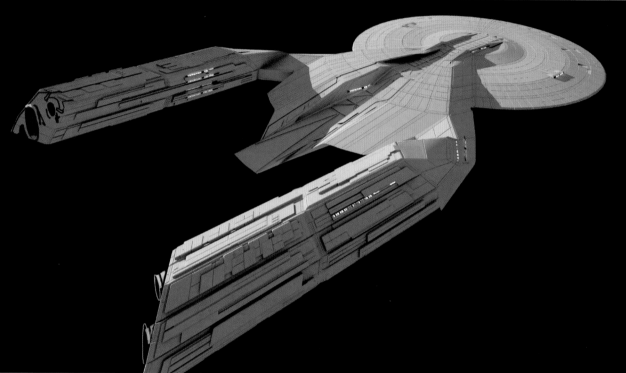

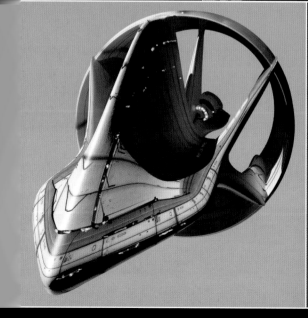

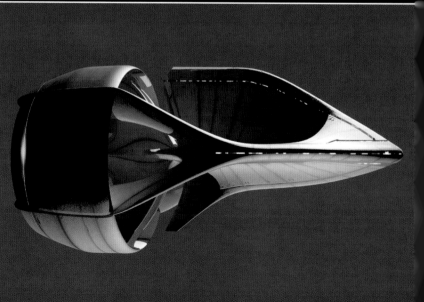

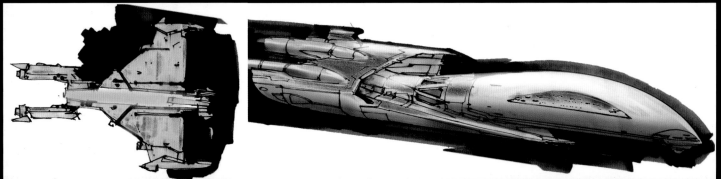

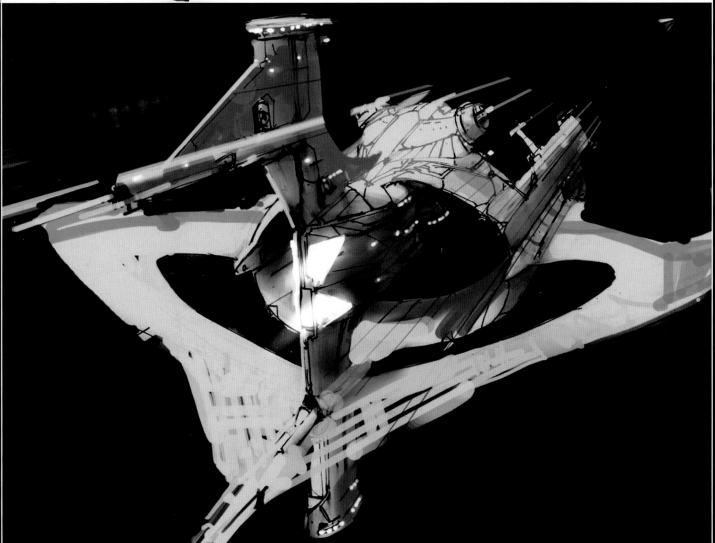

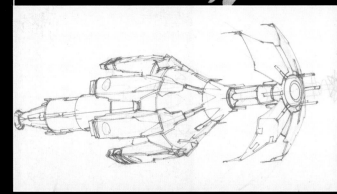

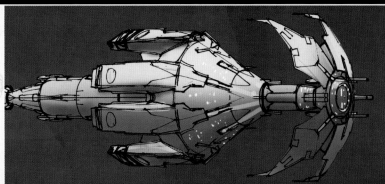